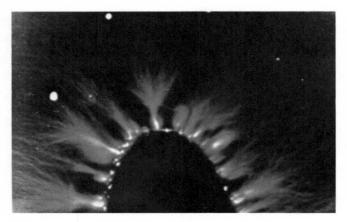

FIGURE 22. Electrophotograph, right index finger pad of A. Krivorotov during state of rest (courtesy, V. G. Adamenko). *COLOR*

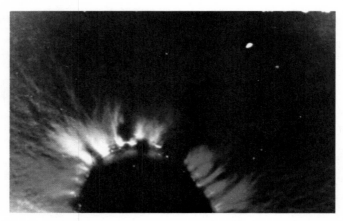

FIGURE 23. Electrophotograph, right index finger pad of A. Krivorotov during attempted "healing" (courtesy, V. G. Adamenko). *COLOR*

THE ENERGIES OF CONSCIOUSNESS

ABOUT THE AUTHORS

STANLEY KRIPPNER

Vice President for the Western Hemisphere
International Association for Psychotronic Research
Prague, Czechoslovak Socialist Republic
Research Consultant, Experimental Electrophysiology Study
Acupuncture Research Project, Department of Anesthesiology
School of Medicine, University of California, Los Angeles

Director of Research
The Churchill School
New York City, New York

Program Coordinator
Humanistic Psychology Institute
San Francisco, California

Honorary Vice President
Albert Schweitzer Cultural Association
Mexico City, Mexico

Founding Trustee and Research Associate
Gardner Murphy Research Institute
Chapel Hill, North Carolina

Editor-in-Chief
Psychoenergetic Systems: An International Journal
London, England

DANIEL RUBIN

Instructor, Department of Physics
California State College, Sonoma
Rohnert Park, California

Research Associate
Foundation for ParaSensory Investigation
New York City, New York

Consulting Editor
Psychoenergetic Systems: An International Journal
London, England

THE ENERGIES OF CONSCIOUSNESS:
Explorations In Acupuncture, Auras, and Kirlian Photography

Edited by

Stanley Krippner and Daniel Rubin

INTER∫ACE

"SOCIAL CHANGE" SERIES, edited by Victor Gioscia

This series of Gordon and Breach books is edited in tandem with the journal entitled *Social Change*. The series includes the following books:

TIMEFORMS Beyond Yesterday and Tomorrow by *Victor Gioscia*

BETWEEN PARADIGMS The Mood and its Purpose *by Frank Gillette*

HOW BEHAVIOR MEANS *by Albert E. Scheflen*

EARTHCHILD *by Warren Brodey*

BIRTH AND DEATH AND CYBERNATION The Cybernetics of the Sacred *by Paul Ryan*

GALAXIES OF LIFE The Human Aura in Acupuncture and Kirlian Photography *edited by Stanley Krippner and Daniel Rubin*

TOWARD A RADICAL THERAPY Alternate Services for Personal and Social Change *by Ted Clark and Dennis T. Jaffe*

THE ENERGIES OF CONSCIOUSNESS Explorations in Acupuncture, Auras, and Kirlian Photography *edited by Stanley Krippner and Daniel Rubin*

Other books in the series will be announced as they approach completion.

An INTERFACE book,
published by Gordon and Breach, New York

*Dedicated to the memory of Virginia Glenn
and William Wolf . . . who brought us all together*

V. Chaloupkoch 59,
Prague 9, Hloubetin
Czechoslovak Socialist Republic
January 30, 1973

Dear Dr. Krippner:

I wish you much success in the organization of the Second
Kirlian Conference.

With friendly regards,

ZDENEK REJDAK

Do Vostrebovaniya
Moscow K-9, U.S.S.R.
February 1, 1973

Dear Dr. Krippner:

Best wishes to you and to all of the scientists who will present
papers during the Second Western Hemisphere Conference on
Kirlian Photography.

Very sincerely,

VIKTOR G. ADAMENKO

Kazakh State University
Alma-Ata, Kazakh, U.S.S.R.
February 5, 1973

Dear Dr. Krippner:

With warm regards to all participants in the Second Conference
on High Frequency Photography.

Sincerely,

SEMYON D. KIRLIAN

Foreword

The modern study of electricity, especially of electric currents, began in the eighteenth century when the battery, or voltaic cell, was invented by the Italian physicist Alessandro Volta. Electricity had been known for centuries in the form of lightning and similar discharges. Although static electricity created by rubbing objects together was a popular subject of study in the eighteenth century, Volta's device was the first to generate a steady current of electricity over a long enough period of time to allow the properties of that current to be studied (Bernstein, 1973).*

In 1820, the Danish physicist, Hans Christian Oersted, discovered that an electric current would perturb a magnetic compass needle. Magnetism had been known since the time of the ancient Greeks; however, it was never suspected that magnetism and electricity were in any way related. This connection was quantified when the French physicist, Andre Marie Ampere, showed that a circular loop of metal wire with an electrical current flowing through it produced a magnetic force.

By the beginning of the nineteenth century, these developments had clarified three things: Magnets can influence, or interact with other magnets; electric currents can interact with magnets; electric currents can have magnetic influence on each other (Bernstein, 1973).

The English physicist Michael Faraday, working as a laboratory assistant to the chemist Sir Humphry Davy, developed experiments that led, in 1831, to his discovery of electromagnetic induction. Faraday demonstrated that under certain circumstances magnets can induce electric currents.

*The first edition of the Encyclopedia Britannica mentions a Professor M. Jallabert (1771:404–405), of Switzerland, as the first practitioner of healing through electricity. In 1748, Jallabert, through application of electric currents, cured a locksmith whose right arm had been paralyzed for 15 years. Benjamin Franklin is also cited as demonstrating an interest in this type of treatment, even though an attempt at electrical healing he witnessed was unsuccessful.

Faraday theorized that the results of this discovery would apply to the influence of electrically charged objects on each other. Faraday's ideas were quantified by James Clerk Maxwell, a Scottish physicist who related the variations of a magnetic field to the variation in the induced electric field. A field can vary in either space or time; that is, at a given point in space the field can vary in time—or at a given time the field can have values that differ from point to point in space. The Maxwell equations relate the variation of the electric field in space to the time variation of the magnetic field.

One of Maxwell's ideas was that if one can cause an electrically charged object to vibrate, part of the electromagnetic field surrounding the charge will become detached and will move away from the charge as a wave. Maxwell discovered that the speed at which these waves would move approximated 186,000 miles per second, the speed of light. This was the first clue that light itself is an electromagnetic phenomenon.

The existence of electromagnetic waves moving in a vacuum was confirmed experimentally in 1888 by the German physicist, Heinrich Hertz, who invented oscillators to create the Maxwell waves and receivers to detect them. Hertz was even able to confirm Maxwell's prediction that such waves would move with the speed of light.

Hertz' experiment convinced another German physicist, Albert Einstein, that much of Newtonian physics was incorrect. In 1905, he published a paper on relativity. At about the same time, experiments by two American physicists, Albert Michelson and Edward Morley, had disproved the long-held notion that light moved through an "ether."

One of the most significant aspects of Einstein's 1905 paper was the natural unity it gave to the concepts of electricity and magnetism. An example has been presented by Bernstein (1973).

> The unity . . . can be most clearly illustrated by considering a single electron. If we are at rest with respect to this electron, it produces a pure electric force. We can test this by taking another electron initially at rest with respect to the first and observing that these two principles repel each other according to Coulomb's Law—discovered by the French physicist, Charles Augustin de Coulomb, in 1785—which gives the quantitative formula

for a purely electric force. (If a magnetic compass is brought into the vicinity of such a purely electric force, it will not react.) Once the electron is set in motion, however, the electric force is modified, and in addition, the electron generates a magnetic force ... In other words, electricity and magnetism are essentially the same phenomenon—or are different aspects of the same phenomenon, and which aspect is observed depends on the velocity of the observer with respect to the electron.

This had been previously understood in other ways; the Maxwell equations, for example, were helpful in clarifying the nature of electromagnetic fields (Maxwell, 1881; Zahradnicek, 1948). However, it was only with the appearance of Einstein's theory that the connection between electricity and magnetism was fully understood.

The continual interplay between theory and experiment rests at the heart of scientific methodology. On the one hand, the existence and properties of the positron were predicted theoretically before positrons were experimentally detected. On the other hand, the universal interpretation of Maxwell's theoretical equations describing electromagnetic phenomena was that they accounted for light waves which moved through the "ether." The Michelson and Morley experiments showed decisively that the "ether" did not exist; the negative result of their experiment led Einstein to speculate on relativity. Further, the experimental data accumulated by atomic spectroscopists led directly to quantum theory (Jungerman, 1973). In quantum theory, the atom is seen as constituted by functionally interacting nuclear and electronic fields rather than by mechanically interacting parts.

A basic tenet of the earlier experiments was the position that the experimenter was an impartial observer of objective reality. However, the quantum theory—which explains quantitatively vast domains in atomic and solid state physics—demands that one's consciousness be unavoidably connected with the inanimate world. Rather than conceptualizing the experimenter as an impartial observer of reality, it requires that one be an active participant in that reality. Thus, an experimenter's very effort to understand reality is part of the phenomenon that earlier experimenters incorrectly believed could be impartially observed.

Niels Bohr (1966), who originated the quantum theory of the

atom, stated that reality understood is reality changed. To Bohr, the magnificent orderly systems of classical physics appeared as narrow interpretations of a more comprehensive reality.

Bohr felt that a deep conflict existed between the concepts of description and causality. If one described the world to any desired accuracy and produced a sort of photograph showing where everything was, the photograph could only be taken at the cost of foreswearing any connection between it and future photographs. That is, the act of determining the present changes our prediction of the future. The more we know of the present, the less we can know of the future (Jungerman, 1973).

Quantum mechanics describe the physical world by means of the wave function of a mathematical concept (Schrodinger's equation). If we know the wave function, we have a description of that world. According to the American physicist, E. P. Wigner (1962), the impression the observer gains at an interaction of observer and physical system—called the result of an observation—modifies the wave function of the system. Wigner (1962:289) continues:

> The modified wave function is, furthermore, unpredictable before the impression gained at the interaction has entered our consciousness; it is the entering of an impression into our consciousness which alters the wave function because it modifies our appraisal of the probabilities for different impressions which we expect to receive in the future. It is at this point that the consciousness enters the theory unavoidably and unalterably. Therefore, an "uncertainty principle" (conceived by Heisenberg) is at the heart of quantum theory, holding that the observation of an event may change the outcome of that event.

Einstein was never convinced of the uncertainty principle (Jungerman, 1973), stating that "God does not play dice." Einstein (1934:60) had written, "The belief in an external world independent of the perceiving subject is the basis of all natural science." The view put forward by Bohr which was not acceptable to Einstein was that the wave function represents our knowledge of a physical system, not the physical system itself. In other words, the wave function is an information field (Jungerman, 1973).

Ervin Laszlo (1973:57) has remarked that the mechanical model

of the atom had to be discarded with the advent of quantum physics. Jungerman (1973) has noted that quantum physics has made plausible the idea that an observer can interact with a physical system through his or her consciousness. Jungerman (1973) has also suggested that the *quality* of one's consciousness can play a decisive role in this interaction:

> In psychokinesis, the spectacular abilities of Nina Kulagina are not available to everyone. The experience and training if not the inherent ability of Robert Pavlita permit him to charge his psychotronic generators. It has been reported that the consciousness of others witnessing an experiment involving Nina Kulagina can affect the result. Witnesses with concealed doubts or skepticism required this subject to exert much more mental effort to achieve the same physical effect. So here we have a situation where a critical, objective posture of the scientist may actually impede the experiment.

These qualities of consciousness provide a theme which runs through the papers from the Second Western Hemisphere Conference on Kirlian Photography, Acupuncture, and the Human Aura, held in Town Hall, New York City, on February 13, 1973. Over one thousand people heard a variety of theoretical, clinical, and experimental reports. Work with Kirlian photography revealed how different people can produce widely varied pictures on the Kirlian apparatus. The intriguing results of acupuncture treatment suggest that the quality of consciousness a practitioner brings to the treatment session may influence the results. Laboratory research on the human aura presents a similar variability in this field; the instruments used to detect emanation registered more of an effect from some individuals than from others.

Are there previously ignored energies which are measured by the aura researchers, which assist healing in acupuncture, and which produce the flare patterns seen in Kirlian photography? If so, how do they relate to electromagnetic fields? Further, how can quantum theory assist us in understanding these phenomena? Science has helped us to discover many of nature's secrets since the days of Volta, but some of the greatest surprises may still be ahead.

Pioneers in physics now know that our picture of the universe as a predetermined gigantic clockwork is incorrect and misleading

(Jungerman, 1973; Laszlo, 1973:242). These physicists also know that the experimenter is an active participant in the reality being investigated. The unusual phenomena discussed in this book should not be discarded and ignored because they will not easily fit into the old paradigms (Kuhn, 1962). Indeed, the energies of consciousness can be of great benefit to humanity if they are properly investigated and utilized. To do this requires courageous investigators who will not hesitate to utilize new paradigms, fresh methodologies, and innovative concepts of reality.

Stanley Krippner and Daniel Rubin

For current developments in the fields of:

Acupuncture	Psychotronics
Auras	Biocommunication
Kirlian Photography	Unorthodox Healing
Energy Interactions	Quasi-Sensory Communication
Consciousness	Psi-Processes
Matter	Subliminal Perception
Brain Research	Psychokinetic Effects
Paraphysics	Bioelectric Fields
Parapsychology	

Subscribe to the international journal:

Psychoenergetic Systems

For more information, please write to:

Gordon and Breach	Gordon and Breach
One Park Avenue	42 William IV Street
New York, New York 10016	London WC2, England

Preface

Man is an endangered species.

We think the separation of fact from value is the principal illusion responsible for the nearly terminal condition of species man on planet earth. This series is an attempt to share the facts and values of intelligent people who know valuable things that might help us find, live, and experience in ways that are species-enhancing, not species-destructive.

We think sharing information of this kind is as vital to humans as water is to fish.

We think we can depollute our information environment by introducing life-enhancing values into the changing currents of our lives.

We think the series should serve as a critical information resource for people who are seriously trying to enhance the life of species man.

We will publish hard science only when we think it will help us do that. We will publish opinion, analysis, exhortation, review, speculation, experiment, criticism, poetry and/or denunciations if we think it is of critical human benefit. We are not naive. We don't think publishing a few truths will set us free. We are not optimists. We don't think the chances for human survival are very good. We are not elitists. We don't think that showers of wisdom from Olympus will illumine the simple man's darkened awareness.

We believe that human consciousness both guides and responds to human interaction, and that most contemporary interaction proceeds from and perpetuates assumptions about human life that are no longer valid. We believe that these assumptions *can* be changed if/when we want to.

Some of our fondest assumptions have already been unmasked by changes, unleashed by blind commitments to short run values. The most glaring example—we once believed technology made interaction "easier." Now we know that when our technologies violate ecological laws, we murder each other.

Some new forms of interaction (and some old ones) are currently being touted as *the* way. We don't think there is, or can be, any *one* way. How to sort out the promising ones from the blind alleys constitutes our principal aim.

We therefore deliberately adopt a post-disciplinary stance, believing that no one view, be it philosophical, scientific, aesthetic, political, clinical, what have you, has *the* answer.

We intend to be a sort of whole earth idea catalogue for people who think that thinking about the human predicament *might* help us to live as one self-aware species, deliberately guiding its own evolution for the first time.

As editors, we will select and publish things *we* value as attempts to foster that kind of voluntary humanity.

Therefore, we invite anyone, whether clinical, social, behavioral scientist (or fan), student, faculty (or interested person), young or old (or in the middle) to join us in the attempt to make a joyful human future not only possible but likely.

So—if you think "Science" is *the* way, we're not for you, and you probably won't like us. If you think radicals are mad (née crazy, disturbed, insane, deviant, misguided, *etc.*) we're not for you, and you'll probably loathe us. If you think the world will not be safe until sociologists are kings, we think *you're* mad. Ditto for politicians.

Every day, changes race into our world like mad flood-waters, undermining all we hold sacred and sure.

Change is called for.

Yet, change is crisis.

What to do in such times. How to live. Feel. Know. Experience. That's what this Series is about.

Victor Gioscia,

Series Editor

Contents

International Developments In Biological Energy

1

Stanley Krippner

On June 28, 1971, I delivered an invited address on para-psychology at the Institute of Psychology, a part of the Soviet Academy of Pedagogical Sciences (Krippner & Davidson, 1972c). This was the first time that such topics as telepathy, clairvoyance, precognition (the receptive–perceptual phenomena studied by para-psychologists), and psychokinesis (the expressive–motor phenomena) had been aired at the Institute of Psychology. The Moscow auditorium was filled for my presentation, the audience consisting of physicists, psychiatrists, physicians, and space scientists as well as psychologists. In my address, I presented recent research findings from our laboratory in the Maimonides Medical Center, which indicate that altered states of consciousness (such as dreams and hypnotic induction) appear to favor the occurrence of telepathy and other "psi" phenomena (Ullman, Krippner, & Vaughan, 1973).

Moderator of my presentation was Edward K. Naumov (Figure 1), director of the Institute of Technical Parapsychology, and popu-larizor of Soviet parapsychological research (or "psychoenergetics," as many of the Soviet investigators prefer to call it). Before my

*Dr. Krippner's trips to Moscow in 1971 and 1972 were supported by grants from the Erickson Educational Foundation, Baton Rouge, Louisiana. Edward K. Naumov, Krippner's host on these visits, was sentenced to a two-year prison term by a Moscow court in 1974, apparently because of his efforts to popularize Soviet parapsychology.

FIGURE 1. E. K. Naumov, Moscow, 1972 (courtesy, R. P. Harris).

assistant, Richard Davidson, and I left Moscow, Naumov proposed
that an international meeting be held in Moscow during July, 1972,
centering on the problem of psychokinesis or PK (referred to as
"biological energy" or "bioenergetics" in the U.S.S.R.). Special
emphasis would be placed on methods to study PK (e.g., Kirlian
photography) and to use PK (e.g., "psychic healing"). Great
advances had been made in this field by Soviet scientists who are
not parapsychologists but whose work borders on the area of
psychoenergetics (Kholodov, 1966; Miroshnitzenki, 1972; Presman,
1964; Repin, 1967). Therefore, Moscow seemed to be a fortuitous
choice for an informal discussion of these areas.

 Over the next several months, plans proceeded for this meeting.
I took the initiative of contacting North American scientists while
Naumov invited the Europeans. The response was very gratifying
and our plans eventually fell into place.

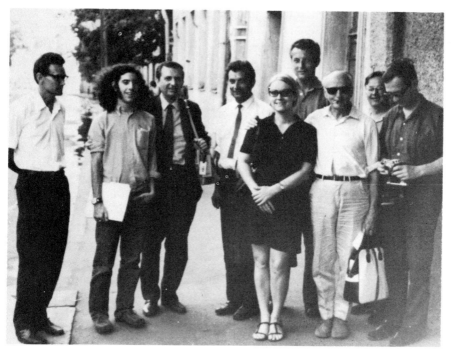

FIGURE 2. Participants, Moscow Meeting, 1972 (courtesy, G. Albert).

Most of the participants in the International Meeting on the Problem of Bioenergetics and Related Areas arrived in Moscow on Sunday, July 16 (Figure 2). We were met at the Intourist Hotel by Naumov, Larisa Vilenskaya (Naumov's assistant and a para-psychologist who specializes in the study of dermal–optical vision— "seeing" with the fingertips), Viktor Inyushin (a physicist from Kazakh State University in Alma-Ata), and others. Although most of the scientists were from the United States and the U.S.S.R., there were also representatives from Canada, Austria, Italy, Switzerland, Eire, the United Kingdom, the Czechoslovak Socialist Republic, and the Federal German Republic. The approximately 60 participants in the meeting included some of the world's most distinguished parapsychologists (e.g., Viktor G. Adamenko, Hans Bender, E. Douglas Dean) as well as a number of students, psychic sensitives, and interested lay people.

On Monday morning, we arrived at the Moscow Institute of Psychiatry for the meeting's first session. Presiding was Yuri S. Nikolayev, the renowned researcher in schizophrenia whom I had met in 1971. Dr. Nikolayev took us on a tour of the 80-bed schizophrenia clinic, introduced patients, and outlined his therapeutic program (Cott, 1971).

When patients arrive at Nikolayev's clin, they are placed on a fast which lasts approximately 30 days, depending on the patient. Although they can have as much mineral water as they like, the patients can have no food. Nikolayev hypothesizes that many types of schizophrenia are caused by toxins in the system which can be eliminated through fasting (and an enema with a magnesium solution, administered daily). Indeed, his patients' delusions and hallucinations usually begin to disappear, their emotionality becomes more appropriate to their overall behavior, and they develop more sociability than they had previously demonstrated. They receive a daily massage, supportive counseling, and are encouraged to walk out-of-doors for long periods of time. They discuss their personality changes with other patients in regularly scheduled periods of group therapy. In some cases, hypnotherapy or autogenic training are also utilized.

Their physiology appears to change dramatically and underlies the psychological improvement. At first, the patients' appetite is very intense. The tongue is coated and acidosis occurs. After the first week of fasting ends, the acidosis diminishes, the tongue clears, and the skin color improves. However, the hunger is still great and the patients' dreams are generally about food. During the third week, the hunger diminishes and the psychological improvement becomes obvious. By the end of the fast, about 20 percent of the patients' body weight has been lost.

After the toxic agents are felt to have left the patient's body, the fast ends and foods—beginning with strained fruit and vegetable juices—are gradually re-introduced. Vitamins and minerals are given in large quantities. Buttermilk and salads are then tried. Whenever a food is associated with a recurrence of symptoms, that particular food is removed forever from the patient's diet. As a result, most of the patients cannot eat white sugar again and some cannot use

salt. In addition, certain meats have to be banned for some patients as their ingestion brings back the signs of schizophrenia. The typical diet of the former patient emphasizes fruits and vegetables; alcohol and tobacco are avoided as well as any food found to be harmful.

Nikolayev told us how he had initiated the fasting procedure 27 years ago and how 8,000 patients have been treated—two-thirds of them making complete recoveries, according to his follow-up studies.

Following Nikolayev's talk, a number of patients were introduced and, through an interpreter, told their stories. One was a young man who reported the onset of schizophrenia at the age of 16. He lost his time and space orientation; his speech became irrational and he began to think of suicide. His aberrant behavior was noticed and he was hospitalized. At the time of our visit, he was in his 28th day of fasting. He reported that he was free of his former symptoms and would be breaking the fast in a few days.

When asked if the fasting treatment was being applied in the United States, Nikolayev referred to a project for schizophrenics at a Manhattan hospital administered by Allan Cott, a psychiatrist. "However," Nikolayev pointed out, "the American program costs one hundred dollars per day, while ours is free."

Although several aspects of the therapy were pertinent to parapsychology (e.g., the possibility that the schizophrenic picks up telepathic messages which become part of his delusional system), this topic was not discussed on Monday. The meeting at the Moscow Institute of Psychiatry was held in an institution and was classified as "official." However, psychoenergetics is still controversial in the Soviet Union (especially among the more traditional psychologists) so the presentation of material on psychokinesis and related topics was delayed until the beginning of the "unofficial" meetings on Tuesday.

Approximately 60 persons assembled at the May Day Club on July 18, most of them arriving in the Intourist buses. (Intourist officials had graciously prepared packed lunches for the all-day meeting and sent buses to pick up the participants in the afternoon.) Dr. Eugene Salnikov (Figure 3) head of the U.S.S.R.'s Institute of Progress in Medical Science, served as moderator of the

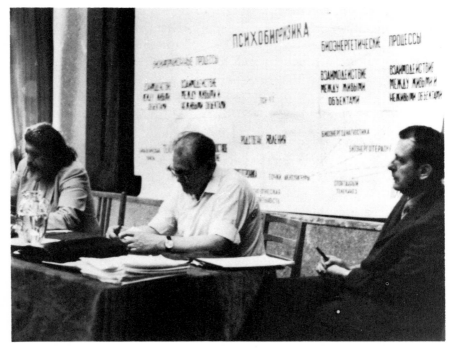

FIGURE 3. C. Harari, E. Salnikov, & S. Krippner (courtesy, R. P. Harris).

session, expressing friendship to the international group, and pointing out that his department is interested in a wide range of physiological and psychological problems. Carmi Harari replied to Dr. Salnikov, expressing interest in scientific cooperation on behalf of the Association for Humanistic Psychology (for which he was serving as chairman of the Committee for International Development).

The first address was given by Naumov who presented the long history of Soviet research in psychoenergetics tracing it back to work done by one of Pavlov's students, Vladimir Behkterev (1920; 1971) who founded the Institute for the Study of the Brain and Nervous Activity in the first part of the twentieth century. Naumov told how the research had been interrupted by World War II and how it had been denounced as "idealistic" and "anti-materialistic" after the war. In 1955, parapsychology (or psychoenergetics) was

described as "the non-scientific idealistic consideration of super-natural abilities of perceptual phenomena" in the official Soviet *Encyclopedia of Philosophy* (Ebon, 1971).

However, in 1968, parapsychological laboratories were organized in both Leningrad and Moscow with government support. In the most recent *Encyclopedia of Philosophy*, parapsychology is referred to "as a field of research which basically studies (1) forms of perception affording a means of receiving information which cannot be explained by the known senses, and (2) corresponding forms of the impact of an organism on physical phenomena occurring outside the organism without assistance of muscular efforts."

The Soviet classification system emphasizes the biophysical approach(Naumov & Vilenskaya, 1972).Western parapsychologists refer to paranormal events as "psi phenomena" while many of the Soviet researchers use the term "psychoenergetic phenomena." Westerners divide psi events into two classes: psychokinesis or PK (the motor-kinetic aspect) and extrasensory perception or ESP (the perceptual–sensory aspect). For PK and ESP Soviets often substitute the words "biological energy" (or "bioenergetics") and biological information (or "bio-information"). The major theme of the meetings was to be bioenergetics or PK, an area in which Soviet investigators have made some major contributions.

The second speaker was Viktor G. Adamenko of Moscow's Institute of Radio-Physics, who studies both the manifestation of bioenergetics and its underlying mechanisms. It was Adamenko who trained Alla Vinogradova, an educational psychologist, to move objects at a distance. It was also Adamenko who helped develop such devices as the tobiscope, the biometer, and Kirlian photography to study bioenergetic phenomena (Krippner & Davidson, 1972b).

Adamenko showed a film of Nina Kulagina apparently moving paper clips and pen tops across a table although her hands were several inches away from them. Over the past few years, Ms. Kulagina has demonstrated her PK ability for various Western scientists (e.g., the physicist, William Tiller of Stanford University; the psychiatrist, Montague Ullman of Maimonides Medical Center). She has also attempted "psychic photography" (see Eisenbud, 1967)

and in one experiment was reportedly able to produce, at a distance, an "X" upon several frames of film (Figure 4). For this experiment, each frame was advanced without releasing the shutter, thus unexposed to any conventional light source. However, she was in poor health and could not attend the Moscow meetings. Adamenko told how the film of Kulagina was shown to Ms. Vinogradova who was motivated to attempt PK herself.

A film was then shown of Vinogradova moving various objects at a distance. Following the film, she was introduced to the audience and answered questions. Ms. Vinogradova described ways in which she has always "thought with the body" and emphasized that to engage in PK experimentation, one must learn to expand this kinetic method of thinking.

Apparently, Vinogradova works best when in a highly emotional state. She is able to "roll" cylindrical objects (e.g., cigar tubes, film containers) greater distances than she can "push" rectangular objects (e.g., match boxes, wooden and metal squares). She claimed she was able to concentrate her bodily energy first to her finger-tips and then to the object she is trying to move. She also reported that the attitude of the people present at the demonstration is an important variable. Greater success characterizes those PK sessions in which the people are not hostile to the idea of bio-energetics. She exercises to keep in good physical health and limits her PK work so as not to produce excessive physical and psychological strain.

Adamenko then told how he has studied Vinogradova's acupuncture points with the tobiscope and the biometer. The former device is the size of a small flashlight. It is held in one hand while the experimenter's other hand is placed on the patient. When the tobiscope's tip makes contact with the subject's skin, an electrical circuit is completed from the base of the device, through the body of the experimenter, along the body of the subject, to the tip of the tobiscope and, via internal connections, to the base of the device. Moving the tip over the skin, with slight pressure, various locations are found that cause a light to appear near the middle of the device. These locations on the skin which light up the tobiscope because of low electrical resistance, are identified as

FIGURE 4. Examples of N. Kulagina's attempts to produce an "X" upon unexposed film at a distance (courtesy, E. K. Naumov).

9

acupuncture points. When the light is dim, the diagnosis of poor health is given, while a bright light indicates good health.

The biometer detects acupuncture points by a different method (Adamenko, Kirlian, & Kirlian, 1973). The device consists of a zinc cylinder with a bushing of dielectric material pressed into its hold. A brass or copper rod is then inserted into the device. Two insulated flexible wires are soldered to these metals; the wires lead out through the opening in the bottom of the cylinder and are connected, one to the negative terminal of the micrometer, the other to the positive terminal of the micrometer. Thus, the biometer consists of two different metal electrodes separated by dielectric material and connected to a measuring device.

The experimenter holds the zinc cylinder of the device in the hand. He then presses the other hand to the subject's body. To complete the electrical circuit, the skin of the subject is probed with the copper point of the device. At the moment the acupuncture point is located, the indicator needle of the micrometer is deflected, indicating—on a scale—the strength of the current which is conducted, and, therefore, the health of the subject, regarding the functions associated with that particular point.

Using both of these devices, Adamenko has detected rapid shifts in the electrical conductivity of acupuncture points during Vinogradova's PK sessions (Adamenko, 1971).

Adamenko also spoke of a photography process invented by S. D. and V. Kh. Kirlian of Kazakh State University some 30 years ago (Kirlian & Kirlian, 1958).* Basically, the Kirlian apparatus is

*Kirlian photography was virtually unheard of in the Western Hemisphere until reports appeared in the popular press (e.g., Leonidov, 1962; Ostrander & Schroeder, 1970) and until technical details and schematics were brought across the Atlantic by scientists who visited Eastern Europe (e.g., Krippner & Davidson, 1972a, 1972b; Moss, 1971; Tiller, 1972). However, the U.S. government has had information on Kirlian photography for many years and has made no attempt to share this knowledge with either the scientific community or the general public (Mastrion, 1973). On September 19, 1959, the Foreign Technology Division of the Air Force Systems Command, Wright Patterson Air Force Base (Dayton, Ohio) received a copy of a technical report by S. D. Kirlian and V. Kh. Kirlian which had been published in 1958. This report was translated from Russian into English. On January 29, 1963, copies

an electric Tesla coil connected to two metal plates. Between the plates are placed living or non-living objects and a piece of film. When a switch is turned on, a high voltage, high frequency electric field is generated that causes the film to record the discharges. Adamenko showed motion pictures of leaves taken with Kirlian photography. We noticed flare patterns emerging from the leaves and were told that this process has practical implications for agriculture (e.g., the determination of plant disease). We were then shown films of human skin and again saw flare patterns, supposedly emanating from the body's acupuncture points. The Kirlians' laboratory was also shown on the film and it was reported that they view their technique as enabling the conversion of non-electrical effects of living systems to be converted into effects that can be visually observed.

of the English translation were sent to several agencies, most of them governmental. The complete list follows, including the number of copies forwarded:

The Department of Defense	(2 copies)	
Major Air Commands		
SCFDD	(1 copy)	
ASTIA	(25 copies)	
TDBTL	(5 copies)	
TDBDP	(5 copies)	
Other Agencies		
CIA	(1 copy)	
NSA	(6 copies)	
DAI	(9 copies)	
AID	(2 copies)	
OTS	(2 copies)	
AEC	(2 copies)	
PWS	(1 copy)	
NASA	(1 copy)	
U.S. Army	(3 copies)	
U.S. Navy	(3 copies)	
PG & E	(12 copies)	
RAND Corp.	(1 copy)	

Permission to reproduce the Kirlian photography paper was not granted by the Foreign Technology Division, Air Force Systems Command, until January 12, 1973. This was exactly one month before the publication of a similar article (Kirlian & Kirlian, 1973) which S. D. Kirlian had made available for publication in *Galaxies of Life* (Krippner & Rubin, 1973).

Adamenko showed Kirlian photographs taken of Vinogradova in her ordinary state of mind and while she was involved in PK (Figure 5). The flares were more concentrated and less scattered during the PK condition. In addition to the ordinary blue–green flares, there were red blotches which appeared during PK. Adamenko interpreted these results as demonstrating the psychological concentration and focusing of attention necessary for PK to be successful.

During the question period, Krippner reported the success of the First Western Hemisphere Conference on Kirlian Photography, Acupuncture, and the Human Aura held in New York City during May, 1972. Papers by Viktor G. Adamenko and S. D. Kirlian were read in absentia at the Conference; the proceedings have been published and are dedicated to V. Kh. Kirlian who died in 1971 (Krippner & Rubin, 1973).

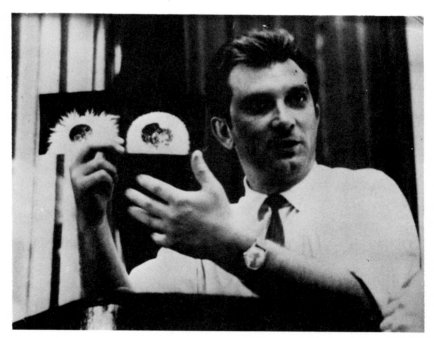

FIGURE 5. V. G. Adamenko displaying electrophotographs of A. Vinogradava (courtesy, R. P. Harris).

The third speaker of the day was Viktor Inyushin, a physicist who has worked for many years with the Kirlians at Kazakh State University in Alma-Ata (Inyushin, *et. al.*, 1968). Inyushin told of his long-time interest in bioenergetics which he found interesting because PK phenomena were unknown in traditional physics (Inyushin, 1967, 1970). He was especially intrigued by Ms. Kulagina's reported ability to move a compass at a distance, even when the compass was enclosed in a plastic shield. He felt that the PK effect was analogous to a surface charged accidentally by lightning. Therefore, Inyushin postulated that biological energy represents the interaction of an object's electrostatic and electromagnetic fields with the human operator's fields (Inyushin, 1970).

However, there is an additional variable, according to Inyushin. This is the amount and nature of biological plasma, or "bio-plasma" the operator has available. Inyushin holds that bioplasma is a previously overlooked state of matter consisting of electrons and other subatomic particles that are associated with living objects. Bioplasma interacts with solids, liquids, and gases—perhaps transforming itself into them from time to time, just as water becomes steam or ice. Inyushin suspects that bioplasma is associated with PK, telepathy, and other phenomena which are currently considered paranormal.

Dr. Inyushin speculated that the "biological plasma body" is some kind of counterpart of the body composed of solids, liquids, and gases. However, the highly ionized particles of the bioplasmic body behave differently from the atoms, molecules, and compounds which make up the other body. Indeed, the body's bioplasmic system may some day take its place as an important component of the organism along with the circulatory, lymphatic, and nervous systems. Currently, Inyushin is studying the voluntary control of internal states (through brain-wave biofeedback, etc.) to determine how bioplasma may be utilized more effectively.

The final speakers of the day were Irving Oyle, Frank A. Salisbury, and Alexander Everett. All three emphasized the healing of physical disease through biological energy.

Dr. Oyle is the director of a free medical clinic in Bolinas,

California. He offers his patients, most of whom have very little money, traditional medical care as well as osteopathy, herbal medicine, Dō-In acupuncture massage (de Langre, 1971), and "psychic healing" (based on PK).

Dr. Oyle reported several instances where patients recovered from a variety of ailments through the intervention of a psychic healer. He postulated two principals of success: the healer must believe in the utility of his treatment and the patient must believe in the effectiveness of both healer and treatment.

Dr. Oyle also described how he had developed "positive imaging" in a group of 20 individuals through autogenic training and fantasy techniques. As a group, they entered an altered state of consciousness and visualized the healing of a patient in a distant hospital. Oyle reported that the patient's rate of healing typically increased following the group's efforts. He noted that his work is clinical, not experimental, in nature, but that research studies could easily be initiated.

Mr. Salisbury, a psychic healer from Irvine, California, reported that he has engaged in "non-medical healing" for 20 years. Salisbury's main contention was that when the individual human consciousness is "in tune" with the universal consciousness, it can be directed toward healing. Salisbury accomplishes this state of mind through meditation which he practices daily.

Mr. Everett (Figure 6) organized "Mind Dynamics" in San Rafael, California. He discussed his training program by which individuals are prepared to do psychic healing, both for other people and themselves. Again, an altered state of consciousness is necessary to enter the psychological condition necessary for this effect.

Our group reassembled on Tuesday evening at the Sports Cinema for an evening of motion pictures. Featured was a documentary film from the Czechoslovak Socialist Republic depicting psychotronic generators, the small machines which purportedly store biological energy (Ostrander & Schroeder, 1970). The film showed the activated machines magnetizing non-metallic substances, purifying polluted water, and stimulating seed germination. However, no hint was given as to the way in which the devices are

FIGURE 6. G. Lieb, A. Everett, & O. W. Markley (courtesy, R. P. Harris).

able to store energy from the people to whom the generators are exposed.

A filmed demonstration of dermal–optical vision was presented in which several blindfolded women appeared to be able to identify colors, first by touching the colored cards directly and later when the cards were enclosed in opaque metal containers. (The latter procedure is important because some individuals have attempted to peek through their blindfolds.) It was reported that virtually anyone can develop this skill to some extent although women can be trained more quickly than men. One investigator has reportedly detected dermal–optical sensitivity in animals. Ms. Vilenskaya works in this field and has even become adept in "skin vision" herself, having given a demonstration for Thelma Moss during Dr. Moss' visit to the U.S.S.R. in 1970 (Moss, 1971).

Another film portrayed the use of dowsing (or "biological field effects") by American troops in Viet Nam. The Soviet parapsychologists have long held a special interest in dowsing because it appears to have potentially practical applications in detecting water

and mineral reserves. The Americans in the film were shown
holding dowsing rods at arms' length; the rods would often turn
downwards abruptly. At these times, a close examination of the
ground area would often result in the location of a land mine.

A number of films were presented dealing with other topics of
interest to parapsychologists. One was an account of Yoga classes
in Eastern Europe and in India. Another showed the work in
"hypnoproduction" of the Soviet psychiatrist Vladimir Raikov.
Dr. Raikov has hypnotized students, telling them they are
prominent figures who can do something extraordinarily well.
Using this technique, he has reportedly improved students'
performance in such fields as mathematics, music, and art. For
example, the film portrayed a pianist who played exceptionally
well when she was hypnotized and told that she was Rachmaninoff.
My assistant, Richard Davidson, and I had met Raikov in 1971;
at that time Raikov hypnotized several individuals—including
Davidson—to demonstrate his technique. It was mentioned that
many of the films shown at the theater were excerpts from a
popular documentary, "Seven Steps Beyond the Horizon," which
deals with advances in psychoenergetics and related areas.

The morning sessions on August 19 were held in a suite in the
Ukraine Hotel and opened with another motion picture, Irving
and Elda Hartley's documentary, "Psychics, Saints, and Scientists."
The film includes an interview with Ma Sue, a psychic healer
being studied by parapsychologists at West Georgia College. It
contains segments on biofeedback research conducted at the
Menninger Foundation and at the Maimonides Medical Center, as
well as PK experiments being conducted at the University of
California's Davis campus. The motion picture concluded with a
description of Kirlian photography studies conducted by Thelma
Moss at U.C.L.A. Dr. Moss pointed out that the "auras" surround-
ing the bodies of Christ, Moses, Buddha, and Mohammed in
religious art may relate to the energy fields captured on film by
the Kirlian device. If so, Kirlian photography provides the field
of psychoenergetics with an extremely useful tool by which
biological energy can be investigated.

Following the film presentation, Krippner gave a copy of the

motion picture to Naumov on behalf of *Psychic* magazine, a periodical devoted to the reporting of current developments in parapsychology. Krippner then reported that his own utilization of Kirlian photography has indicated its utility in measuring psychokinetic effects. In an investigation carried out with the Foundation for Gifted and Creative Children, a Kirlian device was built by a young student. He took photographs of a leaf every few minutes while a psychic sensitive, in an isolated part of the building, attempted to affect the leaf's energy field at a distance. The psychic sensitive only attempted PK at certain time periods, the times being determined randomly by an experimenter who was in the same room as the sensitive. An examination of the photographs indicated that the energy field was smaller and narrower when PK was being attempted than during the control periods when the psychic sensitive was resting. Krippner also described his work with Ingo Swann, a Manhattan artist. Using a Kirlian photography device designed by Kendall Johnson of U.C.L.A., Krippner and Johnson had Swann attempt to change the type of photographs obtained of his fingertips. Swann was successful in this attempt. When he imagined heat coming from his fingers, the resulting photographs showed flares surrounding his fingertips that were absent on the other pictures (Krippner & Rubin, 1973: 171-172). O. W. Markley (Figure 6), of the Stanford Research Institute, mentioned that Swann would be a subject in a forthcoming series of PK experiments involving attempts to influence the directional flow of subatomic particles in a shielded chamber.

E. Douglas Dean, a former president of the Parapsychological Association, showed photographs taken with a device he constructed in association with the Jersey Society for Parapsychology. Photographs taken of the psychic healer Ethel DeLoach in a state of rest showed blue emanations. However, a bright orange field appeared as she was photographed in the state of consciousness in which she reports healing ability (Dean & DeLoach, 1972).

James Hickman and Allayne Scott, students at the University of New Mexico, described the Kirlian device which they built and showed several slides of a cat's paw, a leaf, of several insects, and of a musician's hand before and after a concert (Figures 7, 8, & 9).

FIGURE 7. Electrophotograph, *Cannabis sativa* leaf (courtesy, J. L. Hickman).

FIGURE 8. Electrophotograph, finger pads, right hand of Z. Hussain before tabla concert, Ektacolor film, 2½ sec. exposure (courtesy, J. L. Hickman).

FIGURE 9. Electrophotograph, finger pads, right hand of Z. Hussain after tabla concert, Ektacolor film, 2½ sec. exposure (courtesy, J. L. Hickman).

Most interesting were slides taken of a leaf at various intervals after it was picked. From hour to hour, one could see the field surrounding the leaf grow smaller and less vivid, attesting to the relationship between the field and some aspect of the life process (Amos, Hickman, & Krumsick, 1972). Gratitude was expressed to the Czech researcher, Zdenek Rèjdák, who had made his schematic of the Kirlian device (Figure 10) available to the New Mexico team.

I concluded the discussion of Kirlian photography by pointing out that Dr. F. F. Strong, of Tufts Medical School, was performing electrophotographic experiments in 1917 (Figures 11 & 12). However, this work was not followed up in the United States and it took the devoted efforts of the Kirlians to demonstrate the importance of the discovery.

I then reviewed the theories of A. S. Presman, a Soviet psychologist I met in 1971, who has studied the electromagnetic and electrostatic fields of living objects. Presman (1970) views the functions of these fields as informational in nature—relaying information to the organism from other parts of the organism, from other organisms, and from the non-living environment. I called upon parapsychologists to apply the techniques of information theory to the data being produced in Kirlian photography experiments (Krippner & Drucker, 1973).

On Wednesday afternoon, an Austrian parapsychologist, Gunter Lieb (Figure 6) showed a film depicting "psychic surgery" in the Philippines (Sherman, 1967; Valentine, 1973). Other psychic healers supposedly produce their effects by a simple "laying-on of hands" or by "sending" bioenergy to the patient across distance. Psychic surgeons, as dramatically shown in the film, purportedly thrust their hands into the patient and pull out the diseased part of the body. The opening appears to close immediately, leaving no scar.

In discussing the film, Hans Bender of Freiburg University, urged that a cautious approach be taken to the phenomenon, citing several ways in which clever magicians can perform so well that even a filmed record cannot detect their chicanery. Hans Naegeli, president of the Swiss Society for Parapsychology, took a different position, discussing how psychic surgery is quite possible

FIGURE 10. Schematic, Kirlian photography apparatus (courtesy, Z. Rejdak).

FIGURE 11. F. F. Strong demonstrating effects of Tesla coil (courtesy, S. Krippner).

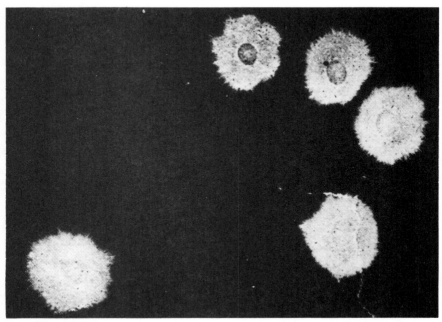

FIGURE 12. First electrophotograph taken in U.S.A.; finger pads, right hand of F. F. Strong (courtesy, S. Krippner).

from the standpoint of recent theoretical developments in physics. Both Dr. Bender and Dr. Naegeli have witnessed the Filipino psychic surgeons and each have reached different conclusions.

The day ended with a discussion by Benson Herbert on modern physics and biological energy. Herbert is the editor of the *International Journal of Paraphysics,* a British publication which carries frequent articles by Naumov, Adamenko, and Inyushin. Mr. Herbert indicated that there are subatomic particles which are thought to move backward in time and perform other feats heretofore debunked or limited to psi phenomena. Joining in the discussion were three Moscow scientists: Nina Slavinskaya, a physicist, M. S. Smirnov, a biophysicist, and V. V. Efimov, a physiologist (Krippner & Davidson, 1972a).

The August 20th meetings opened with a paper by G. S. Vassilchenko, one of the Soviet Union's leading specialists in sexual dysfunction. He has pioneered in the use of acupuncture and said that this technique is now employed in many Russian hospitals and clinics. Instead of using needles, Soviet physicians usually stimulate the appropriate area with massage, ointments, lotions, mild electrical pulses, and laser beams. Dr. Vassilchenko (1969) has found acupuncture especially helpful in cases of eneuresis, frigidity, and impotence. Noting that some acupuncture practitioners theorize the existence of meridians which conduct bioenergy through the body, while other practitioners suspect that acupuncture works on principles similar to hypnosis, Vassilchenko concluded, "To me the empirical results are more important than theoretical speculations."

Vassilchenko told how he had created special workshops to train physicians from all over the U.S.S.R. to deal with their patients' sexual problems. He suggests an examination procedure which evaluates the patient's endocrine system, urino-genital functioning, and psychological status. Following the examination, appropriate therapeutic measures can be initiated. When asked about the controversial approach taken by Masters and Johnson to sexual dysfunction, Vassilchenko stated, "We have obtained excellent results with therapeutic programs similar to theirs; our first papers on the topic will be published in the near future."

Following Vassilchenko's address, Krippner introduced Tina

Johnson, a psychic sensitive from the United States. He told how Ms. Johnson had been an outstanding subject in clairvoyance experiments at the Maimonides Dream Laboratory (Krippner, Hickman, Auerhahn, & Harris, 1972). Johnson related how she used "automatic writing" to obtain information about pictures in the sealed envelopes used during the experiments. Krippner noted that Ms. Johnson produced a brain wave pattern characterized by high amplitude theta during her periods of automatic writing. Indeed, the less conscious control she felt over the writing, the higher the percentage of theta waves appeared in her EEG record.

Ilmar Sommere, a psychiatrist from the Estonian Soviet Socialist Republic reported on several hundred spontaneous cases of psi phenomena he had collected over an eight-year period. According to Dr. Sommere's case reports, the optimal age for psi is between 21 and 25. Sixty percent of his cases came from men, 40 percent from women—the reverse of some similar studies of spontaneous cases done in America. More instances of psi took place in dreams than in other states of consciousness. When the dream concerned someone's death, the dreamer was more likely to awaken immediately than if it concerned another event—in which case the dreamer was more likely to remember it in the morning.

Thursday afternoon's session opened with a paper on the history of humanistic psychology by Myron Arons, head of West Georgia College's psychology department. He traced some of the roots of humanistic psychology to the existential themes in Russian literature, especially the novels of Dostoevsky. He cited Oriental philosophy, gestalt psychology, and the writings of such Western writers as Charlotte Buhler (1933; 1971) and Abraham Maslow (1954) as the other roots of the humanistic movement. Dr. Arons told how Maslow originally saw humanistic psychology as a "third force," presenting an alternative image of the person to those proposed by psychoanalysts and behaviorists. This image of the person stresses one's potential as a human being, especially insofar as creativity is concerned. Arons concluded by listing psi phenomena as one of several human potentialities and describing the graduate program in parapsychology at West Georgia College.

Vivian Guze, of the Institute for Bio-Energetic Analysis in

Manhattan, related how the term "bioenergetics" is also used by American psychologists (e.g., Lowen, 1967). Specifically, "bioenergetics" is a type of psychotherapy which pays special attention to the physiology of the patient, his posture and body movement, and how he seems to be handling the energy he potentially has at his command.

Ms. Guze demonstrated bioenergetic analysis with the help of Dr. Arons who served as her patient. Guze showed the audience how Arons' body musculature was relaxed in some areas, tense in other areas, and how this could affect his behavior. The demonstration was especially valuable to Giorgi Albert of the Milan State University Psychological Institute. He was familiar with the writings of Wilhelm Reich (e.g., 1942) on "orgone energy" and could see how Reich's controversial ideas related to bioenergetics in both its definitions.

At this point, another Hartley and Hartley film documentary was shown. Titled "Potentially Yours," it featured Dr. Arons and other leaders in America's "human potential" movement. Having seen filmed accounts of sensitivity training in the motion picture, the members of the audience were asked by Carmi Harari if they would like to try some of the procedures themselves. After an enthusiastic affirmative response, Dr. Harari initiated a "micro-lab."

Harari began the micro-lab by having the group move about the hotel suite, smiling at people but making no verbal statement. He then had them close their eyes and keep moving—necessitating the use of bodily contact on everyone's part to minimize jostling. The group then was told to keep its eyes closed but to shake hands. On the basis of handshakes, they paired off with a partner. Gradually, verbal interaction was introduced (beginning with a conversation consisting only of "yes" and "no"). Finally, the partners conversed briefly on such topics as "love" and "work."

Reactions to the micro-lab were varied but everyone found it an interesting experience. One psychiatrist proclaimed, "Today I learned more about myself than I had learned in all my years of psychiatric training."

Further opportunities for person-to-person contact came on Thursday evening. Dr. Harari hosted a reception, on behalf of the

Association for Humanistic Psychology, at the Ukraine Hotel for the 60 conference participants and about 20 other guests. Featured at the reception was a film produced by James Hickman, Allayne Scott, and other students from New Mexico State University and the California State College in Sonoma campus. The movie consisted of several hundred brilliantly colored Kirlian photographs accompanied by music from albums of the Beatles ("Back in the U.S.S.R."), Ravi Shankar, the Grateful Dead, and George Harrison ("Bangladesh"). From time to time, the music faded out and voices could be heard—R. Buckminster Fuller describing planet Earth as a closed energy system, Alan Watts discussing the relationship between persons and their natural environment, Stanley Krippner praising the advances of Soviet research in psychoenergetics. The film was wildly applauded and had to be shown again for the latecomers. One of the Russians called it "the best combination of art, science, music, and politics I have ever seen on film." I reported how Kirlian photography was used as an art form in the United States on record jackets (Figure 13), magazine covers (Figure 14), and in erotic art (Figures 15, 16).

FIGURE 13. Record jacket showing electrophotographs of George Harrison's hands (public domain).

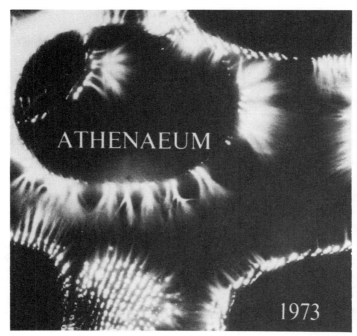

FIGURE 14. Cover, *Athenaeum* literary magazine showing electrophotographs of various finger pads (courtesy, R. P. Harris & C. R. Salerno).

FIGURE 15. Electrophotograph, human vagina (courtesy, R. Mastrion).

FIGURE 16. Electrophotograph, human penis (courtesy, R. Mastrion).

Following several hours of food and drink, closing toasts were offered by Naumov and Harari. The entire group sang Russian folk songs, accompanied on the guitar by Robert Nelson, director of the Central Premonitions Registry and (with Larisa Vilenskaya and Barbara Ivanova—a linguist at Moscow University) one of the week's invaluable translators. The good will and pleasant feelings that characterized the reception were symbolized by the final frame of the Hickman–Scott film which portrayed a dove—and the word "peace" in both English and Russian.

Friday was spent in small group meetings. Brendan O'Regan, research coordinator for R. Buckminster Fuller, went over some technical questions with the Soviet physicists. Several psychotherapists from various countries had many inquiries to make about humanistic psychology.

Krippner was invited to a small meeting at the offices of

Technology For Youth, a popular scientific magazine. Also present were Hans Bender, Benson Herbert, Giorgi Albert, Robert Nelson, and a few other parapsychologists. Adamenko showed the bio-energetics film in which Vinogradova moved objects at a distance. He then introduced Ms. Vinogradova to the assemblage (Figure 17).

Vinogradova sat on a chair near a transparent plastic table. Adamenko placed a metal cigar tube on the plastic table. Vinogradova placed her right hand to the side of the tube and it began to move across the table. When it reached the far side of the table, she shifted her hand to the other side of the tube and it moved back. She proceeded to move the tube back and forth several times.

FIGURE 17. A. Vinogradava & V. G. Adamenko (courtesy, R. P. Harris).

Adamenko then removed the cigar tube and substituted a heavier tube. Vinogradova used a similar procedure to move this object. However, she preceded her attempts by picking up the tube and rubbing it briefly (Figure 18). This seemed to initiate the movement immediately once she placed it back on the table. However, the tube rolled across the table in choppy movements rather than smoothly as had the lighter tube.

The next object placed before her was a pingpong ball. In this instance, Vinogradova moved her hand in a circular motion a few inches above the object. The ball obediently followed her hands. It was noted that she rubbed her hands briskly before attempting this feat and that she directed the ball's motion with a few fingers rather than with her hand. For the two tubes, however, Vinogradova appeared to be utilizing her entire hand for the movement.

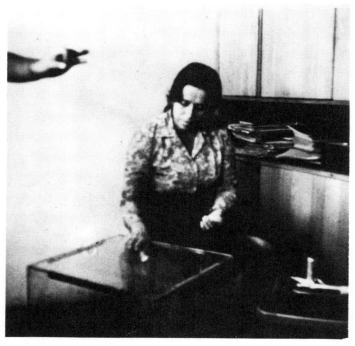

FIGURE 18. A. Vinogradava and cigar tube, demonstrating voluntary control of bioelectric field (courtesy, S. Krippner).

Next, Adamenko placed a Marlboro cigarette on the plastic table. Vinogradova rubbed it lightly but the movement was not forthcoming. She then asked for another cigarette, which was supplied by one of the onlookers. Without rubbing it, she placed it on the table and it followed her right hand back and forth several times. Apparently the Phillip Morris cigarette she used was more tightly packed, thus more cylindrical with less friction. We could imagine the advertising potential of such a characteristic if PK ever became popular in the United States!

Vinogradova next worked with a film cylinder. Despite its uneven surface, it rolled fairly well across the table. She then placed it on its end to "push" it rather than "roll" it. We were immediately aware that the pushing motion required much more effort than the rolling motion, and did not propel the object as far.

At this point, Adamenko placed a tube on the table which was the longest and largest yet moved. Vinogradova was successful in propelling it across the table several times. Adamenko then took a small light bulb and touched the bottom to the cube. The bulb lit up for an instant. (This was one of several indications that an electrostatic field was involved in the observed phenomenon.)

Finally, two tubes were placed before Vinogradova. She held her hand above both of them. Adamenko pointed to one of the tubes. With only a slight hand movement, Vinogradova was able to move the specified tube while the other remained still. This ability to move objects selectively indicates the role of volition in the phenomena.

Adamenko then took one tube away and Vinogradova rolled the remaining tube back and forth. She then announced that it might be possible for someone else to move the tube. I came to the table and, using the identical hand motions I had observed during the demonstration, rolled the tube several inches. I was able to move it back and forth for about 30 seconds, and the decline in its motion was obvious as time passed.

After Vinogradova "activated" it again, Friedbert Karger of the Max Planck Institute of Plasma Physics was able to move it. Dr. Karger's successful efforts were followed by those of Brigitte Rasmus, a colleague of Hans Bender at Freiburg University.

I later reported that I had a tingling feeling in my right hand for the next two hours. Furthermore, I had interviewed two magicians before leaving the United States. They had described several ways that PK could be accomplished through sleight-of-hand (e.g., concealed threads, hidden magnets). Even though the Vinogradova demonstration was not a laboratory experiment, it was difficult to imagine how sleight-of-hand could have accounted for the results.*

Following the demonstration, I showed "Psychics, Saints, and Scientists" while Hickman and Cook showed the Kirlian photography film. Both movies were well received by the staff of *Technology For Youth* who expressed the hope that copies would some day be available to show to young people in the U.S.S.R.

And so the International Meeting on the Problem of Bioenergetics and Related Areas came to an end. It had been a time of warm days and white nights—and vivid, never-to-be-forgotten experiences.

Before I left Moscow, Adamenko gave me a print of the Vinogradova film to show in Tokyo. His paper on bioenergetics had been accepted for presentation in Japan at two August meetings: the Twentieth International Congress of Psychology and the Third International Invitation–Conference on Humanistic Psychology (Adamenko, 1972). Adamenko was unable to go to Tokyo himself and asked me to present the report.

The presentations aroused international interest. In addition to being the only time in anyone's memory that a Soviet scientific report had been delivered by an American at two important conventions, it was also the first time that a report on psychoenergetics had been approved and presented at the International Congress of Psychology.

*Upon returning to the United States, James Hickman and Jean Mayo built a similar plastic table and were able to replicate the effects with cylindrical objects simply by rubbing the table top briskly for several minutes with a cotton cloth, then directing one's hand toward the object. The judgment of the U.S. investigators was that the effects thus achieved could be explained in forms of electrostatic principles. Some investigators are of the opinion that all of Ms. Vinogradova's effects are electrostatic, demonstrating her voluntary control of a bioelectric field but little, if any, actual PK.

Adamenko, in his paper, related how he was discouraged by his colleagues when he first began to study biological energy. His colleagues told him that he was insane if he continued these esoteric pursuits. "However," Adamenko related, "I decided to search for the truth no matter what discouragement I met."

In Adamenko's paper, he reported that a dielectric cube made of plastic had been found to be the best type of table. The intensity of the electrostatic field induced by Vinogradova on the objects varied, but sometimes reached 10^4 volts per centimeter as measured by voltmeters. The distance between the objects and her hand also varied but effects had been observed when the distance was as far as 50 centimeters (2 feet). For sliding movements the objects weighed as much as 10 grams and for rolling movements, 100 grams.

During the experiments, Vinogradova's pulse rate increased rapidly. She worked best when her skin was dry and when she felt extremely self-confident about her abilities. She found it easier to move objects in the evening, on starry nights when there was a full moon. Whether this relates to environmental differences, mood, or to the fact that Vinogradova likes to watch the stars is unknown.

When she has been moving an object successfully, and a heavier object is substituted that looks the same as the previous object, Vinogradova will often be able to move the heavier object. However, she has had difficulty in moving that same object if she is told it is as heavy as it is presented to her. In conclusion, Adamenko's paper stated, "The data acquired in the course of these experiments give some idea as to how we may investigate the biological and electrical fields which surround the body and the extent to which they may be controlled by voluntary means."

Upon returning to the United States, I felt that the most important Soviet contribution to the field of psychoenergetics appears to be their work in biological energy. This is a field which would seem to have practical application, especially in medicine (Figures 19, 20, & 21) and "psychic healing" (Figures 22 & 23; Herbert, 1968). On the other hand, the major American contribution to psychoenergetics has been the implementation of rigorous

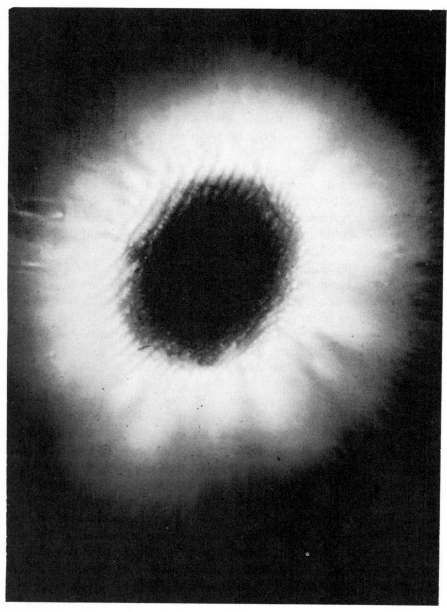

FIGURE 19. Electrophotograph, right index finger pad, male subject one day
before showing symptoms of London flu (courtesy, D. Kientz &
R. Joseph).

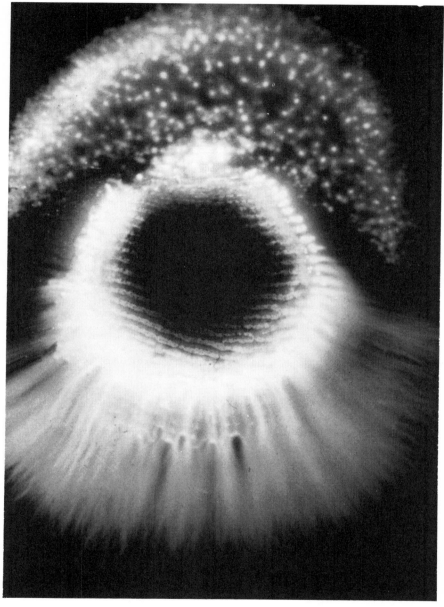

FIGURE 20. Electrophotograph, right index finger pad, male subject 8 hours
before showing symptoms of contacting London flu (courtesy,
D. Kientz & R. Joseph).

FIGURE 21. Electrophotograph, ball of hand; acupuncture point is at far
left (courtesy, V. G. Adamenko).

experimental designs. Soviet parapsychologists rarely present reports
which tell of well-designed tests with conditions that rule out
sensory–motor "leakage," that employ control groups or control
conditions, that isolate variables, or that use sophisticated
techniques of statistical analysis (Zinchenko, Leontiev, Lomov, &
Luria, 1973).

 International cooperation, including cross-cultural studies of
psychic sensitives and cooperative research programs would greatly
aid the absorption of psychoenergetics into the mainstream of
science. It would, I feel, also contribute to the understanding of
human potential. Perhaps the Moscow meeting of June, 1972, was
a small step toward the accomplishment of a giant task.

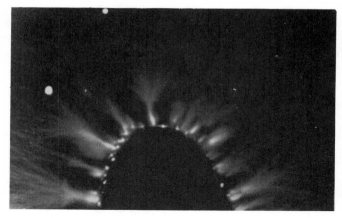

FIGURE 22. Electrophotograph, right index finger pad of A. Krivorotov during state of rest (courtesy, V. G. Adamenko). *COLOR*

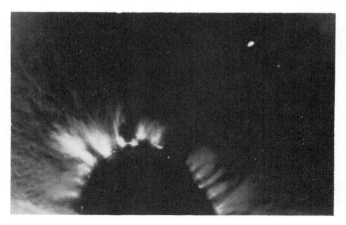

FIGURE 23. Electrophotograph, right index finger pad of A. Krivorotov during attempted "healing" (courtesy, V. G. Adamenko). *COLOR*

2 The Promise of Photopsychography

Don H. Parker

PHOTOPSYCHOGRAPHY (foto si cog' raphy)

What is it? It may be to the new ability of the human to see into inner space what the telescope was to the beginning trip into outer space! For what was originally called Kirlian photography after its discoverers in the U.S.S.R., the author proposes herewith the word *photopsychography*—a generic term instead of a subjective one—to be used to express this exciting new phenomenon. Not incidentally, the word lends itself to a convenient abbreviation: photo-psy, and to the even handier acronym for use in scientific writing: Ph ψ

Photopsychography is both a tool and method that may provide a number of clues concerning those elusive, yet profoundly meaningful aspects of human nature. Much rigorous research needs to be performed to unveil the meaning of these curious pictures. It is my hope that the introduction of this new term, photo-psychography, will be both a stimulus and a catalyst for the further exploration of this unusual phenomenon.

Discovered in 1939, but only surfacing through the international bureaucratic maze in the early 1960s, its discoverers were a man and wife team, S. D. and V. Kh. Kirlian (1958). After a chance observation of a high frequency instrument used in electrotherapy, S. D. Kirlian began pursuing a hunch. Working in their two-room apartment which served as both home and laboratory in Krasnodar, near the Black Sea, he and his wife exposed objects such as leaves and twigs, then human hands in a high frequency electrical field over a photographic negative, first working in black and

38

white, then color. What they saw were light shows beyond their wildest imaginations, a spectacular panorama of colors flashing, twinkling, often flaring forth like Roman candles to disappear into space.

Through lucky accidents as well as through dogged pursuit of the "why" behind these luminous outpourings, differences were found in types of emanations from various types of organisms (Kirlian & Kirlian, 1961). Excitingly enough, differences were found in the health of the organisms by comparing what they saw. A dying leaf showed a dimmer surround than a healthy leaf. But most mind-blowing of all, the Kirlians found that varying emotions and mental states in the human body caused differences in the patterns of light and color emanating from the human hand! Now physicians, physicists, and other scientists became interested. Finally, after over 20 years, the Kirlians' discovery was acknowledged officially by the Soviet government. They were given a pension, a new apartment, and a newly equipped laboratory.

The proposal to begin using the word photopsychography is in no way meant to discredit the brilliant, insightful, and at times almost superhuman work of the Kirlians. Rather, the new word is seen as a better handle for the grasping of a complex tool. From the very make-up of the word, one learns at once that the phenomenon has something to do with light, or some source of light. *Photo* is then related to *psyche*—something not ordinarily seen—much less photographed, and *graphy*, or recording the thing not seen. The word at once makes a statement and asks a question. Here is what happens. How does it happen?

To illustrate the utility and logic of substituting a generic term for a subjective one, recall the work of Pierre and Marie Curie with radium and radioactivity, leading to the naming of the X-ray, radiography as a profession, etc. They could have easily named their discovery "curium," "curiation," or "curiography," but instead, a more descriptive, generic term was chosen. Let us follow this useful precedent. To do so will generate at once some common ground of understanding, one on which to build quicker, easier, and more definitive communication among the flurry of new workers this exciting new window on the world is bound to attract.

In the U.S.A. the phenomenon has not yet caught the attention of "big research" and is currently being explored in a mere handful of locations mainly by university students who have pulled together a few pieces of equipment based on reading, intuition, and reports of recent visitors to the Soviet Union (Figures 13, 14, 15, 16). At this writing, the Soviets are using this latest finding in the field of photography as an important linkage in the study of psychokinesis, acupuncture, biofeedback, and varying states of physical and mental health. These vary in types of information reflected by the electrical energy glowing in and around all living organisms as revealed by photopsychography.

Now You See It; Now You Don't　　**3**

Thelma Moss, Kendall Johnson,

John Hubacher, and Jack I. Gray

During the First Western Hemisphere Conference on Kirlian Photography, Acupuncture, and the Human Aura, in 1972, we showed several photographs (Moss & Johnson, 1973). These pictures were photographed by a special electrical technique adapted from the Soviet apparatus developed by the Kirlians. The photographs were exotic, and often inexplicable. For example, a picture of a geranium leaf, photographed with a conventional camera, looks very much like a geranium leaf as the eye sees it. However, taking a radiation field photograph of that same geranium leaf, on the same kind of film, barely resembles the geranium leaf. But what does that picture mean? What information is being conveyed by its exquisite pattern of blue, red, white, lavender and purple bubbles? We did not know the answer at the 1972 conference and we theorized about "corona discharge," "bioplasma," the "cold emission of electrons," the "aura," and "the energy body"—and it was anyone's guess about what the picture actually represents. Now, several years later, the same situation exists.

But we have learned some things about what we refer to as "radiation field photography" (Moss & Johnson, 1972b). In 1972,by taking picture after picture after picture of the human finger pad, we were able to corroborate what the Soviet literature had reported, that different states of emotional or physiological arousal in the human being would reveal very different patternings in these photographs (Moss & Johnson, 1972a). In our laboratory,

FIGURE 24. Electrophotograph,
right index finger pad, relaxed subject
(courtesy, T. Moss & K. Johnson).

FIGURE 25. Electrophotograph,
right index finger pad, relaxed subject
(courtesy, T. Moss & K. Johnson).

we found that with satisfactory relaxation, we would typically
find a brilliant blue–white corona, together with a distinct pattern-
ing of the finger tip (Figure 24), as well as scar tissue and other
surface details. With less relaxation, we learned that the finger
print inside the corona generally disappeared (Figure 25). Then,
with some arousal of the subject, the blue–white corona became
less brilliant and full; in fact, we found that persons who are
habitually tense show, characteristically, a very thin emanation
(Figure 26).

Occasionally there would appear gaps in the corona which
remained in the same location on each photograph obtained
during that time. (It had been our custom to take nine photo-
graphs of the same finger pad on one 4 x 5 piece of film.) Why
did the gaps appear in one location on all nine pictures on one
day, and then disappear on the next photographing session? We

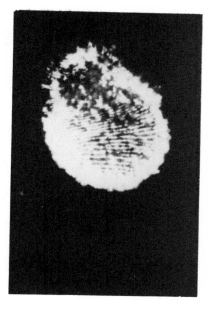

FIGURE 26. Electrophotograph, right index finger pad, habitually tense subject (courtesy, T. Moss & K. Johnson).

FIGURE 27. Electrophotograph, right index finger pad, aroused subject (courtesy, T. Moss & K. Johnson). *COLOR*

did not know in 1972 and we do not know now. But it became clear that these dynamics of the finger pad were a repeatable phenomenon.

Since that time, in our laboratory, some of us learned how to generate a particular pattern *on demand*, by practicing special techniques (for arousal, tensing, becoming angry, holding the breath; and for relaxation by using hypnosis, breathing exercises, or some form of meditation). Certain persons in our laboratory even learned to arouse themselves to such a pitch that they generated, on command, a pattern of the finger tip which, when developed in color, reveals a strange looking red blotch (Figure 27).

Recently, we discovered an entirely different phenomenon, even more remarkable. Two members of our staff were able to arouse themselves to such a pitch that they could voluntarily produce a very unusual picture (Figure 28). What happened? The finger pad

FIGURE 28. Electrophotograph, right index finger pad, unusually aroused subject (courtesy, T. Moss & K. Johnson).

FIGURE 29. Electrophotograph, American coin, condition 1 (courtesy, T. Moss & K. Johnson).

was photographed, but the picture has totally disappeared. How can we explain this phenomenon? We cannot. But we can repeat the phenomenon again and again, reliably. We would like to suggest that if what is being photographed is simply a corona discharge (which is what some theorists maintain), then something has occurred which has prevented the corona from appearing. And yet, all of the electrical parameters of the photographic apparatus have been held constant. This would suggest that the disappearance of the picture of the finger pad might be due to changes in the human body.

We went further with our investigations of this disappearance phenomenon, and found two other repeatable experiments. One such experiment we have called the "Magic Penny Trick." Now you see it (Figure 29); now you don't (Figure 30). And now you see it again, but not as clearly as before (Figure 31). What have we done? One thing must be clearly understood: we have not changed any parameters of the photographic apparatus. What,

FIGURE 30. Electrophotograph,
American coin, condition 2
(courtesy, T. Moss & K. Johnson).

FIGURE 31. Electrophotograph,
American coin, condition 3
(courtesy, T. Moss & K. Johnson).

then, are the variables responsible for this magic disappearance
act? We believe that this dime, or any other coin, responds with
its own dynamics when a human being interacts with the coin.

For example, one can examine a picture (Figure 32) which
portrays a 4 x 5 negative of the same penny, each row represent-
ing a different condition. Each photograph of the penny on this
picture was taken in the same way, by touching it for 1/12 of a
second exposure with a metal electrode. The top row is the penny
photographed normally, the "control" penny. The second row
shows the same penny; but this time, before each picture was
taken, the experimenter put his finger on the penny, and kept it
there for approximately one minute. The contact of the finger on
the coin seems to have diminished the brightness of the penny.
The third row shows that same penny, photographed in the same
way—but this time, before each picture was taken, the experimenter
cupped his hand about one inch above the penny, and kept it

FIGURE 32. Electrophotograph, American coins, conditions 1, 2, & 3 (courtesy, T. Moss & K. Johnson).

FIGURE 33. Electrophotograph, American coin, sponged condition (courtesy, T. Moss & K. Johnson).

there for approximately one minute. This effect, emanations from the experimenter's hand interacting with the penny, causes—as can be seen—the image of the penny to fade even more than the previous condition. The last row, which appears blank, also represents the same technique of photographing the penny. But each time, before the picture was taken, the experimenter *breathed* on the penny. And that caused the image of the penny to disappear.

Why? Again we had no answer, but one hypothesis was suggested: that the moisture from the breath of the experimenter caused a breakdown of the corona discharge, or bioplasma, thus interrupting the photographic process. To test this hypothesis we took a warm, wet sponge and held it over the penny for approximately one minute, and then took its picture (Figure 33). The result was an extra-bright picture of the penny.

STUDIES OF HEALERS

This series of experiments occurred as a result of a lengthy investigation we had undertaken over the summer and autumn months, an investigation into the supposed "healing energy" connected with the ancient technique known as the "laying on of hands," and the associated technique of "magnetic passes." Summarizing briefly, a healer volunteered to come into the laboratory and treat a group of terminally ill kidney patients who had volunteered for this treatment, under the medical supervision of Marshall Barshay. It was, in fact, Dr. Barshay who proposed and conducted the research, he being a kidney specialist with access to patients from local hospitals. All of these patients had suffered kidney failure and were being dialyzed two or three times a week. Without the dialysis machines they would not have been able to survive. Should any one of these patients respond to the healer's treatments, so that he or she would no longer require the use of a dialysis machine (such an event has not occurred in the short history of dialysis treatment), we believed this would be solid laboratory evidence that a healer can, in truth, heal a terminal illness.

This was certainly a rigorous criterion. And it was not met. Not one of the twelve patients who were given an average of eight treatments each, was cured so that he or she was freed of the dialysis machine. There were minor improvements documented, such as immediate relief from headaches, or changes in hematocrit, which can occur from a variety of causes. One rather dramatic incident occurred when a male patient, who suffered so much from the side effects of the drugs he was taking that he was chronically dizzy and could not walk without a cane, responded on the first treatment to such an extent that his dizziness disappeared, and he no longer required the use of the cane. But to repeat, the main objective of the study had not been achieved.

What we did find, as a frequent phenomenon, was a seeming transfer of energy from the healer to the patient, as revealed through radiation field photography. It was our standard procedure

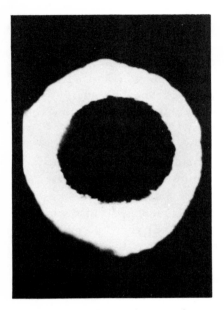

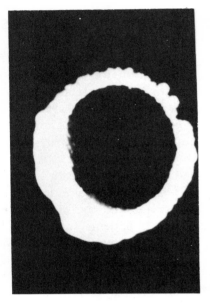

FIGURE 34. Electrophotograph,
right index finger pad, "healer"
during state of rest (courtesy,
T. Moss & K. Johnson).

FIGURE 35. Electrophotograph,
right index finger pad, "healer"
following attempted healing
(courtesy, T. Moss & K. Johnson).

to photograph the finger pads of both healer and patient before,
and then again after, the treatment. For example, the finger pad
of the healer before treatment, shows a vivid, large corona
(Figure 34). The same finger pad after the treatment reveals that
the emanations have diminished considerably (Figure 35). In
contrast, one may examine a picture of the finger pad of a patient
before treatment (Figure 36) and after treatment (Figure 37). The
picture has considerably increased in brightness, and in the width
of the corona. The pictures demonstrate quite clearly the difference
between the healer and the patient, pre- and post-treatment
(Figure 38). It should be emphasized that this phenomenon does
not necessarily demonstrate *healing*; it simply seems to reveal a
transfer of energy from healer to patient.

That this faculty, the ability to transfer energy, belongs to a
healer as opposed to a non-healer was demonstrated vividly when

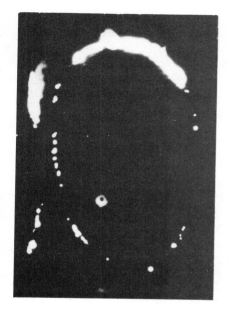

FIGURE 36. Electrophotograph, right index finger pad, patient during state of rest (courtesy, T. Moss & K. Johnson).

FIGURE 37. Electrophotograph, right index finger pad, patient following "healer's" attempted healing (courtesy, T. Moss & K. Johnson).

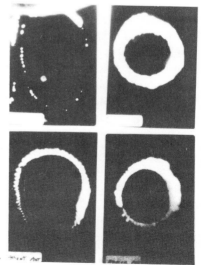

FIGURE 38. Electrophotograph, right index finger pads, "healer" and patient, two conditions (courtesy, T. Moss & K. Johnson).

 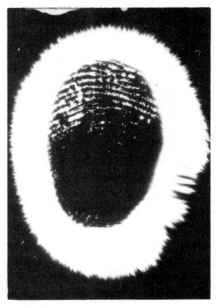

FIGURE 39. Electrophotograph, right index finger pad, control "healer" during state of rest (courtesy, T. Moss & K. Johnson).

FIGURE 40. Electrophotograph, right index finger pad, control "healer" following attempted healing (courtesy, T. Moss & K. Johnson).

we had a series of "control healers" do exactly what the healer had done. These persons volunteered to keep their hands for 20 minutes on the lower part of the back (in the location of the kidneys) of some of the patients. When we examined a control healer's print before treatment (Figure 39), and again after treatment (Figure 40), there was no major difference. When we scrutinized the patient's pictures before treatment (Figure 41), and again after treatment (Figure 42), we were hard put to detect any pre- and post-treatment differences.

This phenomenon of energy transfer, which apparently occurs in certain people, was subjected to further study—this time, not from healer to patient, but from healer to plant leaves. It has long been an old wives' tale that gifted gardeners have a "green thumb" and can make plants and flowers flourish when they care for them. We sent out a call from the laboratory for people who

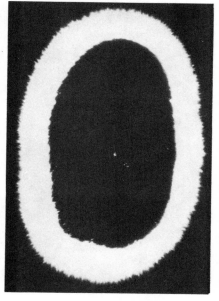

FIGURE 41. Electrophotograph, right index finger pad, control patient during state of rest (courtesy, T. Moss & K. Johnson).

FIGURE 42. Electrophotograph, right index finger pad, control patient following attempted healing (courtesy, T. Moss & K. Johnson).

believed themselves to be healers and who would like to try their skill with leaves.

About 25 people participated in this study. Generally, we used a very photogenic leaf, the campanula, just after it has been plucked (Figure 43). After taking its picture in its normal healthy state, we gashed the leaf, and also punched a hole in it. This injury inflicted on the leaf usually resulted in a totally different picture (Figure 44) in which the leaf had dimmed in luminescence. In the areas surrounding the gash, there seems to be a sympathetic diminution in brightness, even though the leaf has not been gashed or punched in those areas.

On color film, this effect is dramatized vividly. An intact leaf, on color film, shows predominantly blue and white patternings, with occasional pink and red tinges (Figure 45). After being gashed and punched, that same leaf shows vivid red and orange

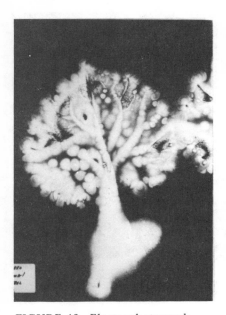

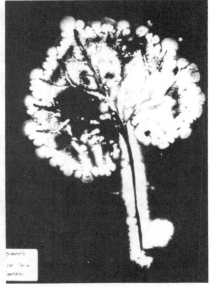

FIGURE 43. Electrophotograph, campanula leaf, intact (courtesy, T. Moss & K. Johnson).

FIGURE 44. Electrophotograph, campanula leaf, immediately after mutilation (courtesy, T. Moss & K. Johnson).

patterns, where the injury has occurred (Figure 46). If the leaf is left for a brief period of time, untreated, those colors of red and orange disappear, and the resulting picture reveals an overall, blue coloration (Figure 47). (In corroboration of the Soviet literature, after a lapse of somewhere between 24 to 48 hours, it is no longer possible to obtain a picture of the leaf.)

Before the start of this "healing" experiment, we knew these facts. What we did *not* know was what effect, if any, a healer might have on the leaf. That question had not even occurred to us until William A. Tiller visited our laboratory, asked the question, and even tried to find an answer—an answer which certainly suggested that a person could influence the picture of a leaf. As a result of Dr. Tiller's visit, we inaugurated a study in which we would routinely photograph a leaf in its normal state, then we gashed and punched it, and photographed it again. Then

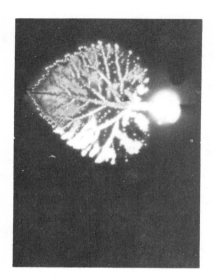

FIGURE 45. Electrophotograph, campanula leaf, intact (courtesy, T. Moss & K. Johnson). *COLOR*

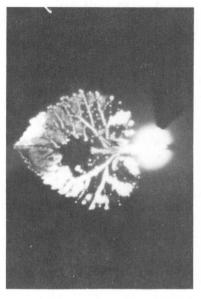

FIGURE 46. Electrophotograph, campanula leaf, immediately after mutilation (courtesy, T. Moss & K. Johnson). *COLOR*

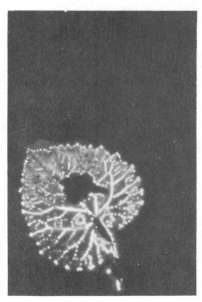

FIGURE 47. Electrophotograph, mutilated campanula leaf, untreated (courtesy, T. Moss & K. Johnson). *COLOR*

we asked the volunteer "healer" to place his or her hand at a
distance between one and two inches above the leaf, for as long
as he or she thought necessary to effect a "healing." Generally,
this length of time lasted between one and two minutes, after
which the leaf was photographed again.

When we compared a gashed leaf before treatment (Figure 48),
and after being treated by the "healer" (Figure 49), we found
that the leaf had greatly increased in luminescence.

Generally, we asked the healer for a second "treatment," and
photographed the leaf again. Sometimes the leaf would grow even
brighter on the resulting photograph. Of the 22 persons who
served as "healers" in this study, 19 of them were able to effect
this increase in the leaf's luminescence after treatment. However,
a few of the "healers" seemed to show no effect at all.

In every instance, for every experimental leaf, we provided a
companion leaf plucked from the same plant, which would serve
as a control. Each control leaf was photographed intact, and then

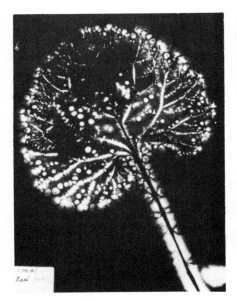 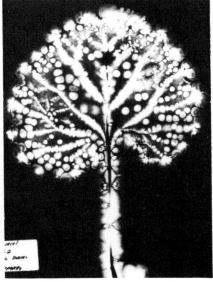

FIGURE 48. Electrophotograph,
mutilated campanula leaf, untreated
(courtesy, T. Moss & K. Johnson).

FIGURE 49. Electrophotograph,
mutilated campanula leaf after
treatment (courtesy, T. Moss &
K. Johnson).

again, after mutilation. The control leaf was then left, untouched, for the same period of time as the "healer" gave the experimental leaf its treatment. After this control period of time, the control leaf was again photographed. In almost every instance, there was a diminution in brightness with the control leaves. As a result, we believe we have been able to produce a repeatable phenomenon— the transfer of some kind of energy, from person to plant, at a distance of an inch or more—an effect which does *not* occur when there is no interaction with a person.

UNUSUAL DEVELOPMENTS

On two occasions, we received astonishing results. One of America's most celebrated healers, Olga Worrall, visited the laboratory and agreed to work on the leaf study. We obtained an intact control leaf for Dr. Worrall, photographed it (Figure 50), and then mutilated it (Figure 51). After a further passage of time, in

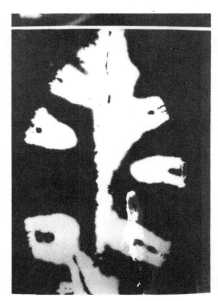

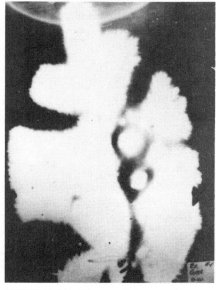

FIGURE 50. Electrophotograph, intact control leaf (courtesy, T. Moss & K. Johnson).

FIGURE 51. Electrophotograph, control leaf immediately after mutilation (courtesy, T. Moss & K. Johnson).

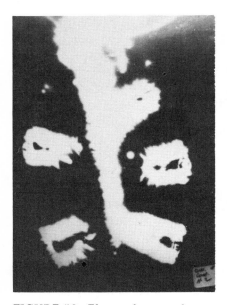
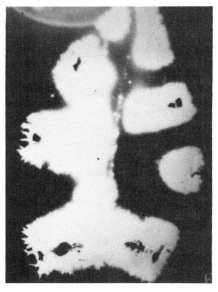

FIGURE 52. Electrophotograph, mutilated control leaf, untreated (courtesy, T. Moss & K. Johnson).

FIGURE 53. Electrophotograph, intact experimental leaf (courtesy, T. Moss & K. Johnson).

which nothing had been done to it, there was a general diminution in brilliance (Figure 52). We also obtained an intact experimental leaf (Figure 53) and mutilated it (Figure 54). After it was given a healing treatment, the image of the leaf just about disappeared (Figure 55).

It must be confessed, after this set of pictures was developed, the workers in our laboratory experienced panic. Dr. Worrall is a lady for whom we have the greatest respect. How could we tell this lovely person what she had done to her leaf? But, naturally, she wanted to know the results of her treatment. We showed her the pictures and she examined them with quiet dignity. She expressed her desire to repeat the experiment, because she believed she had generated too much power into the leaf and felt that a more gentle treatment might manifest different pictures.

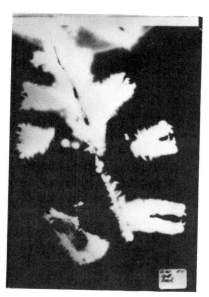

FIGURE 54. Electrophotograph, mutilated experimental leaf (courtesy, T. Moss & K. Johnson).

FIGURE 55. Electrophotograph, mutilated experimental leaf after treatment (courtesy, T. Moss & K. Johnson).

We went back to the laboratory at the very next opportunity, and on this second occasion, we photographed an intact leaf in its normal state (Figure 56), again after mutilating it (Figure 57), and after Dr. Worrall gave it a more gentle treatment (Figure 58). After treatment, the leaf showed its usual brilliance. Up until this moment in time, we had not found a healer who could predict the *direction* that this energy might take. Now, Dr. Worrall had demonstrated that she could *control* this energy flow, to make the leaf either disappear or become more luminescent. This indicates to us that there is something occurring, visible with this kind of photography, that is quite independent of the electrical parameters of the apparatus.

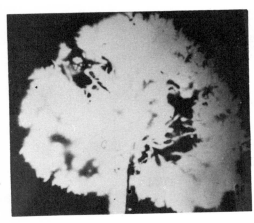

FIGURE 56. Electrophotograph, intact leaf (courtesy, T. Moss & K. Johnson).

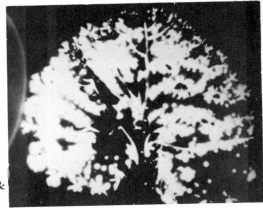

FIGURE 57. Electrophotograph, mutilated leaf (courtesy, T. Moss & K. Johnson).

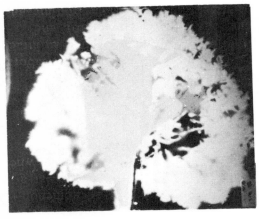

FIGURE 58. Electrophotograph, treated leaf (courtesy, T. Moss & K. Johnson).

We found one other person, Barry Taff, who was able to make the leaf all but disappear. This person (who, incidentally, is a gifted psychic who has worked in the laboratory for several years) did not for one moment claim to be a healer. He claimed to be infamous for his "brown thumb" and maintained that plants could not survive when he was around.

We photographed his control leaf (Figure 59), then mutilated it (Figure 60), and photographed it after a period of time in which nothing was done to it (Figure 61). There was a slight dimming of its brightness.

We photographed his experimental leaf intact (Figure 62) after being gashed and punched (Figure 63), and after his first treatment—which he called "zapping" (Figure 64), we photographed it again after its second "zapping" (Figure 65) and noticed the leaf had all but disappeared.

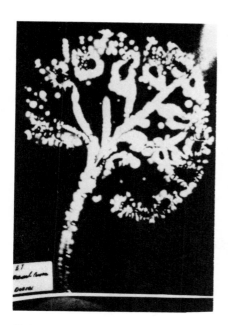

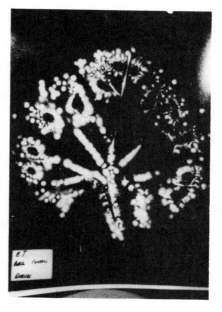

FIGURE 59. Electrophotograph, intact control leaf (courtesy, T. Moss & K. Johnson).

FIGURE 60. Electrophotograph, mutilated control leaf (courtesy, T. Moss & K. Johnson).

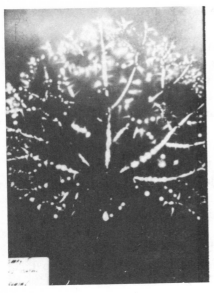

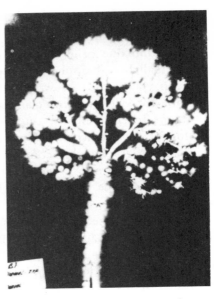

FIGURE 61. Electrophotograph, untreated control leaf (courtesy, T. Moss & K. Johnson).

FIGURE 62. Electrophotograph, intact experimental leaf (courtesy, T. Moss & K. Johnson).

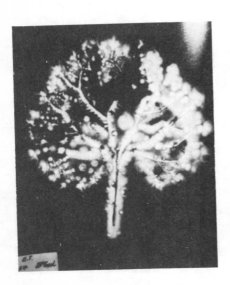

FIGURE 63. Electrophotograph, mutilated experimental leaf (courtesy, T. Moss & K. Johnson).

FIGURE 64. Electrophotograph, mutilated experimental leaf after first treatment (courtesy, T. Moss & K. Johnson).

FIGURE 65. Electrophotograph, mutilated experimental leaf after second treatment (courtesy, T. Moss & K. Johnson).

Mr. Taff volunteered to come in on another occasion to repeat the "zapping," and to try to repeat making the leaf disappear. On that second occasion, oddly, his experimental leaf showed *more* luminescence, rather than the expected extinction.

Mr. Taff, however, was not easily discouraged. He proceeded to build his own radiation photography apparatus, using parameters very different from ours. Our standard machine operates at a low frequency of 1,500 and 3,000 hertz, with a voltage of approximately 5,000 to 25,000 volts at the object. Mr. Taff's device operates at the very high frequency of one megahertz, and 10,000 volts.

Using his apparatus, Mr. Taff again performed his "zapping" procedure with a leaf. He began with an intact leaf (Figure 66), photographed it again after being gashed (Figure 67), again after his first treatment (Figure 68), and again after its second "zapping" (Figure 69). We observed that the actual leaf pattern had all but vanished, and instead there appeared brilliant colors of yellow, red, and orange. Do those colors reflect the "zapping" energy?

Incidentally, the two instruments do have similarities as well as

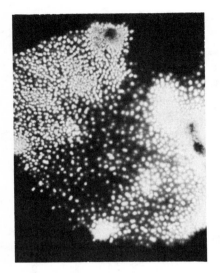

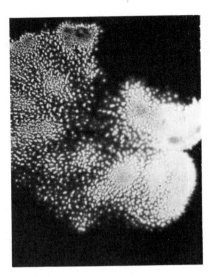

FIGURE 66. Electrophotograph, intact leaf (courtesy, B. Taff).

FIGURE 67. Electrophotograph, mutilated leaf (courtesy, B. Taff).

FIGURE 68. Electrophotograph, mutilated leaf after first treatment (courtesy, B. Taff).

FIGURE 69. Electrophotograph,
mutilated leaf after second treatment
(courtesy, B. Taff).

differences. The main point, in regard to these leaf studies, is that the same kind of phenomenon manifests itself on two quite different kinds of apparatus. Therefore, we may have detected a repeatable experiment.

It appears as a result of these studies that this energy, whatever it may be, can work in *opposite* ways, for reasons we do not as yet understand. Is it that some people can radiate to other organisms which absorb their radiations, while other people can only *absorb* the radiations from other organisms? Or is it that radiation, and absorption, can occur at different times in the same person? In any event, our "healing" studies proved to be far more complex than had been anticipated. And further complexities continued to unfold.

ANTICIPATION AND EMANATIONS

One of us (John Hubacher) was in charge of the leaf studies. It was his duty to pick the leaves, photograph them, mutilate them (he was grimly known as the "leaf gasher"), to perform all photography on the control leaves, to develop the pictures, print them, enlarge them, and make slides of them. He was very busy. He was also very observant. He noticed, again and again, that the

normal experimental leaf would photograph with a rather vacant
spot (Figure 70). *After* photographing this normal leaf, he would
then gash it and photograph it again, usually on the same 4 x 5
piece of film, so that both pictures were developed, necessarily,
at the same time. What Mr. Hubacher noticed was that after
gashing the leaf, an unusual phenomenon would appear (Figure 71).

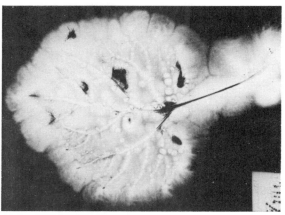

FIGURE 70. Electrophotograph, intact
leaf (courtesy, T. Moss & K. Johnson).

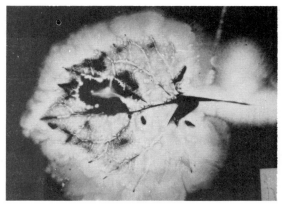

FIGURE 71. Electrophotograph, mutilated
leaf (courtesy, T. Moss & K. Johnson).

The vacant spot in the normal leaf is located in about the same position as the mutilation, which occurred *subsequently*. Since this effect occurred rather often, we began to call it the "anticipation" or "precognition" effect. This effect brought to mind the work of Cleve Backster (1968) who with his polygraph has demonstrated that plants respond to the thoughts and emotions of persons in their environments.

Were our leaves responding to the thought in Mr. Hubacher's mind, that he was going to gash, and puncture a hole in it? The notion seemed absurd, but certainly no more absurd than some of the other results we had been getting. As a result, a series of experiments was undertaken to test the "anticipation" hypothesis. Mr. Hubacher would photograph a leaf intact, in the conventional way. And then a second person, using a table of random numbers, would determine in which of six sections of the leaf the hole would be made. In other words, Mr. Hubacher could have no preconception about where the hole would be made, until after the initial picture was taken. Upon completion of the experiment, the data indicated that the vacant, "anticipation" effect did not occur often enough to make the hypothesis a plausible one. However, it might be wise to repeat it if we could determine plant species with sensitive leaves.

Another fascinating finding in relation to the leaf studies came to light as the result of another visit, from another eminent colleague, Charles T. Tart. He looked carefully at our "leaf healing" studies, and was assured that the effect occurred at a distance of at least one inch from the leaf. Dr. Tart suggested that the leaf might be responding to moisture emanating from the hand. It was our first impulse to debunk that idea but since we ourselves had been debunked so often, we asked Dr. Tart how to test that hypothesis. His suggestion was an ingenious one. As a control, why not use a moist, warm sponge and hold it over the leaf, at the same distance as the healer held his or her hand? Perhaps the "emanations" from the wet sponge might also enhance the luminescence of the leaf. Not only did the suggestion seem sensible, it was easy to do so.

FIGURE 72. Electro-
photograph, mutilated
leaf (courtesy, T. Moss
& K. Johnson).

And we did it. We photographed a gashed leaf (Figure 72) and
then held a warm moist sponge above it for approximately two
minutes (Figure 73). Clearly, Dr. Tart had made a valid point.
The leaf showed increased luminescence. This was a surprise, and
something of a disappointment. What had happened to our con-
cept of a special energy emanating from the hand?

This time it was John Hubacher's turn to do some original
experimentation. He took two leaves, and gashed them. With the
experimental leaf, he held his hand over it for the usual two
minutes and then photographed it. With the control leaf, he let

FIGURE 73. Electrophotograph, mutilated leaf
following exposure to sponge (courtesy, T. Moss
& K. Johnson).

FIGURE 74. Electro-
photograph, mutilated
leaf, 24 hours after
"healing" treatment
(courtesy, T. Moss &
K. Johnson).

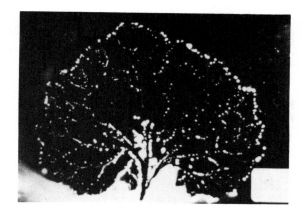

the emanations from the moist, warm sponge permeate the leaf, at a distance of two inches. The experimental leaf, after Mr. Hubacher's hand had been held over it, and the control leaf, after the sponge had done its work, looked about the same. There did not seem to be much difference between the two leaves.

Then Mr. Hubacher's creative mind came into play. He carefully put the two leaves aside, in order to photograph them again, after a lapse of 24 hours. The picture he obtained with the leaf he had "healed" after 24 hours (Figure 74) and the picture of the leaf the sponge had healed, after 24 hours (Figure 75) showed a

FIGURE 75. Electrophotograph, mutilated leaf,
24 hours after exposure to sponge (courtesy,
T. Moss & K. Johnson).

dramatic and unexpected effect which we have successfully repeated. The leaf which was subjected to human radiations retained its photograph for a far longer time than the leaf which the sponge "healed."

This discovery led us into a new avenue of exploration. At least, we thought it was new. Only after several weeks of work did we discover that we had been replicating work done more than 50 years ago, in a field called "human radiations." For these studies, we employed the services of one of our healers, Jack Gray, who is a hypnotherapist, and also an expert at "magnitude passes," a technique he sometimes uses in his work. We suggested to him that he take two flowers, one of which he would "magnetize" (meaning he would spend a few minutes each day making "magnetic passes" over the flower, at a distance of an inch or so). The other flower would serve as a control, subjected to the same environment as the experimental flower, but receiving no "magnetic passes." A picture of the chrysanthemum which had been magnetized daily over a two-week period was taken with a conventional camera (Figure 76) as was a picture of the control chrysanthemum, at the end of the two-week period (Figure 77). After a period of *five* weeks, using our radiation photography, we were able to obtain a picture of the magnetized chrysanthemum (Figure 78) and a very different photograph of the control chrysanthemum (Figure 79).

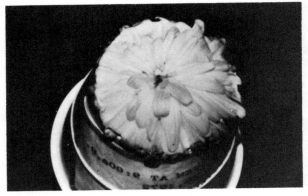

FIGURE 76. Experimental chrysanthemum ("magnetized") following 2-week period (courtesy, T. Moss & K. Johnson).

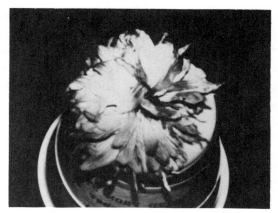

FIGURE 77. Control chrysanthemum ("un-
magnetized") following 2-week period
(courtesy, T. Moss & K. Johnson).

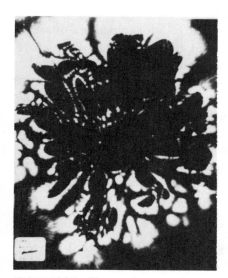

FIGURE 78. Electrophotograph,
experimental chrysanthemum
("magnetized") following 5-week
period (courtesy, T. Moss & K.
Johnson).

FIGURE 79. Electrophotograph,
control chrysanthemum ("un-
magnetized") following 5-week
period (courtesy, T. Moss &
K. Johnson).

We are continuing our explorations of this phenomenon, because the earlier experiments with conventional photographs demonstrating results very similar to ours, were also done with "magnetism," or "magnetic passes." It should be emphasized that this research thus far is preliminary, and perhaps prematurely reported. It will require many strenuously controlled experiments before we can say that this is a reliable, repeatable phenomenon. Should it prove to be, perhaps the effect of magnitude passes—something which has been the subject of controversy since Mesmer work in the eighteenth century—may be demonstrable through the use of radiation photography.

But that remains to be proved.

FIELD INTERACTIONS

Meanwhile, what have we learned? We have been studying interaction effects between healer and patient, between "green thumb" and "brown thumb" people and leaves, and between people and coins. One significant paradox appeared. We found that if a person places his or her hand over a penny, the picture of the penny fades considerably. (We have never found the opposite effect; no one has *increased* the brightness of the picture, although some people have effected no noticeable change.) If the same person who diminishes the brightness of the penny places his or her hand above a leaf, the luminescence of the leaf generall increases. Obviously we are looking at a dramatically different interaction between a person and an organic substance, as against a person with an inorganic substance. Why does the metal grow dimmer, while the leaf grows brighter? Again, we can only pose the question. We have no answer to give.

We believe we are studying the interaction of energy fields. And we have studied, with deep admiration, the work of Harold Saxton Burr (1972) and Leonard Ravitz (1950, 1970), as well as the brilliant monographs of Albert Szent-Gyorgy (1970). But to believe this is the nature of the photographs, and to prove that it is so, are two very different matters, which may take many years of work to determine.

We were delighted, then, to learn of the work that D. R. Milner and E. F. Smart (1973) have been conducting, for the past eight years, at the University of Birmingham. It is remarkable that these two men, independently, built their own electrical photography equipment, long before information about Kirlian photography had emerged from the Soviet Union. Their apparatus, again, differs from the Kirlians, and from ours. (It will probably be a long time, as it was with electroencephalography, before there is a standard apparatus for this kind of photography.) Dr. Milner kindly lent us some photographs, which vividly reveal how an ordinary compass needle looks when photographed with their equipment (Figure 80); and how several compass needles look, when they are apparently *interacting* with each other (Figure 81). Are those strange swirls and patterns indicative of energy field effects?

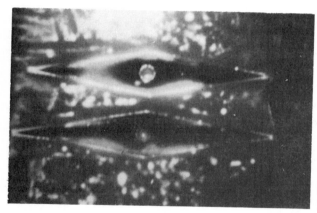

FIGURE 80. Electro-photograph, compass needle (courtesy, D. R. Milner).

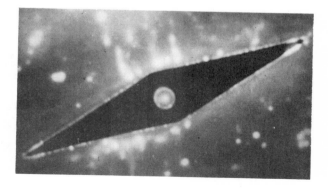

FIGURE 81. Electro-photograph, compass needles (courtesy, D. R. Milner).

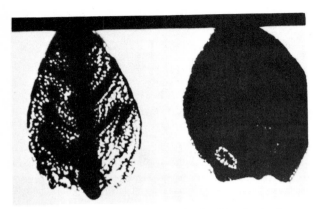

FIGURE 82. Electrophotograph, freshly plucked
leaf and dying leaf (courtesy, D. R. Milner).

Similarly, they have placed a freshly plucked leaf, and a dying
leaf side by side and photographed them (Figure 82). Here may
be seen what looks like a flow of energy going from the fresh
leaf to the dying one. This picture reminds one of the gardener's
advice: if an indoor plant does not seem to be thriving, it is help-
ful to group it together with other plants. Somehow groups of
plants seem to do better. Can it be that they do better because
of this invisible field interaction?

FIGURE 83. Electrophotograph, air patterns
(courtesy, D. R. Milner).

FIGURE 84. Electrophotograph, air patterns (courtesy, D. R. Milner).

Milner and Smart have become extremely curious about these invisible fields around organisms, and have decided to take pictures of air. No objects are present to contaminate what they want to study. By varying the electrical parameters of their D.C. instrument, they have achieved some remarkable patterns of air (Figures 83, 84, 85). They have no true understanding of this phenomenon and neither do we. But one of us (Kendall Johnson) has attempted to replicate their work with his equipment, and

FIGURE 85. Electrophotograph, air patterns around leaf (courtesy, D. R. Milner).

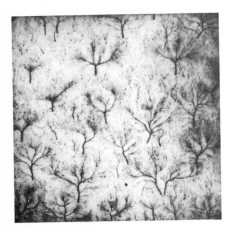

FIGURE 86. Electrophotograph, air patterns (courtesy, T. Moss & K. Johnson).

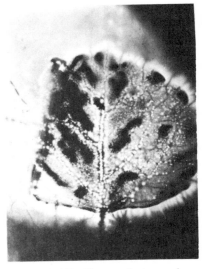

FIGURE 87. Electrophotograph, "phantom leaf" effect (courtesy, T. Moss & K. Johnson).

has produced similar pictures (Figure 86). He has photographed air, and has obtained bamboo, forest-like patterns. Patterns of what?

In summary, we have done considerable work with radiation field photography, and we have obtained consistently surprising results.* And again, as indicated in our concluding statement from the 1972 conference, we can only say that these are the pictures we have taken, these are the data. But it may be a very long time before we know what information these data are communicating. Meanwhile, it is for us an extraordinary adventure.

*A few months after this paper was presented, Mr. Johnson successfully obtained a "phantom leaf" picture (Figure 87), in which the portion of the leaf which had been cut away could be seen, with clear internal structure. Subsequently, John Hubacher has obtained more than a dozen "phantom leaves" on film. He has also been able to observe the "phantom leaf" in vivo, using a transparent electrode. In this instance, the leaf was cut before it was placed on the plate by Mr. Hubacher.

Human Control of a Bioelectric Field

4

Viktor G. Adamenko

The movement of small objects placed at some distance from a human subject has been described in earlier publications by Sergeyev and other Soviet investigators. It was found that an electrostatic field may develop between the object such as a match or a ball, and the grounded subject. This field was detected on the object by means of electrostatic voltmeters and simple neon indicators. It has also been demonstrated that the surface on which the objects move becomes electrically charged.

The purpose of this new investigation was to determine conditions under which the phenomenon could be regularly reproduced and to reveal psychological mechanisms of the effect. For this study, preliminary work was done with several subjects who displayed some ability to move objects at a distance. The best of these subjects, Ms. Alla Vinogradova, demonstrated the greatest ability along these lines. Therefore, the experiments and results reported in this paper all refer to work with this one talented subject.

All tests were carried out on a dielectric (nonconducting) cube with a side length of 50 centimeters. This cube served as a table and the objects to be moved were placed on top of this cube. Several small metallic and dielectric objects were used in the experiments. The intensity of the electrostatic field induced by the subject on the objects varied and sometimes reached 10^4 volts per centimeter.

The other subjects were also able to move objects, but did not develop voluntary control to the degree shown by Ms. Vinogradova. Upon demand of the experimenter, she was able at a distance to

75

push the object forward or backward, to accelerate the object's motion, and to start or stop the motion of the object. In the case of such objects as ping-pong balls, she was able at a distance to make the object rotate accordingly at a signal given by the experimenter. The distances between the objects and the hands of the subject for these experiments were about 5 to 50 centimeters, averaging 20 centimeters.

The phenomenon appears to be based not only on the arm's motion in space, but also on the variations in the subject's electrical conductivity which results in changing configurations of the electrostatic field between the arm and the object.

In one set of experiments the bioelectric field around Ms. Vinogradova's finger was analyzed using the Kirlian photographic process. The first photo (Figure 88) shows the subject's finger before the beginning of the experiment. The second shot (Figure 89) is of the same finger but was taken when the subject concentrated on moving the object. In analyzing the high frequency

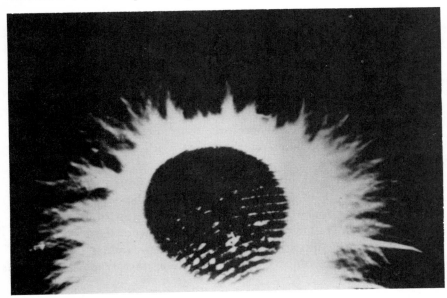

FIGURE 88. Electrophotograph, finger pad, right hand of A. Vinogradava at rest (courtesy, V. G. Adamenko).

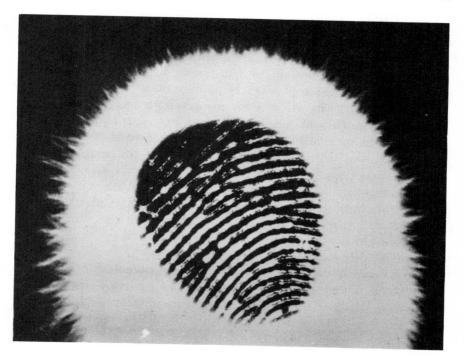

FIGURE 89. Electrophotograph, finger pad, right hand of A. Vinogradava
during attempted control of bioelectric field (courtesy, V. G.
Adamenko).

photographs, one can see that when the subject shifts to a
condition of concentrated attention, the electrical properties of
the skin change. The length of the "streamers" decreases and the
"crown" density increases.

During these tests, the pulse-rate of the subject increased rapidly.
A particularly pronounced psychological and physiological stress
took place in all instances, especially while the subject was asked
to change the direction of the object's motion. The effect in-
creased when the subject was highly motivated or when she was
in a highly emotional state, characterized by either positive or
negative feelings. In such instances, she was able to charge the
object so strongly that other people could cause it to move, even
if they did not have the ability themselves.

The maximum weight of the object to be moved depends on its shape and the type of friction required for movement. In the case of rolling friction, such as an empty cigar tube or cigarette, the subject could move up to 100 grams. In the case of sliding friction, such as the top cover of a fountain pen, she could move up to 10 grams. The effect was stronger if the weight was lighter.

Once the subject became accustomed to a particular object and was switched to a new object, the effect decreased even if the new object was lighter. On the other hand, if the weight of a familiar object was increased without the subject's knowledge, she could move the object just as easily as before—within certain limits. This indicates how the subject's attention is placed on the form of the object and that her familiarity with the form is an important consideration in maximizing the effect.

Several other experiments were carried out to discover the extent to which the electrostatic field was amenable to the subject's voluntary control. Two objects of similar weight and form were placed on the table at identical distances from her hand and arm. The experimenter told the subject which of the two to move, as she held her arm stationary. In these experiments, the object identified by the experimenter moved while the other object did not move. Again, voluntary control is indicated by these results.

In conclusion, then, the data acquired in the course of these experiments give scientists some idea as to how to investigate the bioelectric fields which surround the body and the extent to which these fields may be controlled by voluntary means.

A High Frequency Filter Model for Kirlian Photography **5**

Eric Schwartz

In this paper a model is presented to explain the changes observed in Kirlian photographs of living objects, that seem to be correlated with either the emotional or physiological state of the subject. In this model, the primary process occurring is the variability of skin resistance and body capacitance as a function of emotional and physiological states. The Kirlian photograph itself is then best understood as an indication of the electrical properties of the subject.

The working definition of Kirlian photography in this paper is taken to be the application of a high-voltage, high frequency electrical field to a living subject, and the photographic record of the discharge in air that is created. The subject must be living, and capable of changing either its emotional or physiological state, these changes then being correlated with changes in the appearance of the photographic record of the high voltage discharge. This last element is crucial to the definition of Kirlian photography, since the photography of the high voltage discharge of inanimate objects, such as the study of Lichtenberg figures, or corona discharge, is well understood (Zelany, 1945). It is the premise of Kirlian photography that, through the properties of high-voltage discharge, subtle changes in the emotional and physiological state of living subjects may be studied.

*Gratitude is expressed to Theodore Wolff and the other members of the Energy Research Group of the Institute for Bioenergetic Analysis for many of the ideas expressed in this paper.

The typical setup for doing Kirlian photography consists of a sheet of film supported on a surface that may serve as one of the high-voltage electrodes. The subject is placed on top of the film, and the second electrode is then directly coupled to the subject. In this agreement, the high-voltage is coupled capacitively to ground through the subject. Small objects, such as leaves that have insufficient capacitance, are coupled directly across both electrodes.

Many different waveforms have been used by various investigators; however, they all share the property of having a relatively broad distribution of high frequencies present. Thus, V. G. Adamenko (cited by Tiller, 1973) has used a pulse envelope containing frequencies in the range of 75–3000 kilohertz. D. R. Milner and E. F. Smart (cited by Tiller, 1973) have used a so-called D. C. technique in which the rise and fall time of a pulse are controlled. Since these rise and fall times are in the microsecond region, these so-called D. C. pulses may be represented as a Fourier superposition of frequencies ranging up to a megahertz. Other workers have used simple auto-transformer techniques to produce the high voltage, and here also, ringing and oscillations produce frequencies in the 100 kilohertz to metahertz band.

An important fact about the high-frequency breakdown of gases is that the value of the high voltage at which the gas breaks down is known to be a function of the frequency of the electric field that is applied. For example, Meek and Craggs (1953) report that for point-plane electrodes, the breakdown voltage decreases by 50 percent as the frequency of the field increases from 50 hertz to one megahertz. Since the typical frequency band employed in Kirlian photography is roughly in the range of 100 kilohertz to one megahertz, any mechanism in the subject that could selectively pick out certain frequencies in this range would directly affect the Kirlian image. Such a mechanism exists in the form of a simple RC filter that is supplied by the subject, and is composed of the skin resistance of the subject in series with the body capacitance.

If one takes as values for the skin resistance the range of 50–1000 kilohms, and takes as values for the body capacitance the

range of 20-50 picofarads, and then calculates the cut-off frequency between 100 kilohertz and one megahertz, which is exactly in the band width of frequencies assumed to be applied by the Kirlian device. The meaning of this cut-off frequency is that frequencies that are higher than this cut-off will appear as voltage drops across the resistive element of the circuit, and frequencies that are lower than this will appear as voltage drops across the capacitive elements. Any variation, therefore, either in the value of the skin resistance or the body capacitance will then alter the frequency distribution of the voltages that are applied, and will then alter the appearance of the Kirlian image through the dependence of breakdown voltage on high frequency.

A few remarks might be made on the physical picture that corresponds to this model. First, the body capacitance is a function of the overall geometry of the subject, while the resistive element of this model would be identified with the skin resistance. Thus, the structure of the central part of the Kirlian image would depend on local variation of the skin resistance, causing small regions of high-frequency high voltage to appear where the skin resistance is locally high.

Using the human finger as a subject, this would account for the detailed finger print structure observed in Kirlian images. The structure of the corona surrounding the subject would then be identified mainly with the body capacitance, as this would determine the overall voltage of the subject with respect to ground.

It is important to emphasize that in this model, either changes in the skin resistance *or* in the body capacitance would alter the frequency distribution of the applied voltage, and would then change the pattern of the Kirlian image. Skin resistance is known to be a sensitive function of emotional and physiological state of the subject; whether or not changes in skin resistance are the cause of the changing patterns in Kirlian photography should be carefully investigated. The dependence of body capacity on emotional and physiological states is not known; in general the body capacity would be determined by its size and shape. However, it has been suggested that the skin resistance in the local area of acupuncture points is much lower than the typical values.

This could affect the body capacity by supplying low-resistance shunts for the surface charge to penetrate into the volume of the skin, with an associated increase in body capacity as the surface charge becomes a volume charge.

In summary, a model is presented to explain the changes observed in Kirlian photographs of living objects that seem to be correlated with either the emotional or physiological state of the subject. The model consists of considering that the high-frequency, high voltage applied to the subject is filtered by the skin resistance of the subject in series with its body capacitance. The cut-off frequency for this filter is calculated to be in the range of 100 to 1000 kilohertz. Since it is known that the high voltage breakdown of air is a relatively sensitive function of frequency in this frequency range, it is proposed that the changes of skin resistance and body capacitance that may be associated with emotional and physiological states affect the appearance of the Kirlian image by altering the distribution of high frequency voltage that is applied to the subject.

The Physical Mechanisms in Kirlian Photography

6

Richard Alan Miller

and Karl Elmendorff

Kirlian photography, originally developed in the Soviet Union (U.S.S.R. Patent No. 164,906), has recently been of considerable interest for scientific study in the United States. To date, there have been no completely satisfactory physical explanations for the phenomenon. However, some studies (e.g., Moss & Johnson, 1973) indicate wide potential application in both the fields of physiology and medicine. It is for this reason an attempt was made to understand the physical mechanisms involved with Kirlian photography. Once the mechanisms are understood, a clearer picture can be formed for the direction of study for application.

A complete literature search was made on technique, including private communications with leaders in the field of paraphysics and parapsychology, to determine the initial direction for study. The original device built for our studies consisted of a standard automobile distributor being turned by a motor, a twelve-volt car battery, and a home-made Tesla coil tuned for 75 KHz. Two adjustable aluminum plates were used for the electrodes with a controlled spark gap in another location. The photography was done in a darkened room with unexposed Polaroid film.

The initial photographs were taken of leaves found outside the laboratory. The results were very similar to those described in the literature. The so-called "water-drop" phenomenon was observed to correspond to fine filia on the leaf. This immediately led us to

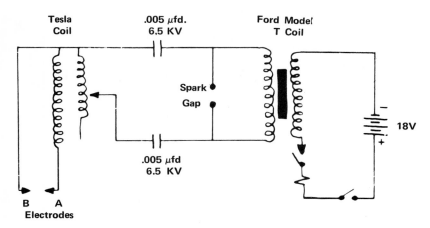

FIGURE 90. Circuit diagram, Kirlian photography unit (courtesy, R. A. Miller).

postulate the Kirlian phenomenon to be some form of electrostatic discharge, since charges or field strengths increase with increasing curvature of radius. With this hypothesis in mind, a new device was built to control the independent variables involved with this form of corona discharge.

KIRLIAN DEVICE

Kirlian photography techniques generally use one of two methods for creating a corona discharge, the Colpitts oscillator or the Oudin circuit.

The most common type referred to in the literature is a form of Colpitts oscillator. This consists of a coil in parallel with two capacitors which are in series. The feedback is called capacitive feedback because it is obtained from the voltage drop across the capacitor in the grid circuit (Figure 90). Tuning is usually accomplished by varying the inductance of L (Figure 91). Because the cathode is connected to the midpoint of two capacitors, there is no d-c path through the oscillator circuit, therefore, shunt feed must be used. The grid-bias resistor must be returned directly to

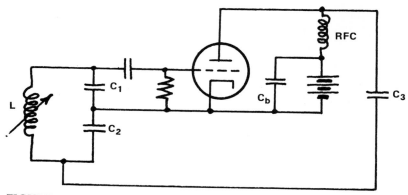

FIGURE 91. Schematic, induction variation for Kirlian photography unit (courtesy, R. A. Miller).

the cathode to provide a d-c path. The operation is the same as in other types of oscillators.

The initial excitation from a change in plate voltage is coupled through the plate blocking capacitor, C_3, in the form of an electron displacement, which in turn also produces a displacement in the plate excitation capacitor C_2. Because of L, this action also causes a current flow in C_1. This current results in a potential difference across C_2 and C_1, which excites the grid with the correct phase and produces oscillations. To determine the frequency of oscillations in the tank circuit C_1 and C_2 are added as capacitors in series.

The other method used for creating a corona discharge is an Oudin circuit. This method was chosen for our work because of its capacity for varying the frequency. The only difference between a Tesla coil and the Oudin coil is that the Oudin coil has one side of the secondary tied to ground. This allows for a stable high frequency with no danger of a floating ground. One side of the primary is also tied to ground. (For additional information, see Figures 114 & 115.)

The primary circuit used was similar to the Lakhovsky Multiwave Oscillator (U.S. Patent No. 1, 962,565). The primary components are an 18 volt supply, a Ford Model T-coil, two capacitors a spark gap (1/16 inch) and a Tesla coil (Figure 92).

The Tesla coil consists of two parts: the primary and the secondary. The primary was wound with 23 turns of bare No. 16 gauge wire. The diameter of the primary was 2.25 inches with a length of three inches. The secondary was wound tightly (no overlap) with No. 34 gauge cotton insulated wire. Its dimensions were 6.0 inches in length and 1.25 inches in diameter. The only real danger with the device in this state is at the primary. This should be covered so that there is no accidental contact with the bare, exposed wire. The high voltage at the secondary may surprise one with a shock, but is completely safe from a lethal point of view.

The bare primary allows a clip-lead to tune the coil for a frequency range of 75–200 KHz. This allows the "Kirlian phenomenon" to be seen with the visible eye in a semi-darkened room. Many of the photographs we took were double exposures so that the detail of the leaf could be seen.

The efficiency of the Kirlian device depends upon the atmospheric variables of humidity, atmospheric pressure, and temperature. The frequency at which the coil is tuned is also important. The spark gap must have some degree of control. This was accomplished by using a controlled atmospheric chamber around the spark gap. A vernier was used to control the spark gap distance. For most atmospheric conditions, 1/16 inch gap was found to be optimum.

Two techniques were employed in photographing leaves. The first had one side of the secondary tied to the primary. This gave a stable ground. The other side of the secondary was attached to a rounded square of aluminum foil. This allowed the secondary electrode to act as a radiating antenna (Figure 92). Any piece of material (organic or inorganic) brought near this antenna gave off classical Kirlian photography phenomena, visible to the unaided eye (e.g., Figure 93). When a double exposure of a leaf in a lit room is taken, the result allows us to see what points on the leaf appear to emit the lines of light (Figure 94).

We found that long term exposure in the Kirlian field tends to dry out a leaf. It was also observed that the radiation field did not appear to penetrate the leaf, which suggests that the recorded phenomenon in Kirlian photography is a surface phenomenon only.

FIGURE 92. Kirlian photography unit (courtesy, R. A. Miller).

FIGURE 93. Electrophotograph, cactus leaf (courtesy, R. A. Miller).

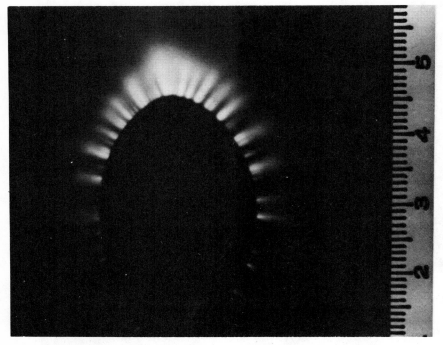

FIGURE 94. Electrophotograph, cactus leaf, including double exposure to ordinary light (courtesy, R. A. Miller).

FIRST EXPERIMENT: CORONA DISCHARGE PHENOMENON

The first step in our work with Kirlian photography was to determine the physics involved with the observed phenomenon. Since preliminary data indicated a corona type of discharge, the first experiment was to test this as a hypothesis. To accomplish this, one side of the secondary was attached to the stem of a leaf. The ground end (Oudin type circuit) of the secondary was attached to the aluminum plate (Figure 95). This procedure set up a control on the geometry for studying the radiation field. The resulting pattern (Figure 96) indicates a form of classical field lines. The calculations involved showed this radiation to be a classical field of electron motion. Considering the geometry, the radius of

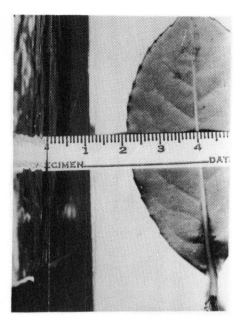

FIGURE 95. Geometry of cactus leaf
for first experiment (courtesy, R. A.
Miller).

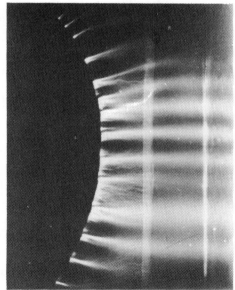

FIGURE 96. Electrophotograph,
cactus leaf, first experiment
(courtesy, R. A. Miller).

89

curvature of radiation from the curved surface of the leaf to the plate indicates a form of electron motion.

These data, in part, indicate that Kirlian photography is simply a technique for ionizing gases about the object within its field to make them radiate light in a visible region. Further tests need to be conducted under controlled environments to study the classical gas-pressure curves for ionization. These data along with that already obtained, would be conclusive in our understanding of the physical mechanisms involved with Kirlian photography.*

In the meantime, one can make some basic descriptive statement about the corona effect. If any of the electrode radii of curvature are small in comparison with their separation, the spark breakdown is preceded by tentacular brush-like or tree-like discharge from the regions of greatest field. This is known as a corona, and it represents a stable form with a positive dynamic characteristic. It is commonly observed when fine wires or points are used as electrodes. If the point or wire is positive, the discharge generally resembles a well-defined, closely fitting, purplish sheath. It is probably a region of intense ionization produced by electrons formed in the gas and drawn to the electrode by the intense field surrounding it.

With cylindrical symmetry the field is inversely proportional to the distance from the center of the wire. Therefore, when the radius of the wire is small, the field in the air near it can become very large. If the small electrode is negative, the discharge is generally more reddish and it is apt to be localized at a series of points along a wire at the extreme tip of a point. Small branching, tree-like discharges appear to grow from these points. This suggests intense, localized, positive-ion bombardment which liberates electrons from minute regions. When these are repelled from the electrode by the intense field, they produce the visible ionization of the gas. There are alternate light and dark spaces surrounding a negative point resembling in miniature the cathode glow, dark spaces, etc. The corona discharge occurs well below the sparking potential if the electrodes are very far apart in comparison with their linear dimensions.

This phenomenon accounts for the purple and red color prints

*This is described in the Addendum.

of Kirlian photography. It also accounts for the small needle-like phenomenon observed on straight surfaces like stems of leafs and wire going to the electrodes. It is our opinion that the color phenomenon reported in the literature is not meaningful. This assertion has not been proven with data at this point, however.

SECOND EXPERIMENT: THE PHANTOM IMAGE PHENOMENON

The Soviets (cited by Herbert, 1972, & Tiller, 1973) have reported an interesting phenomenon which is not congruous with the results of our first experiment. If ten percent or less is cut from the leaf, the resulting Kirlian photograph will often show the missing piece of the leaf as a type of "phantom image."

Our experiment involved a cactus leaf which was cut with a 90 degree edge (Figure 97) and set up in a state similar to that

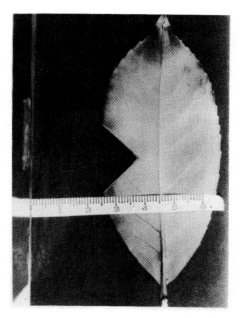

FIGURE 97. Geometry of cactus leaf for second experiment (courtesy, R. A. Miller).

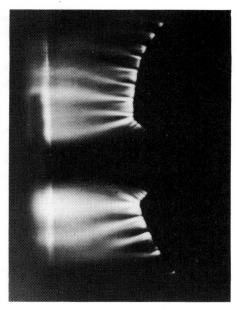

FIGURE 98. Electrophotograph, cactus leaf, second experiment (courtesy,
R. A. Miller).

described in the first experiment. The resulting photograph indi-
cated no ghost image (Figure 98). The lines of light curve from
the cut edge to the plate as per classical expectations. Density
readings of the emitted light were also made. The intensity of
light was found to fall off at a rate similar to the intensity of an
E-field under similar geometry.

However, after some further experimentation, we were able to
conjecture how the results of the phantom image phenomenon
might be obtained. The physical mechanism involved may be
reminiscent of the Xerox process. Thus, the secondary of the Tesla
coil could be fastened to an aluminum plate. The other side of
the secondary (ground side) could be attached to another plate
about six inches above the first plate. A leaf could be placed on
top of the lower plate. The Kirlian device could then be turned
on for one second. This would deposit a layer of charge on the
lower plate. Since the migration of dissipation of charge would be
low, the charge would remain on the plate for some time. The

leaf could then be cut without disturbing the position of the leaf. Film could then be placed on top of the cut leaf and the Kirlian device could be turned on for one second. The resulting photograph could possibly demonstrate the described "phantom image." Of course, this would not explain "phantom images" obtained on leaves cut before placement on the plate.

THIRD EXPERIMENT: INTENSITY OF RADIATION

Many in the field consider the intensity of the photograph to be of significance. A new leaf was cut with pinking shears to give it a many pointed surface (Figure 99). It is evident from the figure that the intensity of radiation is at the points, exactly where charges would collect as per classical mechanics of corona discharge.

It is therefore concluded that the variation in intensity is only significant in that it contains information regarding structure.

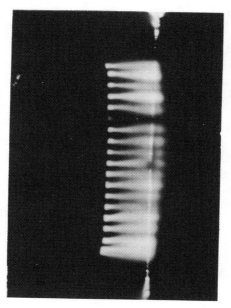

FIGURE 99. Electrophotograph, cactus leaf cut with pinking shears, third experiment (courtesy, R. A. Miller).

FOURTH EXPERIMENT:
PRELIMINARY ACUPUNCTURE STUDIES

Polaroid film was placed on one of the secondary electrode plates and several fingers were placed on top. The Kirlian device was turned on for one second (Figure 100). This photograph is very similar to those described in the literature.

Acupuncture points in the hand area were looked at with Kirlian techniques. Preliminary data indicate no real observed differences between these areas and standard control areas.

The emission off the body was also studied spectrographically, using a diffraction grating technique. Preliminary observations indicate gases are being emitted from the skin at discrete points. These points appear to be the sites described in acupuncture. The gases so far identified are helium, argon, nitrogen, carbon dioxide,

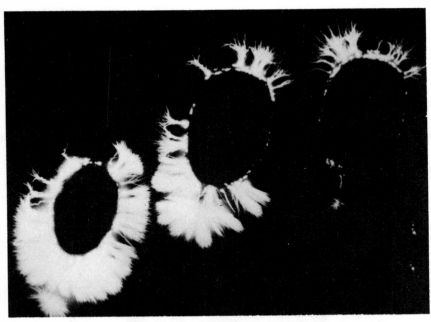

FIGURE 100. Electrophotographs, finger pads, fourth experiment (courtesy, R. A. Miller).

oxygen, and water vapor. The quantities of discharge appear to be greater than those described in the permeability literature.

IMPLICATIONS

It is our theory that the "aura" is, at least in part, a form of gas emission or discharge at discrete points on the surface of the skin. This may be related to how animals are able to "smell" fear. This may also account for the so-called "law-of-territory" and the use of special clothing to change the so-called "odor regions."

Kirlian photography is a form of corona discharge. It is ionizing either gases which are being emitted from the surface or those gases which surround the object. Tests should be conducted with biological objects in a vacuum to study the emission phenomenon more carefully.

We suggest further research in the application of Kirlian photography to the fields of physiology and medicine. Although the color effects are merely aspects of corona discharge, the emission of gases could lead to new ways of medical diagnosis. We have no way of evaluating other investigators' work, but perhaps Kirlian photography can be developed to produce information about internal functioning, since it is a surface phenomenon which might relate to the psychogalvanic skin response.

ADDENDUM

Equation of Motion for Charged Particles off A Curved Surface to a Flat Plate

1. Extreme Case Number One (Figure 101).
2. Extreme Case Number Two (Figure 102).
3. Example Number One (Figure 103).
4. Example Number Two (Figure 104).
5. Example Number Three (Figure 105).
6. Example Number Four (Figure 106).

Extreme Case #1 $\upsilon_{x_o} = 0$

$$\upsilon_{x_o} = 0$$

$$\upsilon_{y_o} = \upsilon_{y_o} \sin\theta = \upsilon_{y_o}$$

$$\upsilon_{y_t} = \upsilon_{y_o} + a_y t$$
$$= \upsilon_{y_o} + 0 = \upsilon_{y_o}$$

$$\upsilon_{x_t} = \upsilon_{x_o} + a_x t$$
$$= 0 + a_x t = a_x t$$

FIGURE 101. Extreme case #1 (courtesy, R. A. Miller).

Extreme Case #2 $\upsilon_{y_o} = 0$

$$\upsilon_{x_o} = \upsilon_{x_o} \cos\theta = \upsilon_{x_o}$$

$$\upsilon_{y_o} = \upsilon_{y_o} \sin\theta = 0$$

$$\upsilon_{x_t} = \upsilon_{x_o} + a_x t$$

$$\upsilon_{y_t} = \upsilon_{y_o} + a_y t = 0$$

FIGURE 102. Extreme case #2 (courtesy, R. A. Miller).

$$x_o = x_1 + (R - \cos\theta\, R)$$
$$y_o = R \sin\theta$$

FIGURE 103. Example #1 (courtesy, R. A. Miller).

96

The particle will follow the path of a parabola of the type equation:

$$y = ax + bx^2$$

FIGURE 104. Example #2 (courtesy, R. A. Miller).

FIGURE 105. Example #3 (courtesy, R. A. Miller).

FIGURE 106. Example #4 (courtesy, R. A. Miller).

We know the acceleration in the x direction is zero.

$$\therefore \; v_x = v_{xo} + A_x t$$
$$= v_o \cos \theta + A_x t$$
$$= v_o \cos \theta + o$$
$$= v_o \cos \theta$$

where A_x is the x component of acceleration. v_o is the initial velocity of the electron.

The y acceleration is dependent on the force acting due to the electrostatic field. The y component will be

$$v_y = v_{yo} + A_y t$$
$$= v_o \sin \theta + A_y t$$

The acceleration is related by $F = MA$. The mass of the electron is known, so we need F to get A.

To find F we know the quantity of charge on dx is qdx. This causes a force at P of

$$dF = \frac{qdx}{4\pi\epsilon(y^2 + x^2)}$$

$$dFy = dF \sin \theta = \frac{qydx}{4\pi\epsilon_o(y^2 + x^2)^{3/2}}$$

Integrating we get from $x = o$ to $x = s$

$$\int_{x=o}^{s} \frac{qydx}{4\pi\epsilon(y^2 + x^2)^{3/2}} = Fy$$

$$Fy = \frac{qs}{4\pi\epsilon y(y^2 + s^2)^{1/2}}$$

If s is large with respect to y, it can be thought of as infinite. Since only s was used for the calculation, we need to integrate from $x = o$ to $x = s$ which would simply double the force.

$$\therefore Fy = \frac{qs}{2\pi\epsilon y(y^2 + s^2)^{1/2}}$$

Since $F = MA$ we know that

$$A = \frac{qs}{M2\pi\epsilon y(y^2 + s^2)^{1/2}}$$

If we were in a gravitational field or an electrostatic force field, we would get

$$v_y = v_{yo} + A_y t$$
$$v_x = v_{xo} + A_x t = v_{xo}$$
① $\quad y = (v_o \sin\theta_o)t - \frac{1}{2}At^2 \quad$ at any time t
② $\quad x = (v_o \cos\theta_o)t \quad\quad\quad$ at any time t

From equation ② we get $\quad t = \dfrac{x}{(v_o \cos\theta_o)}$

and using the quadradic formula on equation ① above

$$t = \frac{-(v_o \sin\theta_o) \pm \sqrt{(v_o \sin\theta_o)^2 - 4(-\frac{A}{2})(-y)}}{2(-\frac{A}{2})}$$

Combining and solving, we get the equation for the motion of y which is

$$y = (\tan\theta_o)x - \frac{\text{Field strength}}{2(v_o \cos\theta_o)^2}x^2$$

which is parabolic in nature, ie. $y = bx + cx^2$. The field strength for gravity would be g. This equation relates y to x and is the equation of the trajectory of the particle.

Since v_o, the original velocity of the particle, θ_o, the original angle of departure of the particle, and the field strength are all constants, we get

$$y = bx - cx^2$$

which is the equation of a parabola.

7 The Light Source in High-Voltage Photography

William A. Tiller

INTRODUCTION

We have all been excited and thrilled by the beautiful Kirlian photographs we have seen and are understandably elated by what we think they may portend about the nature of the universe (Moss & Johnson, 1972b, Ostrander & Schroeder, 1971). However, after a year or two's experience with high-voltage photography in the United States, it is now time to ask ourselves some serious questions concerning the process: (a) Does the evidence show that we are dealing here with physical or what we might for the moment call non-physical effects? (b) Can we realistically account for the observations made to date with a specific model? (c) Are we doing our experiments carefully enough to continue making meaningful progress?

The present paper speaks to these questions and concludes that: (a) There is a specific physical explanation, called the streamer phenomenon of corona discharge, that can account for all the observations made to date. (b) The identification of a specific physical mechanism does not mean that energy interactions with non-physical levels may not be intimately involved. (c) We are definitely not conducting our experiments carefully enough to make rapid and meaningful progress.

To begin this exposition, let us briefly discuss the author's model of the non-physical aspects of the universe so that our frame of reference will have been at least identified and understood (even if not accepted).

MODEL OF RADIATION AND SUBSTANCE

In order to provide a slight background perspective of radiators, absorbers, and radiation, the simplest place to begin is at the level of the atom. A simple model of the atom is that of a nucleus of positive charge surrounded by a number of electrons, each of them being in well-defined but different energy states. Other possible states for these electrons exist but, in the atom's equilibrium state, they are not filled by electrons. If we stimulate the atom, we can cause the electrons to shift to these unfilled or excited levels and, when they drop back into their equilibrium levels, they emit electromagnetic (E.M.) radiation which is often in the visible range of the E.M. spectrum. Some of these energy levels can be schematically illustrated using the simple Bohr model for the hydrogen atom (Figure 107).

FIGURE 107. Circular orbits of the hydrogen atom showing the electron in the n = 3 orbit plus possible energy transitions between orbits (courtesy, W. A. Tiller).

A useful model for simulating the behavior of the electron level changes is the "classical harmonic oscillator." We say that a charged particle of mass M is bound to a position of equilibrium with a spring by a force of interaction G, known as the force constant of the spring (Figure 108).

FIGURE 108. Weight on a spring representation of a simple harmonic oscillator of resonant frequency (courtesy, W. A. Tiller).

$$\nu_0 = \frac{1}{2\pi}\sqrt{\frac{G}{M}}$$

When the particle is displaced from its equilibrium position and released, it is found to vibrate at its resonant frequency νo given by

$$\nu o = \frac{1}{2\pi}\left.\frac{G}{M}\right.^{1/2} \tag{1}$$

and the amplitude decays with time because of the frictional damping in the spring; i.e., it acts something like the familiar tuning fork. For the charged particle, the initial displacement may be caused by the exchange of energy with another atom or by the absorption of some electromagnetic energy.

This provides us with a very simple model of a light source. The vibrating charge will create an electromagnetic field oscillating in a narrow frequency range $\Delta\nu$ about the resonant frequency γ (Figure 117). Here, $I(\nu)$ is the intensity of the radiation from the source at frequency ν. In general, a given type of atom will exhibit a spectrum of such frequencies, i.e., a series of such lines

at different frequencies where each line is associated with an electron transition from one orbital energy level to another.

If we consider groups of identical atoms, the foregoing describes the situation so long as the atoms are far apart and isolated from each other. They give identical spectra (with lines of the type illustrated in Figure 109. If we allow two of these atoms to come

FIGURE 109. Intensity versus frequency plot for a single electron transition (courtesy, W. A. Tiller).

closer together so that they begin to exert a force on each other (an electrostatic force), they become coupled so that G (Figure 108) is no longer a constant; i.e., the motion of one exerts a force on the other. For these two atoms, their resonant frequency changes from one value, ν_0 to two values, ν_1 and ν_2, which depends upon the distance of separation of the atoms (as illustrated in Figure 110). The values of ν_1 and ν_2 diverge from each other as the atoms become closer and closer together and interact with a tighter coupling. We complete the picture by considering many atoms interacting very strongly with each other. This provides a whole range of overlapping resonant frequencies (which cause the simple resonant line of Figure 109 to broaden into the resonant band of Figure 111).

Before we press on, there are a variety of important characteristics that we should note concerning these electronic vibrational states of matter. First, every atom, molecule, cell, gland, animal, etc., has at least one resonant energy band of some bandwidth

FIGURE 110. Effect of oscillator coupling on the broadening of frequency. The example used here is that of a gas of varying density, each molecule or atom representing an individual oscillation. At low gas densities (large distances, r) coupling is negligible and all atoms radiate (or absorb) within the same narrow frequency interval. As two atoms are brought closer together, they form a coupled resonant system at two diverging frequencies (black regions). When more atoms are added to the coupled system, additional frequencies appear, favoring the upper region (indicated by the degree of shading). The frequency distribution at the smallest r represents the density of states for a solid or a very dense gas (courtesy, W. A. Tiller).

$\Delta \nu$ at which it will both emit energy (E.M. radiation) in some spatial pattern and absorb it; i.e., they are both the same for a particular system. Thus, each system is in communication with the outside world (transmitting and receiving) via its resonant

FIGURE 111. Intensity versus frequency plot for an idealized physical solid (many atoms interacting) (courtesy, W. A. Tiller).

frequency spectrum. This particular spectrum is like a unique fingerprint via which we can identify the system.

If we look carefully at the human body with electromagnetic detectors, we are able to see E.M. energy radiated from the body not only as a result of electron orbit changes but also as a result of physical rotations and vibrations of the molecules, cells, etc. In time, we may even come to detect natural X-ray and γ-ray emission from certain regions of the body. In addition, if we carefully scan the body with sonic detectors, we shall detect a unique sound spectrum associated with actual physical movement of cells and body systems—another fingerprint. In time, we can expect to find many such fingerprints radiated from the physical body.

Perhaps one of the most striking techniques for revealing some of these energies is the use of liquid crystals. By painting a person's body with liquid crystals, color patterns can be readily seen. Here, the liquid crystal acts as a transducer to turn the body's radiations into an optical manifestation that can be readily seen.

These are the types of radiation we know at this point in time, and we are trying to use this as a guideline for understanding the uncommon energies we hear about. We hear of psychometry. We hear of dowsing. We hear of clairvoyance and clairaudience and

prophecy and various kinds of channeling activities. We hear about radionics, vivaxis, and many other nonconventional methods of gaining information about our environment and about ourselves. You see, we communicate with each other only through radiation patterns and although we think conventionally in terms of the visual (which is electromagnetic) and in terms of the sonic, we should anticipate that nature is filled with many, many other kinds of energies. As we attune to them and discriminate them, then we, in fact, are obtaining additional information about our environment.

Let us now extend these radiation ideas to substances from other dimensions of the universe than the physical. Starting with the Yogic philosophy of the seven principles operating in the person, I hypothesize that this means there are really seven different levels of substance in the universe and that these different substances have different types of configurations. They obey entirely different kinds of laws—unique types of laws—and they have unique characteristics of radiation (absorption and emission). I further postulate that they operate in different kinds of space-time frames in the universe and so are distinct from each other. The seven levels of substance, then, from the coarsest going towards the finest are: (1) the physical level that we are familiar with; (2) the etheric level (the Soviets call this the bioplasmic body or the energy body; some people call it the prephysical body); (3) the astral level; (4) there are three levels of mind: instinctive, intellectual, and spiritual mind; and (5) another distinct level, which is spirit.

These seven substances interpenetrate each other in nature and may interact with each other. They, through the polarity principle, form atoms and molecules and configurations of these. One can apply the metaphysical principle: "As above, so below; as below, so above," and realize that what we see in the physical may be used as a model and this same kind of modelling understanding may be extrapolated through the other levels of substance, differing somewhat in detail from the physical, and we may begin conceptually to grapple with these other levels. The substances interpenetrate, and their relationship may be visualized by con-

sidering the situation in our own bodies. To visualize our seven bodies, think of seven transparent sheets of paper and, on these sheets, using particular pens of different colors, draw circuitry of another color, and so on through the seven colors. Then, put these sheets all together and look through them, and you will see an organization of substance at the various levels within the bodies of man. That, basically, is the model I wish to project.

In general, these substances do not interact with each other too strongly. However, they can be brought into interaction with each other through the agency of mind, and it is really at the point of mind that one can bring about changes in the organization of structure in these various levels of substance. That is, through mind forces, one can create a pattern, and that pattern then acts as a force field which applies to the next level of substance. In turn, that force field is a force for organizing the atoms and molecules into configurations at that level of substance. That pattern of substance at the etheric level, then, is in a particular state of organization and it has its own radiation field— its own force field, if you like—and that force field, then, is a field for the organization of matter at the next level of substance— the physical level of substance. These etheric forces, then, bring about the coalescence and organization of matter at the physical level of substance.

Here, we see something that I have chosen to call the "ratchet" effect; one can see an action beginning at the mind level and working its way down through to produce an effect on the physical level (and vice versa).

For these seven levels of substance it is meaningful to draw a plot of the intensity of the radiation versus its frequency (Figure 112 is presented as an aid in visualizing this model.) Now, the· thing we have to realize is that this particular representation (Figure 112) is purely for coming into contact with the idea and is not a scientifically correct representation, since these levels of substance represent entirely different kinds of energy, entirely different kinds of physical laws, and they really should be represented on different axes, i.e., different coordinate vectors of phase space. And, in fact, along any one of these coordinates,

FIGURE 112. Schematic spectral distribution curve illustrating, along one
coordinate, relative radiation characteristics of the seven levels
of substance (courtesy, W. A. Tiller).

there may be many different kinds of energy that should be
represented (just like electromagnetic, sonic, gravity, etc., energies
in the physical). But, at least for us to conceptually see the
simplest outlines of the model, it is worthwhile to represent it
this way: the physical, etheric, astral, mind levels and the spiritual
level on one axis. Through focusing attention on the mind and
spirit levels, here we see the true essence of the person. This is
the indestructible reality of the person and is the on-going person.
These levels of energy function (or appear to function) in a non-
space, non-time frame of reference—that is, the patterns of
intelligence (in that frame of reference) are not represented on
coordinates which relate to space and time.

The astral function is largely as a containment vehicle, it
appears, to keep this human essence in a compact form between
incarnations. It is also considered to be the energy construct of
our emotional body. Looking further to the left, we come down
to the temporal reality associated with this kind of physical
existence, i.e., a vehicle that is suitable for experience in this

earth plane (the etheric level and the physical level). In the case of the physical, we have the space-time frame—the Einsteinian frame which we know a great deal about. The etheric level is a companion level and it operates again in a space-time frame but in a different space-time frame from the physical, and yet these two are complementary. That is, as time goes on, for the physical, the potential decreases and entropy increases, whereas for the etheric we have the reverse situation (the potential increases and entropy decreases). A characteristic of the physical frame is one of disorder. A characteristic of the etheric frame is one of the organization of matter. The physical is primarily characterized by electric effects. The etheric is primarily characterized by magnetic effects. In the physical, mass and time are positive; in the etheric they are negative. If we increase the velocity of a physical particle (Figure 113), its energy is predicted to increase towards

FIGURE 113. Energy–velocity relationships for particles between the physical and the etheric frames (courtesy, W. A. Tiller).

infinite values as its velocity approaches the speed of light (according to the theory of relativity). However, although $v = c$ is a mathematical singularity, the behavior will be like most physical processes and, at a sufficiently small difference of v from c, the particle will tunnel through the energy barrier leaving the physical domain and find itself transformed into the etheric domain with a large negative energy. Perhaps we see here an idea that relates to "quasars" and "black holes in space." In any event, by definition, a particle with velocity greater than c is called non-physical (tachyons for electromagnetic particles) and that is why we use the term in this section.

This is the way in which I have come to look at these various energies; i.e., that there are radiations associated with these different levels, and these radiations give rise to the phenomena that we can call psychoenergetics. The majority of these phenomena deal with the etheric vehicle. That is, we have a sensory system in this vehicle which connects us to the·psychoenergetic phenomena just as our five physical senses connect us to physical phenomena.

RATIONAL EXPERIMENTAL EXPECTATIONS

Using our five physical senses and an army of instruments based on similar reference frame experience, we discriminate information patterns radiated to us by reality. We cannot expect to "know" reality but can only ask for consistency amongst the many information patterns we perceived concerning reality. Following this line, suppose we seek to discriminate information patterns radiated to us by Nature but on a non-physical band rather than on a physical band. We will find that the phenomenon which we think is non-physical will influence our physical observations in some way and we will eventually come upon a physical explanation. This should not be too surprising to us because all we can presently perceive, with any reliability, is a physical manifestation of energy and there must be a perfectly logical mechanism and physical explanation for the process of its appearance and registra-

tion by our senses. It is thus necessary to understand the physical process to such an extent that one can track its roots backwards to some causal and non-random event that strongly suggests non-physical connections. An information pattern at a non-physical level will act as a force field with coupling elements to the physical dimension so that a corresponding (not necessarily same shape or intensity) force field pattern will be mapped (or trans-duced) into the physical level which, in turn, sets a physical process in motion which we then observe with our physical instruments.

As an example, we might take the phenomenon of psycho-kinesis. A subject projects a non-physical energy pattern to an object located in a Faraday cage. The object lifts and translates but we can detect no energy manifestation with our sensors anywhere outside the cage (except in the brainwave, neural, etc. patterns of the subject). Eventually, we may decide to look inside the cage with electromagnetic and gravity sensors in the immediate vicinity of the object and may locate a divergence of E.M. or gravity field, or both. Thus we see that the final physical mani-festation (as determined by our sensate observation instruments) is rationally explained in terms of known physical forces. However, we must be honest and recognize a non-physical energy link in the total causal pattern.

THE STANFORD EXPERIMENTS

Mr. D. Boyers and the author (Boyers & Tiller, 1973) have conducted a number of experiments with specially-designed appara-tus (Figure 114). (Figure 115 presents a schematic of the Oudin coil.) Using short (\sim100 usec) pulses of R.F. (1 MHz) applied. to parallel electrodes in air at small electrode spacings (\sim250 microns) and at an applied field $\sim$$10^6$ volts/cm, discharges from both biological and metallic electrodes were found to occur from a network of points in the electrode surface. These discharges were recorded photographically on a film placed within the electrode space. Multiple pulses were found to produce a superposition effect such that a uniform corona exposure appeared on the film.

FIGURE 114. Block diagram of high voltage discharge equipment (courtesy, W. A. Tiller).

112

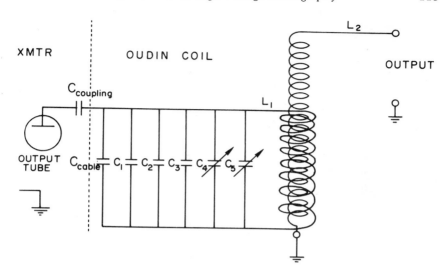

C_C = 100 pf = coaxial cable capacitance

$C_{coupling}$ = 500 pf, 5 kv

C_1 = 500 pf, 5 kv

C_2 = 500 pf, 5 kv

C_3 = 100 pf, 5 kv

C_4 = 23–98 pf, 7 kv

C_5 = 23–98 pf, 7 kv

L_1 = primary coil — 15 turns, 3/16" dia copper tubing, 5" dia, 5" long, supported by lucite supports

L_2 = secondary coil, 500 turns, 24 AWG enameled wire, 3¼" dia, 10" long, wound on fiber board tube 12" long.

FIGURE 115. Schematic of Oudin coil (courtesy, W. A. Tiller).

Photographs were taken to illustrate the effect of single and multiple pulses for both a coin and a fingertip (Figure 116). The clear delineation of all sharp edges on the coin indicates enhanced field emission of electrons from regions of small radius of curvature. The multiple pulses with the finger electrode led to the familiar halo-like pattern.

During the fingertip studies, it was found that the photograph depended significantly on the orientation and spacing of the finger on the electrode-film combination. Considerable variability

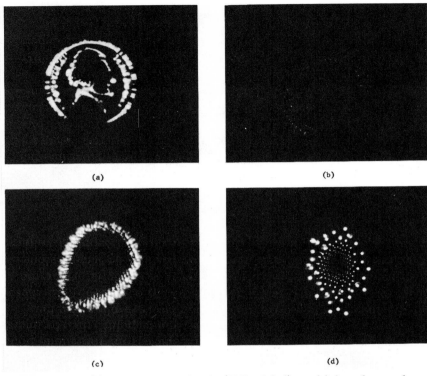

FIGURE 116. (a) Photograph of coin (U.S. nickel); multiple pulses, pulse
 width = 100 μsec, rep rate = Hz, duration = 2 sec. 2X
 (b) Photograph of coin (U.S. nickel); single pulse, pulse width
 = 100 μsec. 2X
 (c) Photograph of fingertip; multiple pulses, pulse width = 100
 μsec, rep rate = Hz, duration = 2 sec. 2X
 (d) Photograph of fingertip; single pulse, pulse width = 100
 μsec. 2X (all courtesy, W. A. Tiller).

occurred in these results as a consequence of the inability to
repeatedly establish a well-defined and controlled discharge spacing,
the orientation and tilt of the finger, plus other unknown factors.
This was especially true with the multiple pulse technique. In
order to gain some reliable information, discharges between flat,
polished, metal electrodes were investigated.

Photographs were also taken of brass (Figure 117). All the

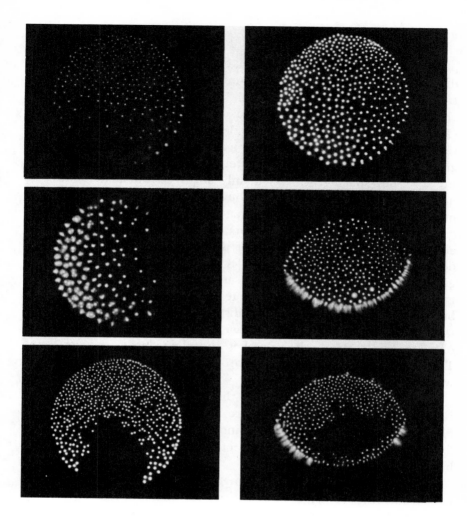

FIGURE 117. Photographs of single pulse discharge between flat, polished
brass electrodes under conditions of different pulse exposure,
electrode spacing and orientation. 4X.
 (a) Pulse width = μsec
 (b) Pulse width = μsec
 (c) Pulse width = 500 μsec; nonparallel electrodes, slight in-
 crease in electrode spacing.
 (d) Pulse width = 500 μsec; electrode areas non-concentric.
 (e) Pulse width = 500 μsec; local film buckling.
 (f) Pulse width = 500 μsec; local film buckling for noncon-
 centric areas (all courtesy, W. A. Tiller).

photographs were found to reveal the same characteristic dot discharge pattern with relatively uniform dot spacing. The general trends noted in the study were the following: (1) For a given electrode material, increased pulse width increased the dot intensity. (2) For a given pulse width and electrode material, multiple pulses resulted in a decrease in the average inter-dot spacing. (3) For a given pulse width and approximately constant electrode spacing, the inter-dot spacing, λ, varied only slightly from material to material even though their electron work functions differed by as much as two volts. (4) For a given material, increasing electrode spacing results in less discrete dots but produced dot clustering and an increase in the amount of diffuse exposure around each dot. (5) For laterally displaced electrodes (relative to each other) giving only a fractional matching area of electrode, the shape of the discharge not only conforms to the shape of the overlap area, but one sees an additional edge discharge from the upper edge that overlies the metal on the lower electrode. (6) In a number of photographs, large clear patches containing no dots were found. This effect disappeared when photographic plates instead of film was used.

One has only to casually read the work of L. B. Loeb (1965) to realize that we are dealing here with the corona discharge phenomena called "streamers." Since this phenomenon will be discussed at length in the next section, we shall deal with it only briefly here.

A few electrons are produced in the interelectrode space either by cosmic ray events, U.V. radiation, or field emission from the cathode. These electrons are accelerated by the field and ionize the air molecules yielding an exponential growth in the number of electrons and positive ions; i.e., an avalanche. The electrons sweep quickly toward the anode and the cluster of positive ions moves somewhat more slowly towards the cathode. When the positive ion cluster reaches a critical density, it strongly attracts the electrons so that a large number of recombination events occur and photons of light are generated to such a degree that the cluster of positive ions is brightly luminous and travels at speeds of $\sim 10^7 - 10^4$ cm/sec. Both positive and negative streamers

move between the electrodes so that, if visually observed, one could see a group of discrete balls of light, "light globules" or "light pulses" moving in various directions.

In air at high field strengths, the normal color of the streamers is a bright blue since the most frequently excited radiation is from the second positive group of highly excited N_2 molecules. One finds ultraviolet radiation produced in abundance also. In air at low electric fields, the ionization and excitation favor the arc spectrum of N_2 and nitric oxide yielding a reddish purple glow. Yellow flashes have sometimes been observed in the streamer corona and this is thought to be due to the presence of Na from NaCl on the electrode surface. In addition, it is thought that if minute carbon flakes are ejected from the electrodes and rendered incandescent in the corona bursts, these could give rise to red or yellow streaks of light. However, a bluish-white color is the overwhelming dominant feature of the discharge.

Loeb (1965) also discusses observations that allow us to consider the color aspect from a new point of view. Studies are described wherein a sheet of color film is exposed to streamers via (a) the emulsion side and (b) via the non-emulsion side. In (a) the discharge patterns were found to be blue whereas in (b) they were red; i.e., the blue light, entering via the back side of the film, leads to a red imprint. To fully understand this effect and to see its possible relationship to Kirlian photography, we must consider the layer construction of typical color film (Figure 118).

The color film consists essentially of three emulsion layers separated by two filter layers and a transparent plastic backing. When white light impinges on the film from the emulsion side, the U.V. and blue components expose the first layer while the green and red are passed. Only the red and green components pass through the first filter layer and only the red passes through the second filter layer to expose the third emulsion layer. The middle emulsion is an orthochromatic emulsion which is sensitive to red, green, blue and U.V. Any attenuation of the red and green components due to passage through emulsion and filter layers is probably compensated for by making the second and third emulsions correspondingly more sensitive.

FIGURE 118. Color film construction, a schematic representation of the effect of U.V. and visible light exposing the film from the emulsion side versus from the support side. Dot in light path indicates exposure of emulsion (courtesy, W. A. Tiller).

When white light impinges on the film from the support side, the situation is quite different. In this case, the third emulsion (red) is exposed by all components, the second emulsion (green) is exposed only by blue and the first emulsion (blue remains unexposed) (Figure 118). The resulting exposure would be a color mixture of red and green which yields yellow for equal exposure intensities. However, it is to be expected that the red layer will receive a much greater exposure than the green layer yielding an overall result of orange or reddish orange. This effect is enhanced even further by the differing sensitivity of the two layers which have been adjusted to deal with light impinging on the film from the emulsion side. A very similar situation exists when only blue and U.V. light impinges on the film from the support side. However, because of the absence of a red component in the incident light, the composite color effect will be more towards the orange than towards the red as in the general case of incident white light.

Let us now consider the effect of different spacings between the film and the adjacent electrodes. Imagine that we have placed a film, emulsion side up, in the electrode device and have located it with the emulsion surface at distance d_1 from the upper electrode and the film support surface at distance d_2 from the lower electrode. Let both electrodes be of the same material. If $d_1 \approx d_2 \neq 0$, both positive and negative streamers bombard both sides of the film and, for only blue light generated by the streamers, color film will show both red and blue patterns. If $d_2 = 0$, $d_1 \neq 0$, so that the film is firmly placed against the lower electrode, no streamers can develop on the support side of the film and the color film will show only blue patterns. Conversely, if $d_1 = 0$, $d_2 \neq 0$, so that the emulsion is firmly placed against the upper electrode, no streamers can develop on the emulsion side of the film so the color film will show only reddish orange patterns.

Since we are always using small electrode spacings ($d_1 + d_2 \sim 200 \, \mu$), unless very great care is exercised, undulations in the film occur so that d_1 and d_2 vary over the surface of the film resulting in some regions where the exposure is predominantly blue, somewhere it is predominantly reddish-orange, and some of an intermediate hue (Figure 119). Our results, indicating blank patches

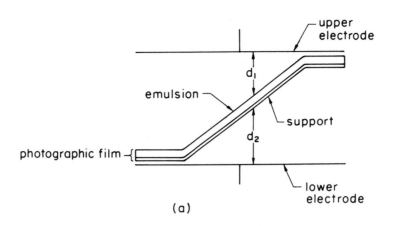

(a)

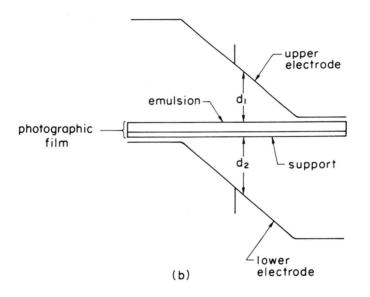

(b)

FIGURE 119. Representation of film bending shown in exaggerated scale.
(a) Film bent, electrodes planar, film exposure from left to right will be blue, white (blue, red, green) and orange (red, green), respectively.
(b) Equivalent topological configuration to that in (a) except that the electrodes are bent and the film is planar. All intermediate combinations of (a) and (b) are also possible (courtesy, W. A. Tiller).

amongst the dots when using film but none when using plates, supports the film distortion hypothesis. The fact that people using polaroid never see anything except blue and white also supports the hypothesis because polaroid film has a fairly opaque backing. Finally, our initial experiments with a transparent electrode have revealed only blue and white patterns of color (no red, yellow, or green).

THE STREAMER MODEL OF ELECTRICAL DISCHARGE
Basic Features

We shall begin by first describing the simplest outlines of the model and then shall elaborate on various subtle aspects (Loeb, 1965; Loeb & Meek, 1941).

One may begin by considering a plane-parallel gap of spacing, $d = 1$ cm, in which the cathode is illuminated by ultraviolet light to such an extent that one electron per microsecond leaves one square centimeter of cathode area. Assume that the atmosphere is air at 1 atmosphere pressure and that the potential between the plates is 31,600 volts (the conventionally observed sparking potention, V_s). The ratio $E/p = 41.6$ volts/cm per mm Hg, where E is field strength and p is pressure, is an important parameter of the process. A single electron starts across the gap, quickly acquiring an average random energy of $\epsilon = \frac{1}{2} m v^2 = 3.6$ electron volts and a drift velocity v in the field direction of about $1.5 - 2 \times 10^7$ cm/sec. As this electron moves, it creates new electrons by collision at the rate of α per cm in the field direction (α depends strongly upon E/p) so that, in a distance x, it and its progeny amount to αx electrons, forming what is called an *electron avalanche*. Therefore, αx positive ions have been left behind by the electron group, virtually where they were formed in the 10^{-7} sec during which the electrons traveled between the plates. The mobility of the positive ions is 10^{-2} to 10^{-3} times that of the electrons.

As the electron avalanche advances, its tip is spreading laterally by the random diffusive movement of the electrons. The radial distance of diffusion is readily calculated to be $F \approx \sqrt{2Dt}$

where t = x/v is the time of advance of the avalanche, and D is the electron diffusion coefficient (readily computed from v). From these data, it is possible to compute the density of positive-ion space charge left behind at any point x. The value of α under these conditions is about 17, making $\alpha d = 2.4 \times 10^7$. The first ion pair is created at 0.04 cm from the cathode and there are 4.9×10^3 ions at 0.5 cm from the cathode, 3.66×10^5 ions at 0.75 cm and, within 0.04 cm from the anode, there are 1.2×10^7 ions. (A schematic diagram illustrating this process is given in Figure 120. Cloud track pictures of such avalanches as they proceed across the gap with time intervals of 10^{-7} sec are shown in Figure 121.)

Most of the electrons will be drawn to the anode except for some few that are bound by the positive ions. Such a distribution of ions does not make a conducting filament of charges across the gap and hence, in itself, an avalanche that has crossed does

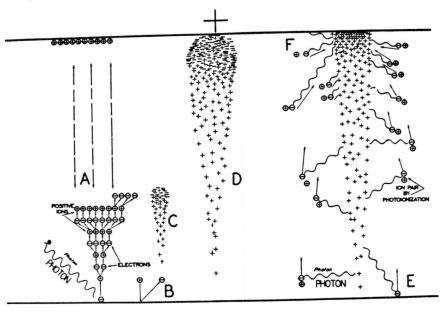

FIGURE 120. Schematic illustration of electron avalanche process (courtesy, W. A. Tiller).

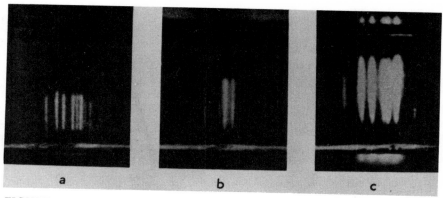

FIGURE 121. Cloud track photograph of streamers from the side (courtesy, W. A. Tiller).

not constitute a breakdown of the gap. To estimate the number of electrons bound by the positive ions, we need to compute the electric field due to the positive ions. For simplicity, we shall think of the ions as being in a sphere of radius r so that the field strength E_1 due to this space charge is $4/3 \pi r e N$, where e is the electronic charge, and N is the density of ions. In a distance dx at the end of the path x, the number of ions resulting from cumulative ionization is $\alpha e^x dx$ and $N = \alpha$

Choosing $r = \bar{r}$ caused by electron diffusion in crossing the gap ($\bar{r} = 0.013$ cm by observation), this yields $E_1 = 6000$ volts/cm or $E_1/E = 0.20$. Thus, the field caused by the positive space charge is 20 percent of the applied field near the cathode. If the initial voltage had been increased by 5%, E/p would have been 5% higher (E/p = 43.6) and α would have been 20, which gives $E_1 = 140,000$. Thus, for this case, part of the electron swarm would have been held back by the heavy space charge some 0.9 of the way across the gap unless there are other important factors which we have neglected.

The single most important fact neglected thus far is that a number of secondary mechanisms exist for the formation of electrons in the air gap. Since α is a constant for a given value of E/p, electrical breakdown can occur only if, before disappearing, this first avalanche itself gives rise to a second avalanche at least

as dense, and so on. This can happen only as a result of other processes for the production of free charges. Some of these are known and others can be imagined:

(1) β effects: ionization of the gas by collisions with positive ions created by the initial electrons.

(2) γ effect: emission of secondary electrons by the cathode under impact from ions in the discharge. It is this process which explains breakdown at medium pressures. It depends on the nature of the gas and the cathode and can occur only after a considerable delay.

(3) δ effect: emission of secondary electrons by the cathode under impact from photons coming from the discharge (de-excitation or re-combination). Since the photons are very fast and scarcely absorbed, this process is very fast and efficient (particularly at high pressures); it depends on the gas and the cathode.

(4) ε effect: emission of secondary electrons by the cathode under impact from excited atoms in a metastable state. The effect is analogous to γ and δ processes but, in this case, the delay is a great deal longer because the atoms diffuse very slowly to the cathode.

(5) η effect: photo-ionization of the gas. The process can play a significant part at high pressures. In pure gases, it can occur only with great difficulty since the photons which arise in the gas due to recombination or de-excitation do not have an energy sufficient to ionize the same gas.

For the generation of streamers, it is the η effect that is of prime importance to us. Accompanying the cumulative ionization, there is produced, by the electrons, from 4 to 10 times as many excited atoms and molecules (Dawson & Winn, 1965). Some are excited to an energy exceeding the ionizing potential of some of the atoms and molecules present, either by excitation of an inner shell, by ionization and excitation, or in a mixed gas-like air by the excitation of molecules of higher ionizing potential, e.g., N_2. These atoms or molecules emit radiations of very short wavelength in $\approx 10^{-8}$ seconds. This short ultraviolet radiation is *highly absorbed* in the gas and leads to ionization of the gas.

The photoelectrons created at points in the gas and at the

cathode at any great radial distance from the avalanche axis will merely create more avalanches. Those photoelectrons, created near the space charge channel of positive ions, and especially near the anode, will be in an enhanced field which exerts a directive action drawing them into itself.

The electrons from the intense cumulative ionization of such photoelectron avalanches in the combined fields E and E_1 which are drawn into the positive space-charge fed into it, making it somewhat of a conducting plasma which starts at the anode. In this fashion, the positive space-charge develops toward the cathode from the anode as a self-propagating positive space-charge streamer. The velocity of streamer propagation, dependent as it is on photo-ionization in the gas and photon propagation at the velocity of light as well as the short distance motion of electrons in high fields near the space charge, is rapid. It has been observed to be about 1.3×10^{-8} cm/sec in one case (Loeb, 1965).

As the streamer advances towards the cathode, it produces a filamentary region of intense space-charge distortion along a line parallel to the field. The conducting streamer of a plasma consisting of ions and electrons extending to the anode thus makes a very steep gradient at the cathode end of the streamer tip. As this advances towards the cathode, the photoelectron avalanches produced by radiation at the cathode begin to produce an intense ionization near the cathode. Thus, as the space-charge streamer approaches the cathode, a cathode spot is forming which may become a source of visible light. As the streamer tip reaches the cathode, the high field produces a rush of electrons toward the end of the streamer. This, if followed by a current of electrons, gives a high-potential wave which passes up the preionized conducting channel to the anode, multiplying the electrons present by a large factor. The channel may thus be rendered highly conducting and, unless limited by external resistance, will then develop into an arc. The velocity of propagation of the returning wave of ionization up the preionized channel may be as large as 10^9 to 10^{10} cm/sec in certain instances.

Aside from all the details, the important factor for us to remember is that *this is the primary source of light detected in*

high-voltage photography. It is found that the process does not occur in vacuum, pure, rare or atomic gases, probably because of the absence of any significant photoionization effect. In addition, the process is only possible if the magnitude of E is sufficient for the charge density of the avalanche to reach a critical density N_c [requires $N_c \sim 3 \times 10^8$ ions with $r \approx 3 \times 10^{-3}$ cm arising from $(\alpha d)_c \approx 20$].

As we look a little deeper, we find that all light-emitting streamers do not propagate completely across the interelectrode space but that some are extinguished in midgap. The streamer length depends on the applied voltage, increasing with the voltage. During streamer propagation, some of the initial critical ball of positive ions are consumed by recombination events so that it becomes subcritical and ceases to propagate, i.e., the energy required to create new ion pairs and excited atoms is derived from the energy of the streamer tip.

To investigate the effect of the electrode material on electron emission, the following experiment was carried out at atmospheric pressure: a voltage pulse $V \gtrsim 1.25\ V_c$ was applied to the electrodes for 10^{-2} seconds and the observed current recorded. The number of electrons emitted per second, I, for $E = 10^4$ V/cm is given in the following table. It can be seen that the emission, even at this small field strength, is far from being negligible.

Steel			Copper		Nickel	Al–Mg Alloy
Milled	Oxidized	Turned	Drawn	Turned	Turned	Turned
10^6	10^6	5.5×10^3	1.4×10^4	5×10^5	7×10^3	5×10^3

This experiment also noted a conditioning effect: when the breakdown current is limited to fairly low values, the emission current I, decreases as the number of tests increase. This would be due to the successive elimination of dust and microscopic irregularities. The study also showed that I varies with E according to the law of cold emission but with coefficients such that the work function,

$\phi \sim 1$ ev and the effective surface areas $S \approx 10^{-14}$ cm^2. These results strongly suggest the mechanism of very localized field emission (perhaps created by chemical contamination or by sharply curved protuberances). In general, we must anticipate a strong geometrical effect due to the field enhancement at any sharply curved point.

The effect of a contaminant for the fossilization of streamers has been illustrated recently by Murr (1972). While studying silicon nitride (Si$_3$N$_4$) ribbons in an electron microscope, he found that hydrocarbon contaminant ions polymerized on the negatively charged streamer regions to build up fossilized corona pictures (Figure 122).

Although the onset of breakdown may depend on the electrode material, the streamer length is not similarly affected. The streamer length is found to be proportional to the applied voltage only. If a photographic film is placed in the point-to-plane gap either perpendicular to and a short distance from the anode point, or parallel to and in contact with the anode point, the streamers move along the surface of the film and leave a photographic record of their path (Lichtenberg figures) (Loeb, 1965). In these experiments, the film seems to act largely as a deflator for the streamer such that the path length in air plus the length along the surface of the film is a constant for constant applied voltage (Dawson & Winn, 1965).

Electrode Polarity Effect

Dr. E. Nasser (1971) has given a representative experimental arrangement used for studying streamer characteristics (Figure 123). The point-to-plane electrode configuration is a favored one by corona discharge researchers because it provides a uniform electric field in the vicinity of the plane electrode and a radially symmetric field in the vicinity of the point electrode having an enhanced field strength due to the reduced radius. Significantly different morphology and features of the discharge exist depending upon whether the point electrode is positive or negative.

The polarity effects recorded with a point-plane or cylindrical

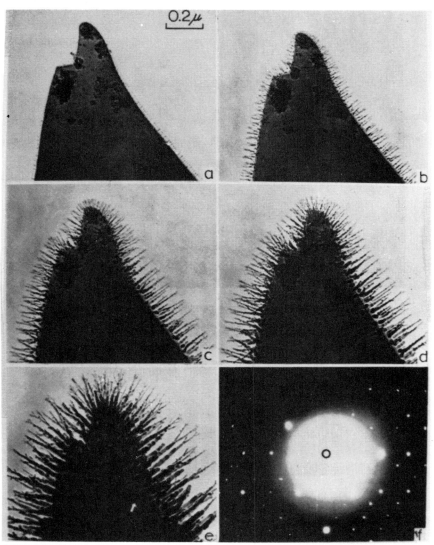

FIGURE 122. Corona streamer development sequence on silicone nitride crystal.

(a) Streamers just developing on the edges.

(b) After 1 min. in beam.

(c) After 3 min. (d) After 5 min. (e) After 15 min.

(f) Selected-area electron diffraction pattern in the very end region of (e) showing diffuse, broad ring pattern of carbonous material composing the fossilized corona streamers superimposed on the single-crystal $Si_3 N_4$ spot pattern (all courtesy, L. E. Murr).

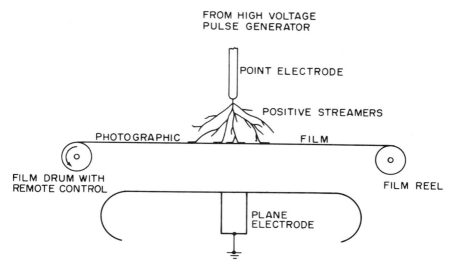

FIGURE 123. Experimental arrangement for studying streamer development photographically (courtesy, W. A. Tiller).

electrode arrangement (Figure 124) are the result of the different roles played by the electrons and positive ions in the discharge gap. The electrons are fast, ionize in avalanche fashion, and tend to move rapidly to the anode $(+ve)$; the ions are slow, stay behind as positive space-charge clouds and tend to drift toward the cathode $(-ve)$. The original electrostatic field between the electrodes is therefore greatly altered as events unfold.

When the point electrode is positive, the electrons are accelerated into a field of increasing intensity and leave behind radial channels of positive space-charge, increasing steeply in charge density toward the anode. This extends the electrical character of the anode, giving it a tentacle-like character which attracts subsequent electrons. As new avalanches strike the radial channels from various directions, a system of positive space-charge branches grows from the positive point electrode into space until, at the tips, the field becomes too weak to support further ionization.

In contrast, from a negative point electrode, the electrons speed out into fields of decreasing strength. Ionizing, they leave behind a positive charge that further weakens the radial driving field and creates tangential field components. Thus, the negative primary

FIGURE 124. Positive and negative Lichtenberg figures (positive: 1 atm, 10 kV,
 point-ring electrode arrangement; negative: 200 mm, 3 kV, point-
 plate electrode arrangement) (all courtesy, A. Voñ Hippel).

discharge broadens into sectors and steepens the field directly in
front of the cathode. This tendency causes the primary negative
Lichtenberg figure to be smaller than the positive Lichtenberg
figure.

A space-charge branch of the positive figure (Figure 125) may
transform into a plasma when a succession of electrons transverse
the same path. As the resistance of the branch decreases, more
current concentrates in it and its field towards the outside in-
creases. Thus, a positive spark develops as if a metal wire were
pushed from the anode along a tortuous path predrawn by the
primary figure. Side branches, robbed of their field by the
advancing channel, die off. Since the voltage drop along the spark
channel is quite small, a positive spark carries the anode potential
practically on its tip. New starting electrons are created by the

FIGURE 125. Onset of transformation of positive space-charge branches into plasma channels (courtesy, A. Von Hippel).

photoeffect in the gas ahead of it. The advance continues, if overvoltage is avoided, by the creation of positive space-charge branches and the transformation of a selected few of these branches into plasma channels. Because the electron flow is a converging flow, the electron density reaches sufficient proportions that the magnetic pinch effect (Lorentz force) becomes operative which squeezes the plasma into narrow channels.

On the other hand, the negative spark can draw on a much more copious electron source provided at the cathode by thermionic or field emissions. The build-up of positive ions at the cathode surface enhances the magnitude of the electric field at the cathode and pulls more electrons out of the cathode. The developing plasma, however, does not find a narrow space-charge branch for intricate guidance but rather a broad sector of space-

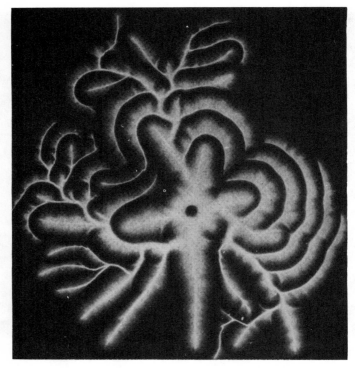

FIGURE 126. Intricate negative spark pattern guided by field buildup of the
primary discharge (4.5 kV, 1 atm air + CCl_4 saturation pressure)
(courtesy, A. Von Hippel).

charge and moves forward along a straight smooth path. Cutting
radially through the primary figure, the spark may be brought to
a temporary halt at its edge if overvoltage is avoided (the
electrons are moving into a region of reduced field). Then the
advance continues in the direction of the highest space-charge
field gradient, which frequently lies tangentially to the old
direction. It transverses its path in a number of discrete steps
(Merrill & Von Hippel, 1939). In this manner, the most intricate
secondary Lichtenberg figures can be created (Figures 126, 127).
Still, the negative spark consists of smooth sections while the
positive spark, in its unruly advance, reveals the guiding space-
charge tracks.

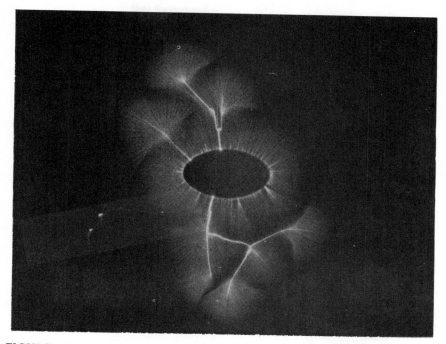

FIGURE 127. Negative spark developing in steps (1 atm, 10 kV, elliptical
electrode (courtesy, A. Von Hippel).

Nasser (1968:127) has shown autographs of ionization obtained
at different locations from the negative point (Figure 128). His
investigations were conducted using a single voltage pulse having a
short rise time of about 1 μ.sec and a slow decline of the order
of a few milliseconds. Applying pulses rather than dc voltages
ensured that the film carried no space-charge prior to the arrival
of the first ionization event. Later processes are modified by the
charge present on the film surface. Using long-duration pulses
reduced the effect of the reversal of polarity that would have
occurred with rectangular pulses in which the voltage, after a
duration of a few microseconds, is reduced to zero. This results in
the creation of "reversed" high fields between the negative space
charge and the point electrode which is now at ground potential.
This field gives rise to the function of "backfires" (erratic positive
streamers) between the space charges and the point electrodes.

(a) 0 cm,

(b) 1.0 cm,

(c) 1.5 cm.

FIGURE 128. A series of lateral photographs taken at increasing distance
from a negative point cathode of 0.05 mm radius, 51 kV and
5 cm electrode spacing.
(all courtesy, E. Nasser).

Certain features of this study are similar to that of Milner and Smart (cited by Tiller, 1973).

With the point positive and facing the sensitive side of the film, the four autographs of Figure 129 are typical of what is obtained as the film is moved from the point toward the plane. The autograph of Figure 129A was taken with the film almost touching the point, yielding the typical positive figure. Such a figure is produced by a streamer emerging from the point and then deflected by the film. Because of the symmetry of the experimental apparatus, the streamer divides into six branches equally distributed around the circumference of the main branch. The six branches continue to branch further resulting in the pattern shown. Moving the film 1 cm away from the point resulted in the autograph of Figure 129B. Here there are a number of streamer branches, called impact points, out of which surface streamers, similar to those of Figure 129C but having different lengths, grow radially outward. Such an autograph is produced by the several branches developed in the main streamer that strike the film and are then deflected into the field. A single streamer starting at a point may branch into as many as 40 branches. Figure 129C, taken 1.5 cm away from the point, shows that the number of impact points reaching the film has increased tremendously. The surface tracks or glide streamers they produce have diminished in length however. From this fact, the electrical potential of streamer tips can be estimated. Finally, Figure 129D, taken 2 cm from the point, indicates the enormous number of branches present; most of them have short surface streamers that repel each other. All four autographs were taken with a 30 kV voltage pulse that was well above corona onset but below the spark threshold of 36 kV. At reduced voltages, the manifestations shown by the autographs become continually less pronounced, finally disappearing.

If very intensive streamers strike the cathode, electron emission is produced. This is due to the high electric field in front of the space-charge of the streamer tips approaching the cathode; the emitted electrons are accelerated toward the positive wavefront. If there is ample time and distance, the electrons initiate avalanches and negative streamers. When the current is observed, a pulse is

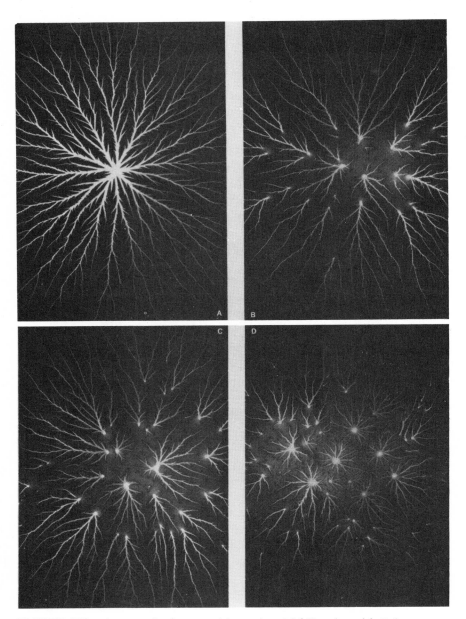

FIGURE 129. Autographs from positive point, 30 kV pulse with 2.5 cm
 interelectrode spacing.
 (a) 0 cm, (b) 1.0 cm, (c) 1.5 cm, (d) 2.0 cm.
 (all courtesy, E. Nasser).

produced when the streamers reach the cathode. A flash of light was also reported when the phenomenon was viewed with the aid of sensitive photomultipliers. A film was placed on the cathode and, depending on the orientation of the emulsion side, either the ionizing processes at the cathode or those emanating from the anode, or both, were recorded. The use of color film shows both phenomena, with radiation coming through the back side exciting the red-layer emulsion and that coming from the front exciting the blue layer. Streamer impact points and tracks are seen in red, whereas cathode phenomena are seen in blue or white because of their high intensity (Figure 130).

Back Figures and Retrograde Streamers

On the negative plates taken at low pressures (Figure 124), a ghost-like structure generally appears behind the sectors. Increase of pressure sharpens the structure of these "back figures"; they change from broad foggy trees to sparks travelling preferentially along the outer edges of the negative primary discharge figures (Figure 131). These sparks of pronounced positive character are soon a dominating factor in the landscape of the surface discharge (Figure 132). They follow the negative sparks and climb like ivy over the negative tree trunks (Figure 133). All the evidence indicates that the back figures are lightning strokes discharging the negative clouds when the transient voltage applied across the electrodes die away. (Figure 134 schematically describes the situation in terms of surface charge and its removal for a typical case such as Figure 132.)

After a rapid building up of the positive charge (cathode fall) by the primary negative figure, a negative spark develops from a preferential point, branches sharply and covers an appreciable area with a new primary figure. The external voltage starts to fall and soon the electrode becomes positive with respect to the negative parts of the cloud. At the point of highest gradient, the return flow of electrons starts with sufficiently intense ionization to create a positive spark. Using the large electron supply available in the negative surface charge, the spark grows rapidly and neutral-

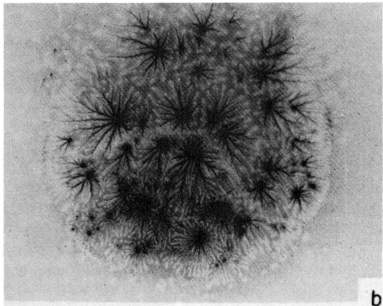

FIGURE 130. (a) Positive print of negative streamers on the cathode just
 below spark breakdown, using a single emulsion film facing
 the cathode (courtesy, W. A. Tiller).
 (b) Negative on a double emulsion film on the same position
 showing the streamers (courtesy, L. B. Loeb).

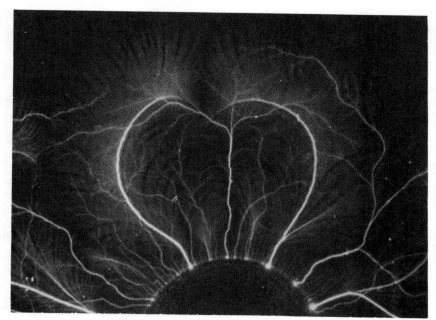

FIGURE 131. Negative sparks with primaries and back-figure sparks (11 atm air, 50 kV) (courtesy, A. Von Hippel).

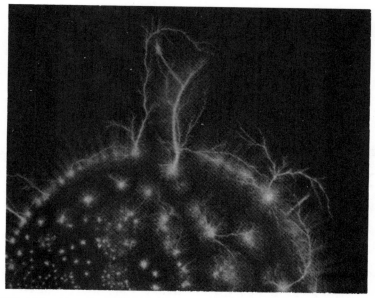

FIGURE 132. Negative primary figure, negative spark and back-figure forming a landscape (16 atm, air, 30 kV) (courtesy, A. Von Hippel).

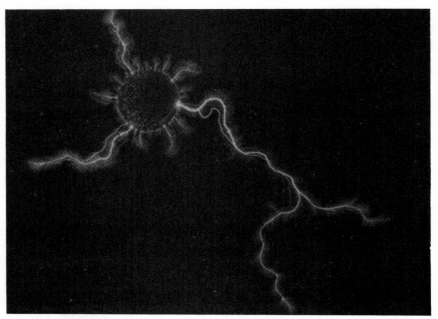

FIGURE 133. Negative sparks followed by back-figure sparks (18.5 atm. air, 50 kV) (courtesy, A. Von Hippel).

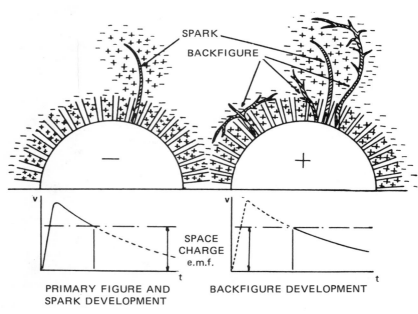

FIGURE 134. Development of the back-figure (courtesy, A. Von Hippel).

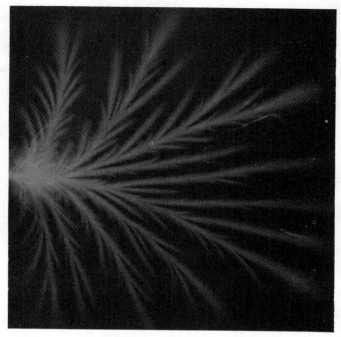

FIGURE 135. Axial autograph at a voltage of 60.4 kV showing the development of a positive retrograde streamer at the right (negative point, 1 atm. air) (courtesy, E. Nasser).

izes the two-dimensional cloud as far as the intensity of the field allows. The final neutralization of the remaining charge is a slow process of local re-combination and conduction.

When the feather discharge (Figure 135) approaches the anode, positive retrograde streamers start to propagate from the positive plane toward the oncoming feathers. (This has been detected by axial photographs and is illustrated in Figure 136.) The lateral extent of the anode action was revealed by placing a film on or near the plane with the photographic emulsion facing the plane. The retrograde streamers emerging from the anode cannot proceed towards the opposite electrode. Instead they strike the film producing patterns similar but not identical to those obtained at a positive point (Merrill & Von Hippel, 1939) (Figure 137). The pattern revealed can take a number of forms that depend on the

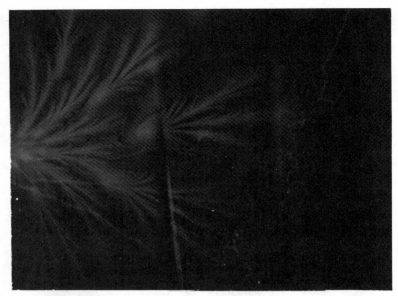

FIGURE 136. Same as Figure 135, showing different stream pattern (courtesy, E. Nasser).

FIGURE 137. Lateral autograph with the emulsion facing the positive plane showing the positive streamers developing from it (negative point, 1 atm. air) (courtesy, E. Nasser).

FIGURE 138. Same as Figure 137, showing a different random pattern (courtesy, E. Nasser).

cross section, number and distribution of the oncoming feathers. If the envelope enclosing the feathers is circular, a circular pattern enclosing the positive streamers is obtained (Figure 137). If the envelope is irregular, its exact image is reproduced on the anode since this is the area where high fields are created by oncoming feathers (Figure 138).

Effect of Electronegative Gases

The influence of electronegative gases on the discharge is helpful for establishing the role played by the positive space-charge. Addition of carbon-tetrachloride vapor to nitrogen changes the structure of the primary discharge figures completely. Not only does the diameter shrink to a small fraction of its initial size but also the fine structure of the positive branches and the sharp

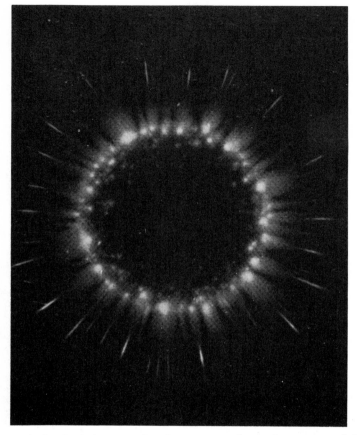

FIGURE 139. The influence of CCl_4 vapor on size and structure of the
primary figures: positive figure in 1 atm. N_2 + sat pressure
CCl_4, 30 kV (courtesy, A. Von Hippel).

division of the negative sectors is lost (Figure 139). This decisive
activity of small admixtures of carbon tetrachloride is easily
understood. Electron impact splits the carbon-tetrachloride mole-
cules into two highly electro-negative components, CCl_3 and Cl.
Both trap slow electrons, thus hindering the start and quenching
the growth of electron avalanches. The negative ions formed
drift slowly through the field like the positive ones, smoothing

out the boundaries of the positive space-charge. No sharp negative sectors appear and, instead of the far-reaching positive branches, only short leaves are formed.

The activity of a suppressor gas (organic vapors are found to be extremely effective) is not constant. The decomposition of the original molecule into electro-negative components, the trapping of electrons by the decomposition products and the release of electrons from negative ions by violent collisions depend on the

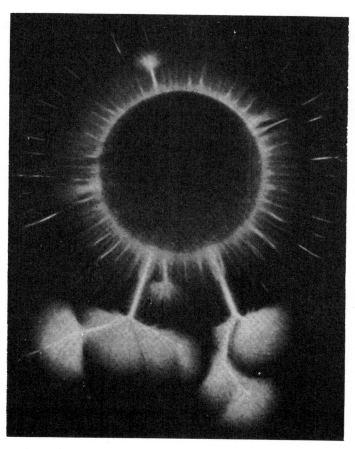

FIGURE 140. Negative figure in 227 mm N_2 + sat pressure CCl_4, 3 kV
(courtesy, A. Von Hippel).

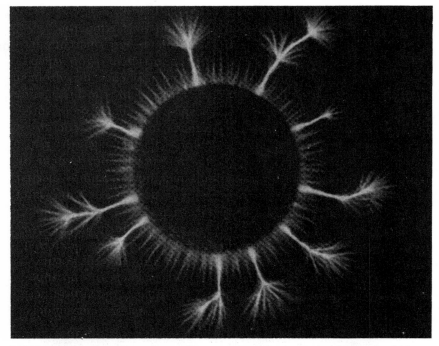

FIGURE 141. Positive primary figure and sparks in Freon (410 mm CCl_2F_2, 3 kV) (courtesy, A. Von Hippel).

character of the gas and the experimental conditions. (Figures 140 and 141 plus Figures 126 and 138 illustrate the altered discharge morphology due to the presence of a suppressor gas for both positive and negative points. In Figures 139 and 140, we note the appearance of radial spikes of enhanced ionization.) In the case of the negative figure, Merrill and Von Hippel (1939) assume that the negative space charge may become so dense that electrons at the outer boundary are projected outwards starting new avalanches. In some cases periodic ring structures are formed by periodically revived ionization. These effects disappear if the electronegative gas is highly concentrated.

The initial breakdown condition is found to be very dependent on the surface condition of the electrodes. Roughening of one

electrode, whether it is positive or negative, reduces the break-down voltage by approximately the same amount. Self-sustaining discharge currents exist before breakdown, decreasing in magnitude with increasing smoothness of the electrode surfaces. Both obser-vations indicate the importance of point discharge created at rough spots on the surface for the final breakdown. (Figure 142

FIGURE 142. Electronic eruptions (7 atm. air + saturation pressure CCl_4 20 kV) (courtesy, A. Von Hippel).

dramatically shows how, at preferential points, the primary figure changes into a spark discharge and, out of this plasma stem, electron clouds are erupted into space. The effects of enhanced oxygen content in the air plus the effect of humidity on point-to-plane electrode discharges are shown in Figures 143 and 144, respectively.)

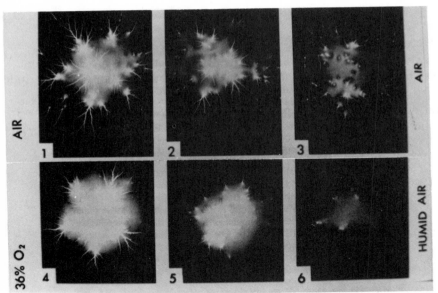

FIGURE 143. Lichtenberg figures at 1, 3, and 4 cm. from a 1-mm diameter point in air with an 8-cm. gap, and in N_2 with 36% oxygen showing the strong suppression in branching and axial range (courtesy, L. B. Loeb).

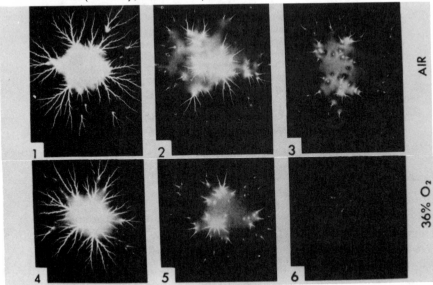

FIGURE 144. Influence of water vapor content on the range and branching of Lichtenberg figures. Upper series for dry air at 2, 3, and 4 cm.; lower series for air saturated with water vapor at 22° C at the same distance (courtesy, L. B. Loeb).

Electrode Polarization Effects

In the last section, a number of results were shown from conventional streamer studies that strongly parallel Kirlian photography studies (Krippner & Rubin, 1974). To complete the picture we must consider the induced electric field in the object under study which arises as a result of the driving field of the electrodes.

When an electric field is applied to an electrode system, two important classes of effects occur: (a) geometry effects and (b) time effects. To consider the first, let us consider what happens when a static electric field, E, is applied between an anode and a cathode. Let us initially assume that they are both smooth parallel surfaces. The application of the field E may produce three effects. (i) The emission of electrons from the cathode which may accelerate and produce a sheath of positive ions at the cathode leading to an enhanced field immediately adjacent to the cathode and a decrease in the region beyond. This is called the cathode fall (Figure 145). (ii) The induction of an additional dipole moment at the surface of electrodes due to polarization forces. This applies particularly to a leaf or to a surface of skin in the applied field. A dipole layer of opposite sign to the applied field is created at the surface and this generates an electrical potential shift on the

FIGURE 145. Buildup of cathode fall by positive space charge development (courtesy, W. A. Tiller).

FIGURE 146. Electrical potential shift resulting from a planar dipole sheet (courtesy, W. A. Tiller).

two sides of the surface (Figure 146). (iii) The cathode fall and the dipole layer combine to influence the electron emission from the cathode. The former enhances the emission while the latter retards the emission.

For a curved surface, the point effect develops and the applied field is accentuated at the curved surface (the field enhancement at the surface will be almost inversely proportional to the radius of curvature of the surface). In addition, for a polarizable material, the induced dipoles in the material will produce a field of opposite sign that will now vary with distance from the surface. The magnitude of the effect will be proportional to the difference in dielectric constant between the material being studied and air. For example, if we consider a spherical dielectric placed in a uniform field (as illustrated in Figure 147A), the applied field will induce an electrical dipole in the material which can be thought to be located at the center of the sphere. The field strength associated with this dipole will fall off the cube of the

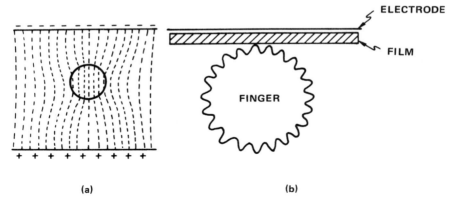

FIGURE 147. (a) Distortion of uniform field due to spherical dielectric.
(b) Illustration of geometrical variations on finger surface which influences field (courtesy, W. A. Tiller).

radial distance from the center of the sphere. Thus, the effective field which is the sum of (a) the applied field, E_a, (b) the shape field, E_s, and (c) the induced field, E_i, will no longer be uniform but may be significantly altered so that streamer formation and the attendant light emission will also be altered by this polarization effect. For two or more such objects, field-line distortion would be such as to create seeming discontinuities between the objects. When one considers the geometrical variations on the surface of a finger placed adjacent to a film-electrode combination (as illustrated in Figure 147B), it should be evident that great field distortion will occur in the vicinity of the film and that the array-like shape of the finger surface may give rise to special effects of a diffraction type nature.

Turning now to the time effect, we must anticipate that the effective dielectric constant of the medium will be a complex quantity which depends on the material properties of both the material being studied and the air gap, the temperature and the frequency of the applied electric field, E_a. Two possibilities exist; in some cases the polarization is in phase with the alternating field; in other cases there is a noticeable phase difference between the two. In the first case, no energy is absorbed by the dielectric from the E.M. field whereas, in the second case, we have a

dissipation of energy in the dielectric (which is called dielectric loss). The dissipated energy per cm² of the dielectric per second is proportional to sin δ where δ is the phase angle between the applied field and the electric current density, i. This phase difference can be due to four different mechanisms: (a) Electrical conductivity, leading to a component of i in phase with E_a, (b) Relaxation effects in connection with permanent dipoles. At low frequencies, the field changes slowly enough to allow the permanent dipoles to reach the equilibrium distribution in the external field before this field has measurably changed. When the frequency of the field exceeds a certain limit, however, the orientation of the permanent dipoles cannot follow the field without measurable lag. This frequency limit is dependent on the chemical composition, the structure of the material and the temperature. In the case of bulk water at 20° C, for instance, there is no appreciable phase difference when the frequency is smaller than 2×10^9 sec⁻¹ (for confined water in membranes, the frequency will be much smaller). For larger polar molecules, this frequency may be reduced by several orders of magnitude. (c) Resonance effects, due to rotation or vibration of atoms, ions, electrons, cells, glands, etc. These effects are noticed in the infrared, visible and U.V. regions, in the neighborhood of the characteristic frequencies. (d) For heterogeneous systems consisting of one or more dispersed phases in a matrix material, the loss angle, δ, is found to be extremely dependent on both the shape and the nature of the particles.

Biological tissues may be represented electrically by an equivalent network which is shown in its simplest form in Figure 148. The

FIGURE 148. Simple electrical model of skin impedance (courtesy, W. A. Tiller).

leaky condenser, which is symbolized by C and R_2, is a function of the polarizability of living tissues due to the properties of the cell membrane. R_1, the internal resistance of the organism, may be measured with a high frequency alternating current when it is found to be small relative to the effective resistance at low frequencies. For practical purposes, therefore, living tissues behave at low frequencies like a condenser and resistance in parallel. During the psychogalvanic reflex, the resistance of the skin drops and this charge can be measured with a direct current. The associated change in impedance depends also upon the behavior of the condenser which is still a subject of dispute. Various estimates of the skin capacitance put it in the region, $C \approx 0.01 - 0.03$ $\mu f/cm^2$ for the skin of the forearm and the hand, and values of R_2 range between 25×10^3 and 10^6 ohms.

In one study (Plutchik & Hirsch, 1963), the impedance of the human skin was found to decrease from approximately 130×10^3 to 30×10^3 ohms as the frequency of the A.C. input increased from 1 to 1000 cycles per second. Over the same range of frequencies, the phase angle, δ, changed from -2 to -58 degrees. In addition, changing the peak to peak current through the subject from 14 to 62 microamperes had no effect on either the impedance of the skin or the phase angles.

In our model of the skin or a plant surface, we must think in terms of a composite system (as illustrated in Figure 149). The

FIGURE 149. Sample physical model of the heterogeneous electrical nature of the skin (courtesy, W. A. Tiller).

inner layer is a reasonably good ionic conductor. The outer layer is quite thin and is of high resistance except in narrow channels of intermediate conductivity at the location of acupuncture points (and perhaps other points). If we consider recent experiments on thin films of mylar polyethylene and polystyrene to which a high electric field has been applied (Swaroop & Predecki, 1971), we find that an oscillatory discharge occurs at fields in the vicinity of 10^6 volts/cm. The current is ~ 1 μamp with a period of ~ 1 sec (depends on temperature). Similar current oscillations occur in germanium (Gurion & Ferry, 1971) and other semiconductors at some critical current (critical field). This effect is probably due to a "streamer" type avalanche process in these solids analogous to that which occurs in gases. We can anticipate that this type of phenomenon may occur in the stratum corneum of the skin surface (especially via the acupuncture channels). In addition, a similar process could occur across the photographic film and might expose the different color layers from internal ionization.

To summarize this section we note the existence of:

Simple geometry (shape) effects which lead to an effect on electron emission, streamer velocity, direction and light intensity.

Array geometry effects — because of superposition effects of the induced electromagnetic fields (acts like an antenna array) one might expect special spiking and diffraction effects at certain locations and certain frequencies.

Simple phase angle effects which lead to a phase angle between the driving field and the induced surface field that depends upon driving frequency.

Heterogeneous surface phase angle effects — at acupuncture points or other points versus normal skin, the phase angle will be different so that the δ-field will have a geometrical character, too.

Other time variation effects — because of carrier trapping in the skin due to current flow through the skin to normal decay procedure, the surface potential and skin conductivity will vary with time (and position) so that δ will be a function of both position and time. We can thus expect to see certain resonant frequency effects and certain twinkling effects associated with moving emission patterns.

WHERE DO WE GO FROM HERE?

To move forward and reliably identify psychoenergetic effects via high voltage photography, we must monitor those parameters of the system that can directly influence the "streamer" process. These are fivefold:

A change in the electrostatic potential, ϕ, of the skin leads to a change in the half-cycle voltage difference between the skin and the driving electrode. Such a change in voltage affects the maximum possible streamer length which determines the width of the corona around a finger tip, for example. Since we know that emotional changes in the human organism can increase the skin potential by up to 500 percent, this effect should be noticed in the corona width and corona brightness.

As a result of mental or emotional state changes in the organism, one may expect to find a change in the surface chemistry of the skin. This effect should give rise to electronegative ion type effects which would alter the morphological character of the discharge. In addition, weak color radiations may come from the excitation of these molecules. It should be noted that small electrical arcs can create hot spots on an electrode as much as 2000° C higher than the ambient temperature; thus, we should not be too surprised if the corona discharge produces a sufficient hot spot to evaporate and ionize organic molecules from biological specimens.

The geometrical induced field effect due both to shape and polarization of the skin surface will lead to certain types of diffraction affects resulting from the spatial and time variation of the dielectric properties of the skin. In order to reproduce and control the "cut-leaf effect" reported by the Soviets (Herbert, 1972; Tiller, 1973), this type of wave interference effect will need to be studied very carefully.

As a result of the driving field on the electrode, we should anticipate some type of resonant energy coupling with the cells of the object. This, in turn, may lead to energy emissions from the cells which could influence the ionization properties of the gas and thus alter the quantitative details of the electron avalanche process.

A change in the electrical impedance of the skin or the surface membrane of a plant will serve to alter the "external circuit impedance" of the electrode system. Since it is the external circuit impedance that largely controls the amount of current flow during the corona discharge, both the light intensity and the film buckling effect (for contact photography) will be strongly influenced by the electrical impedance of the biological subject. It is well-known that this varies quite strongly with change of emotional and mental states.

As a final word of caution, we should recognize the fact that such an electrical discharge is a severe perturbation to the energy states of the biological specimen so that one should not pulse the system too severely and should let it relax and recuperate before repeated stimulation.

In conclusion, I believe it is fair to say that we now know what is the physical process for generating Kirlian photographs. We now know that film buckling is the primary reason for the non-blue or white color in high-voltage contact photography but we also know that it is a non-random occurrence. We also know that we have not been sufficiently careful experimentally in the past but we now know what types of biological effects we are looking for. Thus, now, our search can truly begin!

The Human Energy Field

John Pierrakos

INTRODUCTION

The person is an eternal pendulum of movement and vibration. Humans have attempted, through the ages, to discover and understand their place in the universe. First, they tried to find out who they were by experiencing their own inner pulsatory movements and to become conscious of the world within themselves. Then they attempted to feel and understand the environment around them through their perceptions. These inner pulsatory movements, sensations, and perceptions gave them the experience of being and the consciousness of their person. But what are those inner pulsatory movements? They are the sum total of the processes of life; of all the energies of the metabolism of life within the body. This sum total of energies within one's body also flows out of one's body, in the same manner as a heat wave travels out of an incandescent metal object. They create an energy field made up of lines of force in the periphery of this organism. The human body lives within this energy field which extends several feet away in the immediate vicinity, and at times can be seen traveling several dozen feet out of oneself.

I first became aware of these phenomena, and began to study them, about 20 years ago when introduced to Orgonomy and the observation of the orgone energy accumulators (Reich, 1942). Since then I have combined the observation of these phenomena with my psychiatric practice, and used it diagnostically as well as

checking the flow of energy and removal of muscular blocks, etc. There is intense excitement in attempting to understand life's processes through observing the person's energy field in illness and health, as well as in animals, plants, and crystals. These phenomena can be perceived by a majority of people if their observations are carried out both in a subjective and objective way.

The phenomena of the energy field are to be found recorded over thousands of years in the history of humanity. They were first recorded in approximately 3000 B.C. by the Chinese and expounded in the principle of the yin and the yang. The universe in its dual aspect was perceived as a macrocosm and the person as a microcosm. Chinese cosmology and medicine was based on understanding and working with the principles of bio-energy. Its approach was both animistic and vitalistic but it failed to apply these understandings to the materialistic side of life, and became limited and stagnant. Since 2000 B.C. there has been no development of these concepts.

There is a close relationship and broad general likeness between the yin and yang cosmology and the philosophy of the Egyptians as indicated by the duality of Osiris and Isis, the numerical conception of Pythagoras, Plato's dualism, and the Chrimuz Ahriman of Zoroaster.

If we study the history of symbology, we find that from 1300 B.C. up to approximately 1000 A.D. there has been a universal symbol expressing the sun energy and movement. It originated with the Arians and Greeks. This symbol is the Gamadion and it has been used in variations by several cultures. It originated as an expression, possibly, of the perception of the sun and its rays. But it is actually, in the form of the Swastika, a representation of the movements of the energetic processes of the energy field of man, as confirmed in my own observations of the movement of the field.

There are many indications, in the ancient Greek culture, pointing to the fact that there was knowledge and understanding of the energetic processes in nature and in humans. For instance, Hippocrates shows, in his writings, strong faith in the cosmic influences and weather rhythms on distempers. He also recom-

mended that physicians should not be ignorant of the natural forces because "nature heals and not the physician."

With the advent of a Byzantine theocracy, medicine and natural investigation were greatly stifled. The periods between the third and, approximately, the tenth century, in the West, were the Dark Ages. Around the 16th century, we find, in the work of Paracelsus, the study and application of the natural energetic processes. Paracelsus talked about the harmony of the four elements and about the existence in the organism of a natural force called "the archeus, the ancient one" who heals illness.

In the modern era, the first known scientific attempt to understand living systems in their natural milieu was made by Newton (1729). In his second paper on light and colors, he speaks of an electromagnetic light, "subtle, vibrating, electric, and elastic medium," that was excitable and exhibited phenomena such as repulsion and attraction, sensation and motion. Newton's concepts anticipated in many ways the electromagnetic field of Faraday and Maxwell.

Mead (1712) made an attempt to place living systems under the laws of the Newtonian principles. His theory on atmospheric tides (which are caused by the gravitational effects of the sun and moon and cause periodic shifts in the atmospheric gravity, elasticity, and pressure) is that these tides acted as an "external assistance" to the "inward causes" present in animal bodies. Mead spoke about "a nervous fluid with electricity."

Mesmer (1779) called this force "animal gravitation" and, later, "animal magnetism." He described this medium as filling celestial space and believed it capable of acting on the nervous system of animate forms directly. Later, the famous German chemist, Baron Von Reichenbach (1851) made a detailed study of the energy field of crystals, animals, and plants called the energy field the "odylic fluid." Mesmer's work, though rejected by the prevalent medical circles of his time, had a profound influence in European medicine. It came to the forefront as hypnotism in 1860 when Liebaut founded his clinic at Nancy. Bernheim and Charcot, in their respective schools, used hypnotism and suggestion for treatment.

The discovery of the unconscious mind, upon which Freud's psychoanalysis is based, was revealed with hypnotic techniques. Freud was a pupil of Charcot and a co-worker of Bernheim. Freud's concept of the libido, even though not followed as a purely energetic principle, was based on the understanding of the vital energetic processes of the organism. The physical investigation of the energy field followed very slowly. In 1910 to 1920, a London physician named Kilner (1912) objectively investigated the energy field, which he called the aura of "human atmosphere," by means of colored screens. His book is a wealth of information on the charges and variations of the energy field of humans.

It was Wilhelm Reich who, over a period of 25 years beginning in 1925, conducted a systematic, detailed, and thorough study into the phenomena of the energy field of the person and of nature. Reich (1942) named the specific energy of the vital processes "orgone." His work in the psychoanalytic and biological fields, and in cosmic engineering, has been of great importance in understanding the position of humans in the universe. Reich was a prophet of the profound changes occurring in our culture today as well as those coming with the dawn of the new century. Reich's energy concepts in therapy (1949) were amplified and expanded by Alexander Lowen (1958, 1967) and this writer. Dr. Lowen and I developed specific techniques in working with the energetic system of the organism as a whole and grounding the energy flow of emotions in the feet. It was by application of these bioenergetic concepts on my patients that I have had ample opportunity to study the movements and variations of the energy field of the person.

In the United States, H. S. Burr (1956) conducted a detailed study, in the biological domain, of the vital energies of organisms. He felt that there must be some force behind the living organisms in their ability to organize, direct, and hold together the complex chemical interchanges which accompany biological processes. He has published a great number of articles dealing with fields in primitive organisms as well as in trees and animals (Burr, 1972; Burr & Northrup, 1939). This work was facilitated by the development of specific instruments measuring minute voltage differences.

This work has been continued, in the study of emotional illness, by Leonard Ravitz (1962). He also conducted extensive experiments on the states of excitation of the human organism in relation to neurotic states, hypnotism, sleep, and drugs, finding that significant changes occur in the person's electrodynamic field (Ravitz, 1970).

In England, Kilner's work was followed independently by George de la Warr (1967). He developed specific apparatus for studying the vital processes of man and plants.

A DESCRIPTION OF THE NATURE OF THE FIELD

In nature there are several groups of unicellar organisms such as bacteria and fungi, and also multicellular structures such as flagellates, sponges, fish and fireflies that are able to emit light and "luminate" as the result of their inner movements and biological processes. In higher organisms, it is known that vital processes such as mitosis of cells, oxidation, and other metabolic processes are accompanied by luminescence. Living organisms are able to emit light through the entire surface of their bodies; they have not lost their ability to luminate. This phenomenon constitutes the energy field or "aura," which is, in effect, a reflection of the energies of life processes. (Aura comes from the Greek "AVRA" which means breeze.) The aura, or energy field, is a light cast of the body energies. Energy comes from the word "energeia" which means to produce movement or work. A more functional definition is that "Energy is the living force emanated by consciousness." Consciousness was previously related to perceiving oneself through the inner pulsatory movements expressed, on the surface, as the energy field.

Field phenomena are related to the energy metabolism of the body, its production of heat, emotional excitement, rate and quality of breathing, activity, and rest. They are also affected by atmospheric conditions, relative humidity, polarity of charges in the air, and many other unknown factors.

If one could see this luminous phenomenon around the body, which exists also in the space between people, one would perceive that humans swim in a sea of fluid, tinged rhythmically with

brilliant colors which constantly change hues, shimmer, and vibrate. For being alive is to be colorful and vibrant.

The field phenomena belong to another dimension. They are energetic phenomena that transcend the physical realities of matter and, even though they are tied up with the structure and matter of the body, they have their own laws of pulsatory movement and vibration which are not yet understood.

From my own observations, I have found that when a person stands against a homogeneous background, either very light (sky blue) or very dark (midnight blue), and with certain arrangements so that there is a softness and uniformity in the light, one can clearly see, with the aid of colored filters (cobalt blue) or with the unaided eye, a most thrilling phenomenon. From the periphery of the body arises a cloud-like, blue-gray envelope which extends for two to four feet where it loses its distinctness and merges with the surrounding atmosphere. This envelope is brilliant and illuminates the periphery of the body in the same way as the rays of the rising sun light up the fringes of dark mountains. It swells slowly, for one or two seconds, away from the body until it forms a nearly perfect oval shape with fringed edges. It remains in full development for approximately one-quarter of a second and then, abruptly, it disappears completely. It takes about one-fifth to one-eighth of a second to vanish. Then there is a pause of one to three seconds until it reappears again to repeat the process. This process is repeated 15 to 25 times a minute in the average resting person.

The envelope is roughly divided into three layers. First there is an inner, dark, blue-black layer of approximately one-fifth to one-eighth of an inch. Second, there is the middle blue-gray layer of about three to four inches. The third is an outer sky-blue layer of about six to eight inches

Attempting to describe the exact consistency and features of these three layers is extremely difficult. The first, or inner layer, can be seen only when the observer is close to the subject, about two to three feet away. It is completely transparent and looks like an empty, dark space. It has a crystaline-like quality and its true color is on the border line of ultra-violet and violet in the

spectrum. It can be seen best against a dull, black background and appears to reproduce the form of the body in space.

The second, or intermediate layer, is a complex one to describe as it is made up of a multiple of shapes and forms. It starts at the outer boundary of the inner layer and is clearly defined. Its overall color is blue-gray and it is brilliant, especially around the head. It has, primarily, three patterns of movements. First, there is a wave-like form which homogeneously fills the whole layer to its extremes; like ink on blotting paper. Second, there is a corpuscular movement similar to those seen under a microscope in smoke particles: the so-called brownian movement. Third, there is a linear movement in the form of white or yellow rays that commence at the inner border of the intermediate layer, travel its whole width and extend several feet away from the body into space, almost reaching the walls of the room. In spite of this outer movement, the intermediate layer is dominated in the trunk and extremities by a wave-like movement that moves distinctly along the surface of the body. Its overall appearance is that of a blue, shimmering liquid, extremely rarified, but brilliant. The impression gained is that of a stream of fire-flies extinguishing their glow at rapid intervals and progressing simultaneously in the same direction. The ray-like movement is dominant and very brilliant around the head where it forms a fringe-like effect. The pattern and outline changes with every new pulsation of the organism in the same manner as when the aurora borealis fires towards the sky, in rapid succession, brilliant streamers. Usually, the ray-like movement is perpendicular to the surface of the body.

The third, or outer layer, is six to eight inches wide, but, in an open space, it expands several dozen feet away. And, near the shore it has been seen to extend as far as 100 feet from the person emanating such energies. It has an indefinite inner body commencing at the outer boundaries of the middle layer. It is very thin, practically transparent, and has a delicate sky-blue color. It is also transversed by the vertical rays which commence in the middle layer. The predominant movement of this layer is spiral or vortical. It appears as though the particulate of brownian-like movement of the second layer, finding greater space, expands

in all directions in the same way as compressed gas molecules are allowed to expand by increasing the volume of the container. The outer boundaries of the third layer become so diffused that its margins are lost in the surrounding air. Its general direction of movement is perpendicular to the surface of the organism.

The direction of movement of the three layers, which as far as I can see move simultaneously, is somewhat complicated. Facing the subject we can clearly perceive the energy field on the sides of the trunk, head, arms, and legs. We observe then that the field moves from the ground up on the inner side of the legs and thighs, up the trunk and the outer side of the hands, forearms, and arms; and the two main streams meet and travel upwards towards the neck and over the head. This is phase one of the movement. At the same time there is a movement on the inside of the trunk towards the ground. This is phase two. It is interesting to note that there is an alternating upward and downward movement in each half of the body; each half has a simultaneous upward and downward flow. The streams join at the root of the neck and travel to the opposite half of the head. The alteration in the direction of movement of the field is represented in the alternate shifting in the two halves of the body, as when walking or running, and changing one's place on the surface of the earth. Both these alternate phases of the field fuse in the middle line of the body longitudinally. Thus, upon observing the field while the subject stands in profile, we see that the field pulsates from the mid-section, located in the area of the vital organs, towards the head and feet simultaneously in both the front and the back sides of the body. The assumption is made here that there must be a multitude of movements of the field inside the body, engulfing the body as well as the vital organs, such as the heart, lungs, liver, and the intestines, in a spiral motion. This is supported by the shape of these organs and their spontaneous twisting and turning movements.

However, if we compare the human organism with a flexible cylinder, we see that there can be basically two kinds of movements; one along its longitudinal axis, another along its diameter. All other movements are resulting forces of these two main directions. The longitudinal movement, if applied against the

supporting base of the cylinder, can move the cylinder from one place on the surface of the earth to another. This is done, in the human body, in walking and moving. The movement along its diameter can be towards the center or away from it. And, if they are flexible, it can inflate or deflate the walls of the cylinder. This type of movement has to do with the phases of expansion and contraction of the body. This primordial movement is of utmost importance in primitive organisms such as the amoeba. In man, both movements are an expression of each other. The longitudinal movement keeps the body erect, the transverse makes the organism expand and contract. These principles have been described by Lowen (1958).

According to my observations, the energy field is in almost constant movement. There is a basic longitudinal movement in the core of the human cylinder emanating from the vital organs as the field moves upwards towards the head or downwards towards the feet. It also rapidly permeates, in a radial fashion, all the tissues irrespective of anatomical configuration, and reaches towards the periphery of the body. It then passes the skin and excites the surrounding atmosphere, creating the visual perception of the phenomenon of the energy field with its three layers. What we see, actually, are the changes in the surrounding atmosphere in the same way that we observe steam rising above boiling water. The steam molecules are of the same nature as the boiling water; only of different status, which is gaseous. In the same manner, the energy field seen in the envelope surrounding the human organism is a modified form of the energy flowing inside the body. By studying its characteristics, we can find out its true movement, composition, and consistency and the changes that occur in pathological conditions or in the simple processes of life with its variations. The energy field is actually a reflection of the multitude of energies moving and expanding in all directions within the living body.

One can say that the general basic forms of the movement of the field are the following.

1. If the organism is standing and in full-form the field has the shape of a swastika or an elongated figure eight.

2. If the organism is presenting a side view or profile, the field
 has roughly the shape of a kidney bean.
3. There are spiral movements fusing the two halves of the
 body, and the two halves of each organ.

In summary, it can be said that all living organisms are
surrounded by a radiating luminous envelope which pulsates at a
specific rate and which has specific layering, hue, and structure
depending on the species and the states of that organism. This
envelope is actually a light cast of another body of energy which
penetrates the physical body and spreads its luminous radiations
outwards in the periphery and is perceived as the energy field, or
aura, of that organism. The energy field is also formed by the
many physical energies of the cells, the organs, and the functions
of the body which are characteristic of life.

As for its nature, it is very sensitive and responds to emotional
and physical states and has specific characteristics in illness and
health. People affect each other's energy field since the field
constantly surrounds us and contacts the field of the neighboring
person or groups of people. We are living in each other's field
when we are in close proximity. The field pulsates from 15–25
times a minute in humans at rest, and extends several feet away
from the periphery of the body. The physical body mirrors what
is happening in the energy field. The physical body seems to
reflect the state of energy field which shows, many times,
pathological changes which become structural at a later date in
the organs and tissues.

Experimental Measurements of the Human Energy Field

9

Richard Dobrin, Carl Kirsch, Sander Kirsch,

John Pierrakos, Eric Schwartz, Theodore Wolff,

and Yuval Zeira

Many observers have reported seeing an envelope of radiation or field surrounding living organisms. In order to determine whether any of these radiations are measurable by currently available instruments, a comprehensive evaluation of promising methods of detection was undertaken. As a result of this study, it was decided to use a highly sensitive photomultiplier tube because it stood the best chance of detecting this radiation.

The following is a report of work in progress by the Energy Research Group of the Institute for Bioenergetic Analysis. Photomultiplier tubes were used as energy field detectors. A photomultiplier is a device which responds to extremely small quantities of light by producing a measurable amount of electrical charge. The amount of charge produced is proportional to the amount of light incident upon the tube.

A tube was utilized which responds to light in the visible and ultraviolet, but not in the infrared.* The lack of sensitivity to the

*Methods used to rule out the effect of infrared included: special construction of the phototube's spectral response; calculations of the amount of black body radiation in the spectral response range of the phototube; examination of subjects in passive vs. active states; examination of experimental subjects vs. control subjects; examination of control subjects in similar active states as the experimental subjects; investigation of different heated objects in the temperature range of 30° C to 95° C next to the phototube.

infrared ruled out heat effects; the very high sensitivity in the visible and ultraviolet allowed the examination of the color spectrum reported by many observers. Our program was to use this photomultiplier tube to quantitatively analyze the intensity, the optical frequency spectrum (color range), time dependence (pulsation rate), and spatial distribution (shape).

The photomultiplier is mounted in a light tight room. (Figure 150 is a schematic representation of the experimental setup.) The subject stands in front of the tube. The remainder of the electronic apparatus is located in the laboratory adjacent to it, and is coupled to the photomultiplier through a junction box. The output of the photomultiplier is measured by a Kiethley electrometer and is recorded on an X–Y recorder, producing a graphic record of the phototube output. The chopper is an electronic switch that allows us to record the signal for a predetermined period of time. The high voltage supply powers the photomultiplier.

FIGURE 150. Schematic representation of experimental setup (courtesy, R. Dobrin).

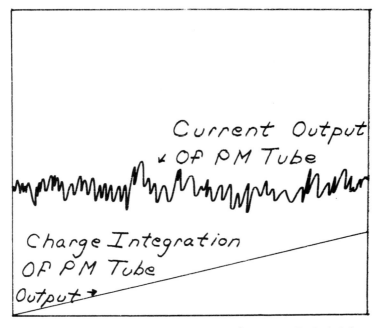

FIGURE 151. Sample, recorded data (courtesy, R. Dobrin).

A major difficulty encountered when a photomultiplier is used to measure extremely low light levels is the inherent internal noise generated by the tube. The charge generated by the noise is of the same order of magnitude as the charge generated by the measured signal. Therefore, the resultant charge generated in any given time period is the sum of these two charges.

The top line of the recorded data (Figure 151) is a recording of the current output (the instantaneous charge output per unit time) of the phototube over a period of time. This current exhibits marked fluctuations and thus makes it difficult to differentiate between signal and noise. In order to accomplish this differentiation, we integrated the signal using the Keithley in the coulombmeter mode. Integration is the summation of the charge output of the tube over a given period of time, as determined by the chopper. The lower line (Figure 151) is a graphic recording of the integrated charge. By dividing the total charge at the end of the integration interval by the integration time, we obtain the

average current for this integration period. By comparing the current with and without the subject in front of the tube, we can calculate the signal produced by the subject alone. Using the known spectral response and gain of the phototube, we are able to calculate the number of photons emitted by the subject which strike the active area of the phototube.

Utilizing this method we have been able to measure the light output of an experimental subject. The level of this light is exceptionally low and is in the range of 50 to 220 photons per second as recorded at the photocathode. This represents an average signal of approximately 10 percent above the background noise.

The percentage increase of the signal above the background noise in nanoamps was computed in three separate experiments (Figure 152). However, in some individual interaction periods the subject was able to give an increased signal as high as 67 percent above the background noise. Each series of measurements was preceded and followed by measurements of the background noise. These indicated stability of the background noise so that the increases of the signal with the subject present are statistically

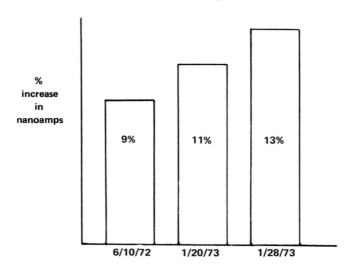

FIGURE 152. Percentage comparison, PM tube output for experimental subject vs. empty room in three typical experiments (courtesy, R. Dobrin).

significant. In addition, the increases in the signal coincided with the subject's attempts to increase his energy field and his verbal descriptions of his perception of these increases.

In order for us to examine the fields emanating from the upper portions of the subject's body, he or she stands in the darkroom without clothing from the waist up. When the subject does not attempt to increase the energy field, there is a definite increase in signal which is smaller and more difficult to separate from the background noise.

Some other individuals have exhibited similar characteristic increases but of smaller magnitude. All these individuals were without clothing from the waist up in order to avoid signals resulting from static electricity discharges and fluorescence of dyes.

The spectral response of the photomultiplier tube was analyzed (Figure 153). This analysis indicated that the tube is insensitive

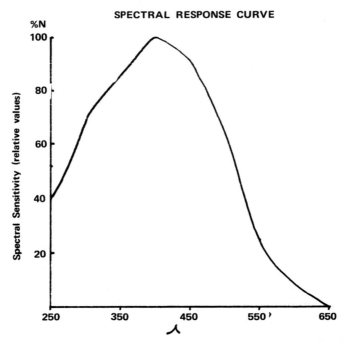

FIGURE 153. Spectral response curve, photomultiplier tube (courtesy, R. Dobrin).

FIGURE 154. The black body spectrum at human body temperatures
(courtesy, R. Dobrin).

to wavelengths greater than 6500 Å, which is still in the visible
red region. Thus the tube does not respond to infrared.

The black body spectrum at human body temperature can be
graphically displayed (Figure 154). It peaks at 9.6 μ; the visible
regions begin at 0.6 μ, and the black body intensith has fallen
tremendously at this point. The intensity of energy at the peak
of the black-body spectrum, per unit of wavelength is

$$\frac{\partial I}{\partial \lambda}\bigg|_{\lambda = 9.6\mu} = 0.003 \text{ watts/cm}^2\mu \qquad (1)$$

This energy intensity has fallen tremendously by the onset of the
visible spectrum, and the total energy of the blackbody radiation
between 0.4 and 0.6 may be estimated as

$$\Delta I\bigg|_{0.4-0.6\mu} = \frac{\partial I}{\partial \lambda}\bigg| = \lambda 0.5\mu = 10^{-34} \text{ Watts/cm}^2 \qquad (2)$$

This energy/unit area may be used to calculate the total energy
output of a human body from thermal radiation, in the visible
region. Assuming 1 m^2 of skin area, and the emissivity of human
skin to be 0.8, the result is 10^{-34} watts $\approx 10^{-14}$ photons/sec.

A schematic representation can be made of the phototube
output (Figure 155). As previously mentioned, only certain

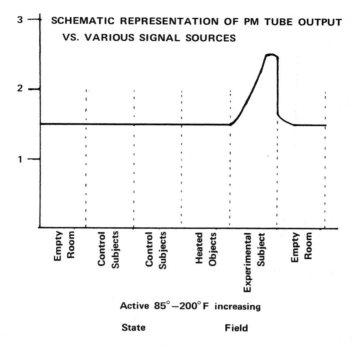

SCHEMATIC REPRESENTATION OF PM TUBE OUTPUT VS. VARIOUS SIGNAL SOURCES

FIGURE 155. Schematic representation, output of PM tube vs. various signal sources (courtesy, R. Dobrin).

individuals were able to produce a signal from the photomultiplier tube. Others, whom we will call infrared control subjects, were unable to effect the output of the tube when standing passively in front of it. The experimental subject has to voluntarily increase his field in order to achieve a maximum signal. One does this by deep breathing and by small vibratory movements of one's body. When the infrared control subjects use the same active techniques, there is no increase in signal. Thus not only infrared, but also movement, vibrations, static charge, and skin fluorescence are ruled out as causes for the experimental subject's signal increase. (The other individuals who gave a small increase in signal are not represented in this figure.) Different inanimate objects, with similar emissivity as human skin and heated to varying temperatures from 30° C to 90° C, do not increase the phototube output

(Figure 155). This rules out radiant heating of the phototube cathode, as well as infrared, as a source of the increased signal when the subject is present.

Since the signal is so small, minute light leaks in the darkroom could easily affect the results by reflection off the subject when he or she moves. The darkroom was scanned multiple times with the photomultiplier tube and a few small light leaks were discovered and sealed. At this juncture, the photomultiplier tube does not show any measurable light leaks.

The darkroom temperature is constantly monitored remotely using a Yellow Springs telethermometer and the darkroom can be vented and cooled. The temperature fluctuations are less than 2° C. These fluctuations in room temperature give a negligible increase in dark current.

The work done to date indicates strongly that a human being radiates a field that can be detected by a phototube. Our knowledge of the properties of this field needs to be expanded further. At present we are measuring this field predominantly in the region of the chest and abdomen. A goal of future work is to determine the spatial distribution of this field using scanning techniques.

Also, we are presently performing computer analysis of instantaneous and integrated data. Since the energy field has been reported to pulsate at a rate of 20 to 40 per minute, this analysis will allow us to determine whether or not this pulsation rate can be extracted from our data. We also intend to approach this problem utilizing pulse counting techniques.

Various optical filters are currently being utilized in a preliminary spectral analysis. The results appear to be a promising way to determine the spectral distribution of the field. However, due to the variability in the intensity of the subject's field, we will need a second photomultiplier tube as a control. This will enable us to calculate the percentage of transmission through the filters irrespective of fluctuations in the intensity of the source.

As mentioned before the observed signals from the experimental subject are of the same order of magnitude as the noise. Certain other subjects exhibited similar increase but of smaller magnitude.

On this basis we contend that a signal could be obtained from any person if the inherent noise of the system could be reduced. A well-known method for reducing this noise is to cool the phototube. We have obtained a commercially available cooling housing which we have modified. Preliminary tests of this show a significant reduction of the noise. In order to better differentiate the signal from the noise another method currently under consideration, which is used in low light level astronomy, is a system that uses amplification, discrimination and differential signal averaging for noise reduction and signal enhancement.

When the capability to record the field, including its spatial, spectral, and intensity distributions is fully developed, we will simultaneously correlate our observations with those of individuals who can directly observe this field.

In summation, the work being done by the Energy Research Group of the Institute of Bioenergetic Analysis has conclusively shown that some portion of the human field lies in the visible and ultraviolet spectrum. This represents the first quantitative measurement of this phenomena in its natural state. This evidence opens up a whole new field of exciting research in basic human energy processes.

10 Acupuncture and Moxibustion in Traditional Chinese Medicine

Lok Yee-Kung

Acupuncture and moxibustion, originating in China, are two methods for curing physical and mental illness. Both techniques have one factor in common: the cure is accomplished by stimulating, either separately or simultaneously, one or more of a very large number of specific points on the human body.

Acupuncture is the name given to the process of piercing the skin at these points with a sharp needle. The needle is inserted to a predetermined and controlled depth, with specific manipulations, for a definite length of time.

Moxibustion is the name given to the stimulation of the points by the application of heat; pellets, sticks, or rolls of dried mugwort (or moxa) are the usual sources of heat. This technique also involves specific procedures and a definite length of time for the application.

Although these two procedures are by far the most effective methods, they are not the only therapeutic actions which can be carried out on the body points. Massage is another procedure which is utilized in traditional Chinese medicine.

HISTORICAL PERSPECTIVES

The first written reference to acupuncture occurred in the *Nei Ching* (Veith, 1970), written at least 2,500 years ago. This classic masterpiece is a summary of the knowledge in ancient

China concerning anatomy, physiology, pathology, and the diagnosis and treatment of disease. It contains a detailed description of the techniques of acupuncture and moxibustion as well as rules and advice for the practitioner. Even at that early date, 365 body points had been located, tested, and listed.

The *Nei Ching,* also known as *The Yellow Emperor's Classic of Internal Medicine,* represents the result of centuries of painstaking research and clinical recording. This book, which includes specifications for nine different types of metal acupuncture needles, mentions that stone needles were the first to be used. These stone needles, or "pien shih," would indicate that acupuncture was already being practiced during China's New Stone Age, some 4,000 years ago.

At Chow-Dow-Dien, near Peking, where the bones of Peking Man were discovered, needles made of stone and polished animal bones were also located. As Peking Man is estimated to have lived over 500,000 years ago, it may be that the origins of acupuncture go far back into human pre-history.

In the years of the Chou dynasty (1122 to 249 B.C.), the use of copper and iron was developed in China. The stone, bone, and bamboo acupuncture needles were gradually replaced, first by copper and then by iron needles. Later, silver and gold alloy needles were used; today, stainless steel needles are generally utilized.

Acupuncture is referred to in many ancient Chinese books. One early volume records a cure of coma by acupuncture, the needle being directed to a point at the top of the patient's head. In about 250 A.D., Huang Fu Mi, a physician, wrote the *Chia Yi Ching,* or *Introduction to Acupuncture and Moxibustion.* During the Tang dynasty (618 to 907 A.D.), schools were founded and examinations instituted for education in Chinese medicine. It was in 1021 A.D., during the Sung dynasty, that two bronze figures were cast, each having all of the points known at that time. These figures were used to teach acupuncture and moxibustion.

These arts continued to be developed during the Ming dynasty (1368 to 1644 A.D.). In 1669, China signed its first treaty with a European nation; in the contact which followed, traditional Chinese medicine began to die out in favor of Western methods.

European physicians emphasized the imbibing of drugs and potions to cure illness. Furthermore, the emperors decided that it was disrespectful to puncture royal bodies with acupuncture needles.

At present, the techniques of acupuncture and moxibustion are stimulating interest and regaining respect. In part, this is due to the adherence to traditional Chinese medicine held, over the years, by the acupuncturists in Hong Kong.

AILMENTS RESPONDING TO
ACUPUNCTURE AND MOXIBUSTION

Acupuncture and moxibustion are both very ancient arts of healing. However, as time progresses, new knowledge is continually being acquired for the cure of additional diseases. Consequently, it is difficult to give a precise list of all ailments which are curable by these methods.

In the present stage of practice, cure by acupuncture and moxibustion is regarded as resulting from a restoration of the body's physiological balance. Therefore, these techniques are useful for ailments concerning nervous disorders such as sciatic neuralgia, trigeminal neuralgia, and various types of neuralgia centered in the head, chest, loins, and limbs. Most of the patients afflicted with these diseases begin to feel an alleviation of their pain after a few treatments. Some patients suffering from sciatic neuralgia are even cured of their malady immediately after the acupuncture needle is removed.

Good results can also be obtained by acupuncture and moxibustion with regard to sensory or motor dysfunction caused by diseases in the central or peripheral nervous system. These would include facial paralysis, oculomotor paralysis, paralysis of the nervus radialis and nervus ulnaris, and hemoplegia caused by cerebral hemorrhage. However, cavitary and sclerosing myelitis have not been found to respond to acupuncture or moxibustion.

Results with regard to the treatment of beriberi are satisfactory. Symptoms of rheumatism and radicular neuritis (e.g., pain, cold, numbness, hypersensitivity, formication) can also be treated with

good results. Most cases of nervous functional disease—hysteria, diaphragmatic spasm, nervous vomiting, neurogenic stuttering—can be successfully treated. Patients suffering from neurasthenia can be quickly or gradually cured of such symptoms as headaches, dizziness, insomnia, tinnitus aurium, constipation, nightmares, and impotence.

Acupuncture and moxibustion can bring relief to most patients suffering from bronchial asthma. Acute gastro-enteritis can be cured within a short period of time. These methods are effective in treating gastro-spasm, neurogenic esophagism, and uriesthesis. In addition, acupuncture and moxibustion can be highly efficacious with regard to irregular or painful menstruation.

AIMS OF ACUPUNCTURE AND MOXIBUSTION

The aim of acupuncture is to restore the natural harmony to a system in imbalance.

Moxibustion is similar to acupuncture in that it produces effects which result in improved blood circulation, increased body resistance, better digestion, and the elimination of inflammation. For example, it achieves remarkable results in curing inflammation of the pleural membrane; it can also be used for lymphadenitis. Moreover, it produces special curative effects in the treatment of pain, muscular jerks, indigestion, constipation, gastritis, bronchitis, and rheumatic arthritis. The importance of moxibustion in medicine cannot be overestimated.

However, acupuncture and moxibustion are not panaceas. These methods can only be used as a supplementary aid in the curing of acute diseases such as typhoid, cholera, and pneumonia. There are other cases such as difficult labor in childbirth, appendicitis, and tumors, where surgical intervention may be necessary. The use of acupuncture, moxibustion, surgery, and other forms of medicine must be used according to the nature and degree of the illness.

Although many chronic ailments of children can be treated by acupuncture, the needles often frighten them. It is easier to treat

them with moxibustion when they are asleep. In acute gastric catarrh, vomiting makes it difficult for medicine to be ingested; here, acupuncture and moxibustion can be used to stop the pains and vomiting almost immediately, and then medicine can be taken to speed up healing of the stomach. However, in meningitis and pneumonia, the injection of medicine into the system will promote a more rapid recovery than with acupuncture treatment. Therefore, the method which is most effective for the patient and the illness should be used. Acupuncture and moxibustion cannot be applied alone for every type of disease.

Acupuncture Analgesia: A Six-Factor Theory

11

John F. Chaves and
Theodore X. Barber

During recent years, physicians from the United States, Canada, and England, have visited China and have observed the successful use of acupuncture to relieve surgical pain (Brown, 1972; Capperauld, 1972; Capperauld, Cooper, & Saltoun, 1972; Dimond, 1971; Hamilton, Brown, Hollington, & Rutherford, 1972; Jain, 1972a; 1972b; Shute, 1972; Tkach, 1972). These eyewitness accounts have produced widespread interest in acupuncture analgesia as indicated by many discussions in the popular press and also by a series of papers in medical journals (Chisholm, 1972; Liu, 1972; Mann, 1972; Matsumoto, 1972; Taub, 1972; Toyama & Nishizawa, 1972).

At least part of the interest seems to be due to the implication that Western medicine cannot explain the efficacy of acupuncture in attenuating pain during surgery. The dramatic successes claimed for acupuncture seem to imply that Western science has failed to delineate important factors that pertain to the nature of pain and its control. We do not accept these implication. On the contrary, we believe that six factors which are already known but usually overlooked by Western medicine can help explain the success of acupuncture in relieving surgical pain. Three of these factors are:

(a) The patients who are accepted for surgery with acupuncture strongly believe in its efficacy and are not fearful or anxious;

*Work on this paper was supported by a research grant (MH-19152) from the National Institute of Mental Health, U.S. Public Health Service.

(b) With few exceptions, narcotic analgesics, local anesthetics, and sedatives are also used, singly or in combination, during surgery with acupuncture; and

(c) The pain normally associated with many surgical procedures is less than is generally assumed. Three additional relevant factors are that

(d) The patients are typically exposed to special preparation and indoctrination for several days prior to surgery,

(e) The acupuncture needles distract the patients from the pain of surgery, and

(f) Suggestions for pain relief are present in the acupuncture situation.

After we have briefly described the technique of acupuncture, we shall discuss each of these six relevant factors. Also, towards the end of the paper, we shall briefly discuss two popular theories of acupuncture—the traditional Chinese meridian theory and the more recent gate control theory.

TECHNIQUE OF ACUPUNCTURE

Although the use of acupuncture to treat specific illnesses such as arthritic disorders and gastrointestinal diseases goes back at least 5,000 years (Veith, 1972), its use to relieve the pain of surgery is very recent. In fact, the Chinese started using acupuncture to produce analgesia in surgery in 1959 and its use has accelerated since 1968 (Capperauld, 1972; Hendin, 1972).

During the 14 years that acupuncture has been used for surgical analgesia, the thin needles have been typically inserted at points that are remote from the location where analgesia is desired. For instance, when a gastrectomy is performed, four acupuncture needles are placed in the pinna of each ear. The needles are usually inserted only a few millimeters and rarely inserted more than two centimeters beneath the epidermis. Moreover, they are commonly placed in innocuous locations such as in the limbs or the pinnae, remote from major organs, blood vessels, or nerve trunks. When acupuncture is used for surgery, the needles are not simply

inserted; instead, they are either twirled and vibrated by the acupuncturist, or electricity is applied to them. Typically, continuous electrical stimulation is applied to the acupuncture needles from a 6- or 9-volt battery at a frequency of 120 to 300 cycles per minute, beginning about half an hour before and continuing throughout the operation (Dimond, 1971; Jain, 1972a). However, it is important to note that electrical stimulation does not appear to be essential to the success of acupuncture analgesia since many surgical procedures are performed using only manual stimulation of the needles.

It is generally assumed that if the acupuncture needles are inserted in the appropriate locations and are either twirled manually or electricity is applied to them, sufficient reduction in pain is produced so that the patient can tolerate major surgical procedures. Since the reduction in pain has been attributed to the effects of the needles, little attention has been focused on six other factors, to which we now turn, that may account for the apparent analgesia that is found in the acupuncture situation.

Strong Beliefs and Lack of Anxiety

The widespread assumption that acupuncture is routinely employed with surgical patients in China is false. The chief delegate of a group of Chinese physicians who visited the United States in the Fall of 1972, expressed concern "lest the Americans misunderstand (acupuncture analgesia) as an established, standard technique in China" (Anon., 1972). Observations by Dimond (1971) indicate that, "The decision to use acupuncture anesthesia depended on the full enthusiasm and acceptance by the patient." Patients who are anxious, tense, or frightened are given general anesthesia. Surgeons typically select patients for acupuncture according to the following criteria: "They decide whether the type of operation would be suitable, whether the patient would be too hysterical, whether the patient believes firmly in Mao's teaching, or would Mao's teaching carry him through" (Warren, 1972). Since general anesthesia is available for surgery in China, the motivation to

forego general anesthesia and to undergo surgery with acupuncture is probably due to the ". . . immense pressure to comply and participate in the current Mao Thought program which is a fundamental requirement for life in China" (Dimond, 1971). Before surgery with acupuncture is commenced, the patient and attending physicians recite quotations from Chairman Mao's book and Mao's picture faces the patient in every operating room (Jain, 1972a). Also, at the end of the operation, the patients routinely thank Chairman Mao for the surgery (Dimond, 1971).

Two additional points should be noted here. First, in some localities in China, the insertion of acupuncture needles is practiced by laymen in about the same way as individuals in Western countries take aspirin tablets (Capperauld, 1972). Capperauld (1972) has pointed out that in some parts of China "young children practice inserting needles into one another's arms, legs, and face to become proficient both as a user and as a recipient."

Secondly, it should be emphasized that the Chinese learn early in life to expect little or no discomfort during surgery, even when the surgery is performed without drugs and without acupuncture. For instance, Brown (1972) states:

> While visiting a children's hospital we saw a queue of smiling 5-year-olds standing outside a room where tonsillectomies were being carried out in rapid succession. The leading child was given a quick anesthetic spray of the throat by a nurse, a few minutes before walking into the theatre unaccompanied. Each youngster in turn climbed on the table, lay back smiling at the surgeon, opened his mouth wide, and had his tonsils dissected out in the extraordinary time of less than a minute. The only instruments used were dissecting scissors and forceps. The child left the table and walked into the recovery room, spitting blood into a gauze swab. A bucket of water at the surgeon's feet containing thirty-four tonsils of all sizes was proof of the morning's work. This tonsillectomy technique is significant inasmuch as it indicates that, without recourse to acupuncture, the Chinese patient is conditioned from early childhood to accept surgical interference with his body with the full knowledge that it is going to be successful and he will experience little or no discomfort.

Kroger (1972) has appropriately summarized these points by noting that "Specific factors responsible for acupuncture anesthesia are: the antecedent variables such as the generalized stoicism of

the Chinese, the ideological zeal, the evangelical fervor, the prior beliefs shared by *acupuncturists* and patients (and) *Mao Tse-tung's New Thought Directives* . . ."

Mann (1972) has recently provided further support for the notion that the patient's belief in the effectiveness of acupuncture is crucial to its success. Working in England, he attempted to use acupuncture to produce analgesia to pinpricks in 100 volunteer subjects. Acupuncture failed to produce satisfactory analgesia to the pinpricks, which were severe enough to draw blood, in at least 90 per cent of these subjects. Mann attributed the tremendous discrepancy between his success rate and the success rate reported from China as due to the following: in contrast to the Chinese, he did not attempt to lead his subjects to believe that acupuncture would be highly effective.

Use of Narcotic Analgesics, Local Anesthetics, and Sedatives

Although popular accounts imply that narcotic analgesics, local anesthetics, and sedatives are not used when patients undergo surgery with acupuncture, eye-witness accounts from Western physicians do not support this notion. Man and Chan (1972) state that, during surgery with acupuncture, the Chinese routinely administer 50 to 60 milligrams of meperidine hydrochloride (Demerol) in an intravenous drip. Of the six cases described by Dimond (1971), three received meperidine hydrochloride (50-60 mg.) intravenously during their operations (a gastrectomy, a subtotal thyroidectomy, and a removal of a thyroid adenoma). A fourth patient, who underwent thoracic surgery, was given 10 milligrams of morphine subcutaneously. A fifth patient received a sedative dose (0.2 gm.) of phenobarbital sodium together with subcutaneous scopolamine (0.3 mg.) prior to surgery and intra-peritoneal local anesthesia (procaine hydrochloride) during the surgery (cophorectomy). A sixth patient received phenobarbital sodium the night before surgery; however, she did not receive pain-relieving drugs during the surgery (removal of brain tumor) and, although she was described as "conscious, but very weak,"

she tolerated the operation without signs of pain. The latter case is indeed remarkable. However, it should be noted that brain tissue is generally insensitive to the surgeon's scalpel (Lewis, 1942) and, in other eye-witness reports of operations for cerebral tumor carried out with acupuncture, it is emphasized that the surgeons infiltrated the scalp with 50 milliliters of 0.125 per cent procaine before the incision was made (Brown, 1972; Capperauld, 1972).

In his eye witness report of surgery with acupuncture, Capperauld (1972) noted that, typically, barbiturate medication was given preoperatively and meperidine hydrochloride and promethazine hydrochloride were given intravenously during the operation. After also noting the use of local anesthetics, Capperauld (1972) asked, "The real question to be answered, therefore, is which therapy, the acupuncture needle or the concomitant Western medication, is the adjunct?"

Recent reports of surgery with acupuncture performed here in the United States also note the use of narcotic analgesics together with sedatives. For instance, Liu (1972) reported a tonsillectomy carried out with acupuncture on a nurse-anesthetist. The patient was given preoperative medication (two mg. of Innovar) which included a narcotic analgesic (fentanyl citrate) and a phenothiazine-like psychosedative (droperidol). As Price and Dripps (1970) have pointed out, this neuroleptic-narcotic mixture produces "general quiescence and a state of psychic indifference to environmental stimuli" and is useful in carrying out minor surgical procedures. It is interesting to contrast this tonsillectomy, performed in the United States with an analgesic, sedation, and acupuncture on a medically sophisticated patient, with the routine tonsellectomies, without analgesics, sedation, or acupuncture, performed on Chinese children.

It should be noted that, in some cases, the drugs that are given during acupuncture fail to control pain, that is, the patient complains of intolerable pain and general anesthesia is administered. Dimond (1971) estimated that this kind of failure occurred in China in at least 10 per cent of the selected patients. During a three-week visit to China, Dr. Marcel Gemperle (1972) failed to

find a single case where acupuncture produced complete insensitivity and, in one case, the patient screamed and moved about on the operating table during surgery. As we noted earlier, Mann (1973) found a failure rate of at least 90 per cent in England when no attempt was made to convince subjects of the effectiveness of acupuncture in reducing the pain of pinpricks.

Overestimation of Surgical Pain

Since, in Western medicine, anesthetic or analgesic agents are now practically always used during major surgery, there is little information regarding the baseline levels of pain experienced by surgical patients who have not received pain-relieving drugs. However, even during the pre-anesthetic era (prior to the 1840s), some patients undergoing major surgery without drugs "bravely made no signs of suffering at all" (Trent, 1946). For instance, in one such operation (a mastectomy) carried out in the early 1800s, the patient tolerated the surgery ". . . without a word, and after being bandaged up, got up, made a curtsy, thanked the surgeon and walked out of the room" (Freemont-Smith, 1950). Although patients of this type probably represented only a small minority of those undergoing surgery during the pre-anesthetic era, they indicate the major importance of determining base levels of pain when evaluating procedures such as acupuncture.

The available evidence indicates that surgical procedures produce anxiety and fear but they usually give rise to less pain than is commonly believed. In summarizing the relevant evidence, Lewis (1942) emphasized that, although the skin is very sensitive, the muscles, bone, and most of the internal organs are relatively insensitive. More precisely, the skin is sensitive to a knife cut, but the underlying tissues and internal organs are generally insensitive to *incision* (although they are generally sensitive to other forms of stimulation such as traction or distention). For example, Lewis (1942) noted that the subcutaneous tissue gives rise to little pain when it is cut and slight pain is elicited when muscles are incised. Most of the internal organs also produce

little or no pain when they are cut; these include the liver, spleen, kidneys, stomach, jejunum, ileum, colon, lungs, surface of the heart, esophageal wall, and uterus. Traction upon the hollow viscera, however, is painful. Also, the surgeon's incision produces pain when it cuts the skin and other external tissues (such as the conjunctiva, the mucous membranes of the mouth and naso-pharynx, the upper surface of the larynx, and the stratified mucous membranes of the genitalia) and also when it cuts a small number of deeper tissues (such as the deep fascia, the periosteim, the tendons, and the rectum) (Lewis, 1942). In brief, although "pain receptors" may be widely scattered throughout the body, and although many tissues and organs give rise to pain when they are stretched or pulled or when pressure is applied, most tissues and organs of the body (with the notable exception of the skin and other external tissues) give rise to little or no pain when they are cut by the surgeon's scalpel.

In the early 1900s, Lennander (1901, 1902, 1904, 1906a, 1906b) published a series of case reports indicating that major abdominal operations can be accomplished painlessly using only local anesthetics, such as cocaine, to dull the pain of the initial incision through the skin. Mitchell (1907), also reported an extensive series of major operations performed with local anesthetics that were used to produce insensitivity of the skin. These included: limb amputations, thyroidectomies, mastectomies, suprapublic cystostomies, laparotomies, excision of glands in the neck and groin, herniorrhaphies, cholecystostomies, and appendectomies.

Mitchell (1907) confirmed Lennander's observation regarding the surprising insensitivity of internal organs. For example, he noted the following:

> The skin being thoroughly anesthetized and the incision made, there is little sensation in the subcutaneous tissue and muscles as long as blood vessels, large nerve trunks and connective tissue bundles are avoided . . . The same insensibility to pain in bone has been noted in several cases of amputation, in removal of osteophytes and wiring of fractures. In every instance after thorough cocainization of the periostium, the actual manipulations of the bone itself have been unaccompanied by pain. The patients have stated that they could feel and hear the sawing, but it was as if a board were being sawn while resting upon some part of the body.

The data presented by Lewis (1942), Lennander (e.g., 1901), and Mitchell (1907) suggest that the pain associated with major surgical procedures may not always be as great as is usually supposed. It is certainly clear that the amount of pain is not related in any simple way to the extent of surgical intervention. Obviously, it is necessary to have a base-line measure of pain in order to evaluate the effectiveness of any procedure, including acupuncture, that is said to produce analgesia. The evidence available at present indicates that, if a patient is relaxed and not anxious and if he can tolerate the initial incision through the skin, many major surgical procedures can be accomplished without much additional pain. The administration of small or moderate doses of narcotic analgesics and sedatives, as is usually done with acupuncture, makes the patient's task that much easier.

Chinese surgeons who employ acupuncture, conduct their operations very slowly and carefully (Brown, 1972; Capperauld, 1972). Rib-spreaders employed during thoracotomies are opened slowly. Also, surgeons avoid putting traction on such tissues as the pleura and peritoneum which are known to be sensitive to traction (Brown, 1972). When these tissues are stretched, acupuncture patients grimace, sweat, and show other signs of experiencing extreme pain (Capperauld, 1972), just as would be expected on the basis of the data summarized by Lewis (1942). Acupuncture is difficult to use in abdominal surgery because it is hard to avoid putting traction on these tissues and because acupuncture does not produce adequate relaxation of the abdominal muscles (Jain, 1972a; Shute, 1972).

In brief, at least some of the success of acupuncture in surgery can be accounted for by three consideration: the patients strongly believe in the efficacy of acupuncture and they are not fearful or anxious; narcotic analgesics, local anesthetics, and sedatives are commonly used, singly or in combination, along with the acupuncture; and most tissues and organs of the body are insensitive when they are cut. However, for a more complete explanation of the success of acupuncture, three additional factors need to be taken into account: the patients are typically exposed to special preparation and indoctrination for several days prior to surgery; the acupuncture needles distract the patients from the

surgery; and suggestions for pain attenuation are present in the acupuncture situation. Let us now look at the latter three factors in turn.

Special Preparation and Indoctrination Prior to Surgery

Patients who are selected for surgery with acupuncture receive rather special treatment preoperatively. The patient typically comes to the hospital two days before the surgery and the surgeons explain to him exactly what they are going to do; they show him just how they will operate, and they explain to him what the acupuncturist will do and what effects the needles will have (e.g., Jain, 1972b). Also, the patient is asked to talk to other patients who have had the same kind of surgery and he is given a set of acupuncture needles so that he can try them on himself. As Capperauld (1972) has pointed out, "Acupuncture anesthesia tended to work better in non-emergency situations in which the patients had a few days indoctrination prior to operation. Emergency operations were done usually under conventional spinal techniques." It thus appears that preoperative familiarization with the medical setting and with the surgical procedures may play an important role in further reducing any anxiety regarding the forthcoming operation and in reducing the need for large doses of pain-relieving drugs (Finer, 1970).

Although this kind of special preoperative preparation and indoctrination for surgery is not employed in the United States, there is evidence to indicate that "preoperative education," even if very limited, can have a beneficial effect on surgical patients. For instance, Egbert, Battit, Welch, and Bartlett (1963), found that a five or ten minute preoperative visit by an anesthesiologist had a greater calming effect on surgical patients than two milligrams (per kilogram of body weight) of pentobarbital sodium. Moreover, patients who were informed about the kind of post-surgical pain they might experience required smaller doses of narcotics for post-surgical pain than uninformed controls. An unexpected bonus was that the informed patients were discharged from the hospital sooner than the controls.

In brief, it appears that the preoperative period of special preparation and indoctrination for acupuncture provides an opportunity to reduce further the patient's anxiety, to strengthen his "belief and trust in acupuncture" (Wall, 1972; 1973), and to reduce his need for large doses of pain-relieving drugs.

Distraction Produced by Acupuncture Needles

The insertion and subsequent stimulation of the acupuncture needles is accompanied by various sensations. At times, the electric current that is applied to the needles is strong enough to produce rather strong muscular contraction. Also, the needles are manipulated by hand or stimulated electrically for 20 to 30 minutes prior to surgery and the patient often feels "sore" at the sites of needle placement (Chen, 1972; Man & Chen, 1972). McGarey (1972) noted that, "A deep but minimal aching sensation is often felt when the needle is properly placed." Some patients report that the acupuncture needles produce severe pain. Mann (1973) found that, in order to reduce the pain of pinpricks it was necessary, with most subjects, to increase the pain produced by the acupuncture needles ". . . to more or less torture levels." In describing his own sensations while undergoing acupuncture for the relief of post-surgical abdominal pain, James Reston (1972:8) noted that the needles ". . . sent ripples of pain racing through my limbs and, at least, had the effect of diverting my attention from the distress in my stomach."

In brief, the acupuncture needles produce various sensations and they can serve as distraction. The evidence available at present indicates that distraction is an effective method of reducing pain. Notermans (1966) found substantial (40 to 50 per cent) increases in the threshold for pain when subjects were distracted by performing an irrelevant task (inflating a manometer cuff). Kanfer and Goodfoot (1966) showed that pain could be reduced by three types of distractors (observing interesting slides, self-pacing with a clock, and verbalizing the sensations aloud). Similarly, it has been demonstrated in several reports (Barber, 1969a; Barber & Cooper, 1972; Barber & Hahn, 1962) that experimentally-induced pain

could be reduced by various kinds of distractions (listening to an interesting tape-recorded story, adding numbers aloud, and purposively thinking of pleasant events).

The distraction produced by counter-irritation is also an effective way of reducing pain. Gammon and Starr (1941) demonstrated that experimentally-induced pain could be reduced by several kinds of counter-irritations including heat, cold, vibration, electric stimulation, and static electricity. Gammon and Starr (1941) also found that counter-irritation was effective in alleviating clinical pain. In one group of 60 clinical patients, 90 per cent obtained some degree of relief from pain, although the most effective type of counter-irritation varied in different patients.

The studies cited above demonstrate that a wide variety of distractions are effective in attenuating pain. Clearly, the acupuncture needles themselves can serve as effective distractors. In addition, some acupuncture patients receive special deep breathing exercises which they later are requested to carry out during surgery (Brown, 1972; Warren, 1972). By focusing their attention on their breathing during the surgery, the patients may be provided with an additional useful distraction.

Suggestions for Pain Relief

It is clear that patients who are selected to undergo surgery with acupuncture believe that the technique is effective in attenuating pain. During the preoperative indoctrination and also during the surgery itself, the patients' pre-existing beliefs are strengthened by direct and indirect suggestions that acupuncture will mitigate pain. Even when acupuncture is used to treat specific diseases, Rhee (1972) noted that ". . . the acupuncturists whom I have watched work, load their therapy with suggestion."

The effectiveness of indirect suggestions in the clinical setting has a long history and has often been observed serendipitously. For instance, Tuckey (1889) wrote:

There are few cases of this kind more remarkable than one related by Mr. Woodhouse Braine, the well-known chloroformist. Having to administer

ether to an hysterical girl who was about to be operated on for the removal of two sebaceous tumors from the scalp, he found that the ether bottle was empty, and that the inhaling bag was free from even the odor of any anesthetic. While a fresh supply was being obtained, he thought to familiarize the patient with the process by putting the inhaling bag over her mouth and nose and telling her to breathe quietly and deeply. After a few inspirations she cried, "Oh, I feel it; I am going off," and a moment after, her eyes turned up and she became unconscious. As she was found to be perfectly insensible, and the ether had not yet come, Mr. Braine proposed that the surgeon should proceed with the operation. One tumor was removed without in the least disturbing her, and then, in order to test her condition, a bystander said that she was coming to. Upon this, she began to show signs of waking, so the bag was once more applied, with the remark, "She'll soon be off again," when she immediately lost sensation and the operation was successfully and painlessly completed.

Working under primitive conditions in a prisoner-of-war hospital near Singapore, Sampimon and Woodruff (1946) found, to their surprise, that "the mere suggestion of anesthesia" was sufficient to perform minor surgery on the soldiers without apparent pain. In a more recent report from Bulgaria, Lozanov (1967) demonstrated that suggestions of anesthesia are at times sufficient to carry out major surgery with little pain. Similar findings have emerged in studies of placebos. Hardy, Wolff, and Goodell (1952) showed that pain thresholds could be elevated 90 per cent over control levels when an inactive drug was administered with the suggestion that it was a strong analgesic. Moreover, placebos have been found to be effective in alleviating post-surgical pain and also chronic pain in many patients (Barber, 1959; Beecher, 1955; Dodson & Bennett, 1954; Houde & Wallenstein, 1953; Laszlo & Spencer, 1953).

Suggestions of anesthesia are also effective in attenuating experimentally-induced pain. Barber and Hahn (1962) and Evans and Paul (1970) showed that suggestions of insensitivity attenuated cold-pressor pain. Similarly, Barber (1969a) and Spanos, Barber, and Lang (in press) showed that suggestions of anesthesia reduced the pain produced by a heavy weight applied to a finger. Using the same pain stimulus on the finger, Chaves and Barber (1973) found that the mere expectation of pain attenuation led to a reduction in pain, although larger reductions were obtained when

subjects were asked to vividly imagine that their finger was numb and insensitive or to imagine pleasant experiences they had had.

Taken together, then, clinical and experimental observations indicate that both direct and indirect suggestions of anesthesia are effective in attenuating pain (Barber, 1963, 1969b, 1970, 1972). It also appears likely that suggestions play a role in attenuating pain in the acupuncture situation.

In summary, we have delineated six factors that help to explain the efficacy of acupuncture in attenuating surgical pain. Surprisingly, none of these factors are taken into consideration in the two most prominent theories of acupuncture analgesia, the traditional Chinese meridian theory and the more recent gate control theory. Let us briefly examine these theories.

TWO PROMINENT THEORIES OF ACUPUNCTURE ANALGESIA

Chinese Meridian Theory

The traditional Chinese theory of acupuncture, which has been described by Mann (1972) and Drake (1972), assumes that there are 12 meridians (Ching lo) or channels running vertically down the body. These meridians are thought to carry a life energy (Ch'i, Ki, or Qi). The flow of this energy is thought to maintain a balance between two forces, the Yin and the Yang. Yin is viewed as the weak, female, negative force, while Yang is the strong, male, positive force. Yin meridians are associated with such organs as the liver, kidneys, and spleen, while Yang meridians are associated with such organs as the stomach, gall bladder, and intestines. Disease is thought to reflect the imbalance of Yin and Yang forces. The insertion of acupuncture needles in appropriate locations is thought to correct the imbalance and thus cure the disease. Consequently, to produce analgesia for surgery, it is necessary to insert acupuncture needles into meridians which control the appropriate organs. Since the meridians are thought to

run through the whole body, the points of insertion may be quite remote from the points where analgesia is desired.

Although this ancient theory of acupuncture still appears to have many advocates in China, it is not accepted by all Chinese surgeons. Man and Chen (1972) note that some Chinese surgeons "totally disregarded the recognized spots on the meridians" and used almost any spot to produce surgical analgesia. It thus appears that the traditional theory of acupuncture points may be misleading.

Mann (1972) who has written several books about acupuncture and who, at one time, accepted the traditional theory, now argues, ". . . I don't believe meridians exist. A lot of acupuncture is based on meridians, and you will see from my theory, I think the meridians of acupuncture are not very much more real than the meridians of geography. And likewise with the acupuncture points." Mann (1972) goes on to note that "The Chinese have so many interconnections in their acupuncture theory that one can explain everything just as politicians do." Wall (1972) is more succinct in his discussion of meridians, stating that "There is not one scrap of anatomical or physiological evidence for the existence of such a system."

Gate Control Theory

Several writers (Man & Chen, 1972; Shealy, 1972; Wall, 1972; Warren, 1972) have commented on the relevance of Melzack and Wall's (1965) Gate Control Theory of pain in understanding acupuncture analgesia. This has been, perhaps, the first attempt to apply a theory of pain that has any degree of acceptance among Western scientists. Briefly, the theory asserts that pain depends, in part, on the relative amounts of activity in large A-beta fibers, activated by non-painful stimuli, and small c-fibers, activated by pain-producing stimuli. Increasing the activity of the A-beta fibers is thought to close a spinal "gate" in the substantia gelatinosa, preventing the further transmission of information from the c-fibers. As applied to acupuncture, it is assumed that acupuncture needles selectively stimulate the A-beta fibers and that the high level of

activity in the A-beta fibers closes the "gate" and thus inhibits pain.

At first glance, the gate control theory may appear to be more helpful than the six factors we have discussed in accounting for anecdotal reports in the popular press which suggest that acupuncture may be useful in performing surgery with rabbits, horses, and other mammals. Of course, these statements in newspapers and magazines cannot be evaluated until such time as non-anecdotal studies are presented which, at least, utilize minimal controls. Since there is much evidence demonstrating that many mammals, including rabbits and horses, can tolerate extremely painful stimuli when they are appropriately restrained (Ratner, 1967), controlled studies may find that acupuncture is not especially helpful in operating on mammals.

There are major difficulties in using the gate control theory to account for acupuncture analgesia. First of all, the "gate" is a hypothetical entity that has not been established anatomically. Even if such a "gate" were shown to exist, the gate control theory, as originally formulated, could only account for analgesia in the vicinity of the nerves stimulated by the acupuncture needles (Shealy, 1972; Wall, 1972). However, as we noted earlier, acupuncture needles are typically inserted at points which are remote from the area where analgesia is desired. A related difficulty is that many of the locations commonly employed in acupuncture, such as the head or pinnae, would be ineffective in closing the spinal "gate." Thus, it is necessary to postulate the existence of a second "gate," presumably located at some higher level of the nervous system, in order to account for the efficacy of needles inserted at these locations (Man & Chen, 1972). While it is difficult to rule out this possibility, the postulation of new "gates" on an *ad hoc* basis to account for anomalous findings is not satisfactory.

As originally formulated, the gate control theory appears inadequate to explain how acupuncture attenuates the pain of surgery. Recently, Wall (1972), who is one of the original co-authors of the gate control theory, stated that "My present guess is that . . . it will emerge that acupuncture does not generate the

specifically pain-inhibiting barrages for which I was looking." However, Melzack (1973a, 1973b), the other co-author of the gate control theory, has recently argued that the theory is relevant to acupuncture. While the gate control theory may appear to be useful in explaining the successes of acupuncture, it is very difficult to see how this theory can account for its failures. Why is it necessary for acupuncture patients to believe in its effectiveness? If acupuncture needles can close the "gate," why is it necessary to administer narcotic analgesics, sedatives, and local anesthetics to acupuncture patients? Why is the "gate" capable of reducing the pain of surgery in China, but incapable of reducing the pain of pinpricks in England (Mann, 1973)? Unfortunately, gate control theory fails to provide answers to these important questions. It appears to us that speculations regarding the physiological basis for acupuncture analgesia may be premature.

CONCLUDING COMMENTS

In this paper we have tried to take into consideration the available data pertaining to surgery with acupuncture analgesia. As more data become available additional factors will surely be identified that will also help to explain this phenomenon. It remains to be demonstrated, however, that acupuncture needles exert any specific analgesic effects beyond those indicated in the present paper. Certainly, future attempts to account for the success of acupuncture in attenuating surgical pain should take into account the factors that we have delineated.

It appears to us that the success of acupuncture analgesia underscores the importance of psychological factors in the control of pain. However, more research is needed to determine the relative importance of the six factors described in this paper and to identify additional factors that could help to explain the phenomenon. Certainly, providing the basis for a more comprehensive explanation of acupuncture analgesia will be an exciting area for future research.

12 Scientific Approaches to the Study of Acupuncture Therapy

David Bresler

This paper describes several scientific notions which have been offered as explanations of acupuncture therapy and, in particular, of acupuncture analgesia.

It has been suggested by several investigators (e.g., Dorcus, 1972) that acupuncture therapy represents an effective use of hypnotic techniques and that its success can be explained on the basis of prior indoctrination, auto-suggestion, expectation, counter-irritation, distraction, etc.

In preliminary experiments with naive human subjects, we have observed a variety of electrophysiological (EEG, EKG, EOG, EMG, GSR, GSP) changes following the insertion of needles into traditional acupuncture points while no systematic effects occurred when adjacent placebo points were stimulated. For example, heart rate and EEG beta activity were increased by tonification of the "Stomach-36" points (which are used to produce general sympathetic arousal) while no consistent changes occurred with tonification of nearby placebo points. Sedation of the "Heart-7" points (used to treat insomnia) produced substantial increases in EEG alpha activity while placebo points were without effect.

In other preliminary studies, we have observed that the galvanic skin potential (GSP) at certain acupuncture points appears

to change with heart rise and respiration rate while no systematic changes in the GSP of other surface areas of the skin could be observed.

We have also determined that specific acupuncture points can be used during dental work to suppress the "gag reflex," while adjacent placebo points were, again, without effect.

In addition, we have successfully used acupuncture therapy for treating a variety of illnesses in horses, dogs, and cats. Analgesia has also been achieved in two-day-old babies. It remains effective in patients who are unfamiliar with the techniques involved, or who are highly skeptical.

In all of the human experiments, subjects were given no prior information about the procedures employed and these results can therefore not be explained on the basis of the "hypnosis" notion.

Acupuncture has been used effectively as a dental analgesic. An abscessed second upper molar tooth has been removed in a volunteer patient. No preoperative analgesics or anesthetics were administered. Acupuncture needles were inserted bilaterally into the acupuncture points HO-KU ("Large Intestine-4") and NEI-TING ("Stomach-44"). A Grass stimulator generated a small electrical current through the needles via wires and alligator clips.

At 10 minute intervals, the oral cavity was probed with a dental explorer to determine the locus and degree of analgesia obtained. When sufficient analgesia was achieved (after 30 minutes), the tooth was extracted using standard dental techniques. The patient reported experiencing no pain or discomfort during this procedure and the amount of bleeding which occurred was judged to be comparable to that usually occurring with standard anesthetic techniques.

The analgesic effects persisted nearly 12 hours following removal of the acupuncture needles. This indicates that a "counter-irritation" theory of acupuncture analgesia is inadequate since the analgesia persisted long after the "counter-irritants" (i.e., the acupuncture needles) were removed.

A number of neural hypotheses were considered. The one-gate theory of pain postulated by Melzack and Wall (1965) is inadequate since a spinal cord gate cannot explain how analgesia can be

achieved in the head and neck areas innervated by cranial nerves. The two-gate theory (Melzack, 1973) implies that once the thalamic or RAS gate is closed, no pain should be experienced anywhere in the body. Although sufficient analgesia to permit tooth extraction was achieved, certain areas in the oral cavity (e.g., the unattached gingiva, the tongue, the lips, etc.) remained sensitive to pain which contradicts this notion. Interestingly, the patient was apparently sensitive to heat, cold and pressure.

Additional research is being conducted at our clinic by an interdisciplinary team of physicians, oral surgeons, neurophysiologists, bioengineers, psychologists and acupuncturists, and will provide valuable data concerning the mechanism of action of acupuncture analgesia.

Points and Practice: **13** Techniques of Japanese and Chinese Massage

Robert Feldman and

Shizuko Yamamoto

Massage occupies a unique position within the practice of Oriental medicine. It is perhaps initially easier to learn than acupuncture and herbalism, although in its more refined stages, it is as difficult to master. Massage can be used in most cases in as effective a capacity as other Oriental healing arts; in certain situations, an acupuncturist will use massage, such as in an emergency, when needles are not available, or if the use of needles or moxibustion might provide too extreme a stimulation, as in the treatment of children and the aged (Editorial committee, Peking, 1973; Galston & Savage, 1973). The purpose of this discussion will then be to provide a description of various principles of massage and techniques of practice.

Massage is the most "physical" of the forms of Oriental medicine as it involves direct and often intensive physical contact with the patient. The degree of physical contact or the kind of techniques utilized will, of course, vary from practitioner to practitioner. Some practitioners will only apply thumb pressure or "shiatsu"; others will utilize pounding or rubbing, etc. There are, in fact, at least seven techniques: shiatsu, rubbing and stroking massage, circular motion massage, kneading massage, pressure massage, vibration massage, and tapping massage.

Precisely in terms of tonification (yang) and sedation (yin)
light rapid, unidirectional movement represents a yang polarity for
use in tonification. In sedation, pressure is applied gradually,
increasing until a strong level of pressure is reached which is
maintained until the practitioner feels a relaxation in the tissues
within the area of point of contact.

Some practitioners will also use their feet in treatment, as it is
easier to treat large numbers of people with less physical exertion
if the practitioner utilizes his or her whole body at some point
in treatment. Most practitioners, whatever their techniques, will
conserve their strength by emphasizing movement emanating from
their abdominal area, located about two inches below the navel
at the "hara" or "vital center."

The hara is an important gathering point of "ki." In treatment,
the practitioner will apply his or her weight emanating outward
from the hara area to the hands or feet, whatever the actual
point of contact. This enables the practitioner to apply massage
most effectively without muscular tension or physical strain. Many
practitioners are, in fact, very light in their actual physical contact
with the patient and rely entirely upon their "concentration of
ki" to the point of application rather than physical force. This,
however, verges upon palm healing or psychic healing and is quite
rare in its application. Thus, a practitioner is consciously trying
to develop a strong polarity between oneself and one's patient
and must necessarily act as a stronger emitter of energy than one's
patient. Otherwise, it might be said, ki would flow in the "reverse
direction" and somewhat "drain" the energy of the patient. The
cultivation and use of strong ki would, of course, depend upon
the health and physical condition of the practitioner. Perhaps a
Kirlian photography study of the "energy emissions" from such
practitioners and their patients would illustrate this more fully
from a scientific point of view (Worsley, 1972, 1973).

Specifically, breathing is the most critical factor in effecting
and maintaining ki during treatment. The practitioner makes the
conscious attempt to control and extend the breathing of his
patient to longer and longer cycles, repeatedly. This breathing
deeply emanates from the hara area, and is coordinated accord-

ingly with one's technique and focus of movement. A practitioner maintains concentration upon one's hara area or upon the point of physical contact with the patient. Principally, the practitioner looks upon his or her position in the process of treatment more as a channel or conductor rather than source of ki.

Treatment is not looked upon as a cure but rather as an attempt to stimulate or revitalize the ki of the patient; thus, the body must utilize its own regenerative powers and cure itself. The practitioner then attempts to treat the whole individual, treating "body" and "mind" as a totality, inextricably involved with each other. Diagnosis and treatment on the highest level are not so much symptomatic as an attempt to reach and change the fundamental cause of sickness or imbalance.

Of course, treatment and diagnosis must go beyond actual techniques and reflect the environment, diet, physical activity and past history of the patient to name but a few factors affecting illness. Reflection upon the mental and emotional state of a patient are important leads or indicators of the patient's physical condition and the practitioner must initially examine and diagnose the present condition of the patient in relation to the patient's constitution. Thus an individual with a strong constitution might respond differently or perhaps more quickly to treatment than an individual with a weaker constitution or past condition.

The massage techniques would vary accordingly. For example, let us imagine that two individuals are suffering with a renal problem. One individual is a physical laborer, the other is an office worker; their bone structure and muscle tone vary as their diet, lifestyles, and constitution may vary. One would, perhaps, apply a treatment similar in some ways in the techniques utilized, yet different in others depending upon their weight, bone structure, size, and muscle development, as well as the nature of their symptoms.

It is also important to examine the physical problem within the context of natural cycles, be it time of the day, year or age of the patient in order to determine the proper treatment. Similar to the acupuncture clock in which ki is most active or deficient, according to the hour of the day and time of the year, a sympto-

matic problem, such as migraines or back pain, might vary
according to the time of day during which they occur. A practi-
tioner might have to diagnose and treat this condition differently
and the fundamental cause might vary accordingly with the diet
and lifestyle of the patient.

The practitioner, then, in holding to the underlying principle
that any part of the "body–mind" is the reflection of the "total
body–mind," can diagnose (and similarly treat) the patient in a
variety of ways. Classically speaking, there are four varieties of
diagnosis (Muramoto, 1971).

1. *Bo-Shin* is a diagnosis which starts from examining all parts
 of the body and uses the eyes and the intuition.
2. *Bun-Shin* is a diagnosis employing hearing and smelling.
3. *Mon-Shin* is a diagnosis which includes questions concerning
 an individual's family, job, situation, case history, previous
 diet, and other matters related to his sickness.
4. *Setsu-Shin* is a diagnosis which uses the sense of touch;
 pulse, shiatsu, and abdomen diagnosis belong to this category.

The practitioner will diagnose or treat the face, ears, pulse,
hands, feet, or postural alignment of a patient as well as specific
points along the meridians of his patient. A detailed discussion of
the points or meridians and their spirit and purpose has been well
described and documented elsewhere (Serizawa, 1972); these points
are perhaps of primary importance in treatment. We shall attempt
here to describe other aspects of massage treatment such as
correspondences of muscular condition and bone alignment which
are also important to the practice of massage.

Generally, massage practice, like acupuncture, is constructed
according to a system based upon the unifying principle of
dualistical monism, namely of yin and yang. As the 10 organs
and the 12 major meridians of Chinese medicine are classified
according to yin and yang, so are the correspondences between
the skeletal system, musculature and appendages. Treatment of a
particular area, say a muscle pain in the upper back, may be
treated by massage of the complimentary antagonistic area of
the lower abdomen (Figure 156). Similarly, migraine headaches,

FIGURE SHOWING SHADED
AREAS UTILIZED FOR
INTESTINAL MASSAGE

FIGURE SHOWING
ANTAGONISTICALLY
RELATED AREAS IN
MASSAGE

FIGURE 156. Important areas in acupuncture massage (courtesy, R. Feldman,
S. Yamamoto, & J. Cohen).

are treated by massage of acupuncture points and areas of the foot as well as acupuncture points on the head and other points of the body. Physiological studies in China have, for example, demonstrated a contractile effect upon the colon by needling points on the governing vessel meridian on the middle line of the skull. Muscular pain, soreness or tension in the muscles of the upper back and shoulders may indicate intestinal problems, or soreness in the area around the Achilles tendon is an indication of possible problems in the genital-urinary system as these muscular and tendonal areas of the leg do correspond to the lower abdominal area according to the principle of yin and yang.

Perhaps these relationships might have embryological significance in their development as certain theorists have postulated concerning the location and development of acupuncture meridians. Acne, sores and other skin discharges may be looked upon as acute symptoms of imbalance in organs corresponding to their location upon the body, while moles, both pigmented and non-pigmented, show more chronic indications.

Massage will often be applied along various neural pathways in treatment, especially along the spinal nerves. Stimulation of these nerves by vertebral adjustment similar to chiropractic techniques are utilized in coordination with treatment of points along the bladder and governing vessel meridians. Postural misalignments may be corrected as well by osteopathic procedures. Exercises and calisthenics may be prescribed for particular postural problems, as well as to aid in healing of weak organs. There are many varieties, both classical and modern, such as "Dō-in" or self-massage (de Langre, 1971), calisthenics, various yogic postures, Tai Chi movement techniques, and forms adapted from the martial arts and from modern physical therapy sources. Certainly, modern physical therapy should examine the potentiality of these exercise forms as readily as modern medicine is examining acupuncture. As a form of Oriental medicine, massage is perhaps most fundamental in that it requires no additional instruments or devices for its utilization in treatment. It requires no more than the skill of the practitioner in its application, and, in the hands of a good practitioner, its effects are noteworthily effective.

The Human System: **14** An Open-Ended Universe

James A. Hurtak

In recent years, certain Tibetan Scrolls have been uncovered which speak of other life systems. It has been my great pleasure to translate some of these Scrolls which have now been removed from Tibet to Tembocha in North Central Nepal. Some of the Scrolls speak of light consciousness energies from other fields of intelligence. With this in mind, I will talk about consciousness from the standpoint of Tibetan and Chinese medical science which studied the behavior of a biological organism within magnetic fields.

Consider that we are but one of many life systems in the thinking universe. The Tibetan and Chinese medical and astronomical texts indicate that in addition to the three major circulatory systems—blood, lymphatic, and nerves—there is a fourth circulation system, and this is the matter–energy–light circulatory system which connects our life system to other levels of evolution.

The human body is a microcosmos or small space/time field within a larger field. Acupuncture was one of the first empirical demonstrations of biological interaction with the universe. It should be noted that many environmental parameters vary with solar and lunar conditions such as air ionization, cosmic radiation, atmospheric electric charge, and magnetic field intensities. As contemporary research (Becker, 1972; Brown, 1969) suggests, these environmental qualities affect the human cycle. It is known that acupuncture acts upon the rates of oxidation, coagulation, electrophorysis, the endocrine glands, and the central nervous system.

In the Chinese, Japanese, and Tibetan medical texts, we find

acupuncture charts showing the larger magnetic field relationships which do not appear on the truncated acupuncture charts that are currently available (Figure 157). If we are to approach acupuncture from biophysics and understand the higher force fields which go through the human system as a small open-ended universe, then we are to really understand how this thinking organism known as the human being, can be attached to other thinking organisms within the local universe.

FIGURE 157. Oriental acupuncture chart showing magnetic field relationships (courtesy, J. A. Hurtak).

The work of the Soviet investigators Mikhalevski and Frantov (1968) shows that photon energy follows the same meridian channels or acupoints as those observed in Chinese acupuncture. A sixteenth century Chinese acupuncture diagram reveals the meridian fields within the human system. The human physical system is regarded as the basic energy vehicle in which there are five bodies. In addition to the physical system, one has an epikinetic body of motion, one has an electromagnetic body, one has a large universal body of many plus and minus fields, and finally, one has a body of light synthesis and light experience. All of these bodies, however, follow certain meridian magnetic field relations. The physical field experiences the surrounding energy field. It pulls into the physical membrane all the energies of the next order of evolution.

In a Japanese medical text from the seventeenth century showing the various months of pregnancy, the embryological development of the human organism is shown to be shaped by the magnetic field factors coming not only from the moon but from the various magnetic fields surrounding the earth (Figure 158). These, in turn, are influenced by other planet spheres throughout the galaxy. We are all part of membrane extensions; we are all fields of life experience energized through light synthesis from earlier periods of time.

Lunar tides and magnetic fields also have influenced the human evolutionary cycle. I emphasize astronomical factors because in Japanese and Chinese medical science we are considered as living fragments of a larger universe. Unless we understand cosmology, we cannot understand how the moon, sun, and planets play such an important role in the human life cycle. Lunar and solar time is recorded within the living membrane, and the membrane then makes its own clockwork of time. Hence, Oriental medical texts include cosmological charts and mappings which extenuate and explain the deeper implications of Eastern medical science.

Some of the medical texts describe 28 lunar stations. The basic acupuncture points relate to these 28 lunar stations, becoming magnetic points at which the human organism is clocked from the point of birth to the point of death. As the field relationship grows, of course the charts become more complex. We must

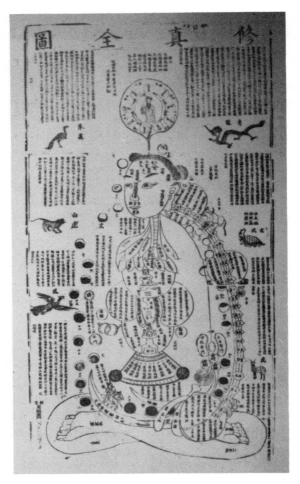

FIGURE 158. Japanese medical illustration showing pregnant woman whose
developing child is being influenced by various magnetic fields
(courtesy, J. A. Hurtak).

remember that much of this research was done thousands of years
before the birth of Christ, and reflects a very high development
in astronomy. We do not know where the Chinese received their
astronomical keys to the local universe. However, if we work on
the assumption that someone ran out of gas in a space ship on

this end of the universe, we may find that much of this material could conceivably have been given directly at an earlier point of evolution.

Human beings, in Oriental art, are often pictured as drinking the larger universe and creating smaller universes within their physical systems (Figure 159). Again, the notion here is that the person is an open-ended universe. Not only is the person between thinking universes, but thinking universes are within the person's universe. The person is a small microcosmos who, nevertheless,

FIGURE 159. Oriental print depicting the human system as an open-ended universe (courtesy, J. A. Hurtak).

can understand thinking currents within one's own system. Although a person is not necessarily able to control these currents, one may be able to synchronize them through experiences of mind expansion and scientific awareness. This brings the person into the use of what many Eastern writers call consciousness light energy.

As this light energy develops, the person is able to throw off micro-energy discharge, depicted by artists as flame consciousness emanations from all over the body. And if one examines the flame sculpture of Tibet, one will see that the flame points follow the meridian channels that we find on contemporary acupuncture charts. Thus, an individual can be thought of as a walking star field. The person is ionized through solar ionization; the sun is a star. In essence, one is a walking star of projected light energy on a lower plane of membrane evolution.

Various Cambodian drawings portray our sun as being devoured by the dragon of the chemical universe just as our growth system is realigned with the higher light energies which devour our universe. These, in turn, create an anti-universe, and re-evolve an anti-universe into a life-giving universe. We have, in Cambodian art, five evolutions of the physical universe and five evolutions of the anti-universe. These evolutions give us a ten-fold model of space/time which is reflected in Tibetan and Chinese medical astronomy.

Medical astronomy tells us that a person can evolve to a point where one can leave the body if one creates a body of chemical transmutation. Therefore, the human psyche can project itself from one body to another. This is seen in the Oriental painting contrasting the body of the student meditating to the body of the student walking away (Figure 160). Consciousness can be directly transferred and projected into another membrane circuit once the experience of light is systematized with a molecular field. If one finds the right molecular field, one can pass through that molecular field. One can do this in music with chord structures and one can also do this with consciousness. If consciousness is conceived of as music, it can be projected through the membrane of human experience into other membrane experiences. These experiences are all tied into a higher light factor in the same way

FIGURE 160. Oriental painting of student meditating (courtesy, J. A. Hurtak).

that a small human biocomputer is tied into a larger computer through a time-sharing or light-sharing factor.

The human system, then, can be seen in terms of the 28 lunar stations and the 28 star constellations that surround the evolutionary field. I stress the star systems because in one of the Tibetan texts, it was mentioned that the star field Arturus was one of the local star fields which had a higher system of life on it. It would

not surprise me that within the next few years it could be re-
leased that we have received information of another network of
intelligence in the star field of Arturus. The field of Arturus is
mentioned as one of the star fields in the Tibetan text, and
human consciousness is aligned with the star fields as one ex-
pression of a light consciousness. Human beings must become
conversant with the notion that they are but one of many life
systems in the universe.

Very advanced Chinese astronomical star charts appeared as
early as 1500 B.C. (Figure 161). We have star fields mentioned by
the Chinese that cannot be seen from our celestial equator. These
star positions are far too complicated to be seen with the simple
perceptual apparatus telescopes that may have been available in
1500 B.C., if there were any at all. Star maps have often been
revealed to us through the Tibetan texts, Egyptian texts, in the
Dead Sea Scrolls, and in the Chinese Sutra texts. All of these are
but small parts of a larger star map which depicts where we are
in the evolutionary pattern of our local universe.

Many paintings of the Buddha in meditation portray psycho-
chemical vibrations around his ears (Figure 162). They may also
show the five energy vehicles of consciousness experience over his
head. This would suggest that the Buddha could communicate not
only with people on this evolutionary scale, but with those on
other evolutionary scales as well. When the Buddha aligned his
biochemical and psychochemical forces, he could literally throw
off flame projections which ride a time element or space element,
as can be seen in Chinese and Indian works of art. The energy is
often painted as coming out of his body and projecting itself in
space. The consciousness that goes with that energy is a function
that will be reconstituted wherever that light factor or heat factor
is found.

We know that the Tibetan scriptures are written in flame letters
or thunderbolts for a reason. We know that the Hebrew texts are
written in flame letters for a reason. Both scriptures are scientific
syntheses of earlier cosmological traditions. The flame cosmology
and the flame points of the caligraphy project into space the
biochemical energies within the mind. Thus, the words of the

FIGURE 161. Early Chinese star chart (courtesy, J. A. Hurtak).

text are seared within the consciousness membranes so the information is coated on all levels of membrane evolution experience. It is amazing the way languages can speak through generations of consciousness about a lower evolution from the standpoint of a higher evolution. It explains why the Hebrew texts have survived thousands of years generating cosmologies of science.

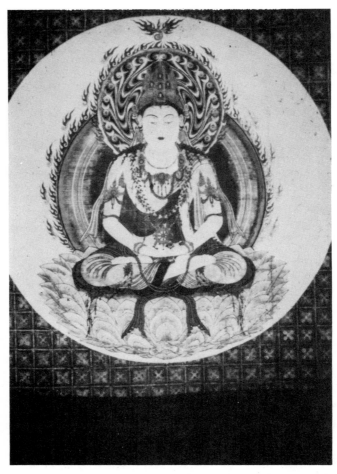

FIGURE 162. Oriental painting, Buddha in meditation (courtesy, J. A. Hurtak).

These theories are partially confirmed by an old Peking oracle bone which was written in three languages: Egyptian, Tibetan, and Chinese. It shows that there was communication between the Egyptian, the Tibetan, and the Chinese astronomers as early as 800 B.C. Furthermore, it speaks of other life systems surrounding our life system (Figure 163).

In conclusion, I would like to relate light consciousness to

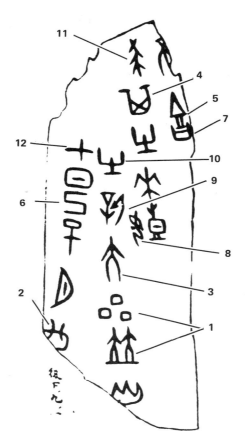

FIGURE 163. Chinese oracle bone possibly showing (1) a man and woman on earth, the third planet from (2) the sun. A (3) space visitor is leaving the planet by (9) reversing an energy field and (10) flying like a bird using (4) a rocket-propelled (7) vehicle of (5) pyramidal shape which is taking off toward a (11) double star system. The vehicle descends from the sky like a (8) lightning bolt and (12) ascends to the stars via (6) a spiraling energy field (courtesy, J. A. Hurtak).

human evolution. As is known from the thermodynamic properties of non-stationary sources which subordinate models of thermodynamic systems with negative temperature, it is possible to exceed

the concentration of radiated energy because of the inversion of electrons placed on various energetic levels, the wholes of which are orientated by the opposite phase. Such systems possess the potentials of mazer exitation and they distinguish themselves by a non-linear character of the dependence of energy and entropy. The physical schema is one in which centropy cradles entropy in the much broader aspect of defining and relating matter and energy as parameters of a single ecosystem. Entropy is then a subset of centropy—centropy being a treatment of metagalactic ordering. Our ecosystem is merely a system which embraces matter energy in our actions which, for example, include such concentrations as thermodynamics—electron-orbital transitions into the single function which relates differences in only a single metagalactic substrate. Thus, centropy is this fundamental relationship which quantitatively catalogues all matter energy interactions. Since a person is more than a host to the linear unity of centropy as the energy potentiality for converting entropy to zero, one can break the matter energy construct through certain forms of mind expansion.

In Eastern psychology, this matter-light projection is known as the third stage of Bardo, or light body enlightenment, and in the *Tibetan Book of the Dead*, mention is made of this (Evans-Wentz, 1957).

With the consideration, then, of light energy as the connecting nexus between many universes of life, let us expect a great leap forward—a great evolutionary leap forward in the consciousness of science.

Consciousness: 15
The Unifying
Concept

Edgar D. Mitchell

When we are working with acupuncture, Kirlian photography, or the human aura (Figures 164, 165, 166, and 167), we are studying various aspects of a holistic entity—the person. In fact, we should not even be limiting our study to humans, but rather thinking of all living systems and their function in the universe.

It was not long ago that someone started talking about the need for systems approach to problems—the need to integrate all of the different parameters into a holistic concept of design (von Bertalanffy, 1966). A systems approach was developed in which one outlines broad parameters, took a detailed first look at individual systems, fit them together into a broad picture, and then proceeded to go about one's detailed design of various aspects of the system (Laszlo, 1973). Today, what is needed is a general systems theory approach to life and the universe.

Up to this point we have been doing a piecemeal job of studying living systems. The biologist, physiologist, psychologist, and psychiatrist each works separately. We cannot afford this approach any longer. Some of us have to become generalists and start trying to unify the various items of research. It is not sufficient to study this complex problem by concentrating entirely on a specific approach that will never quite get us to the right answer. It was not until some 20 years ago, with the advent of computer technology that the neurophysiologists together with computer specialists started to construct a decent model of brain functioning, demonstrating how these disciplines can successfully work together.

FIGURE 164. Early Chinese chart, showing selected acupuncture points and meridians (courtesy, S. Krippner).

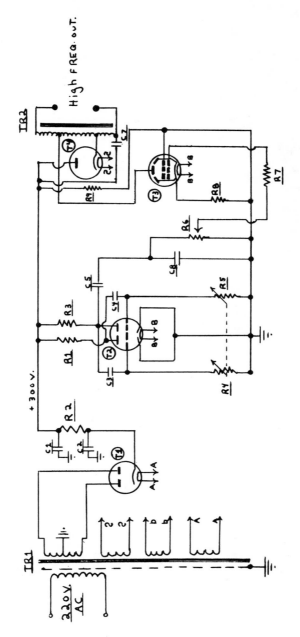

FIGURE 165. Schematic, Soviet electrophotography apparatus (courtesy, R. Ross).

221

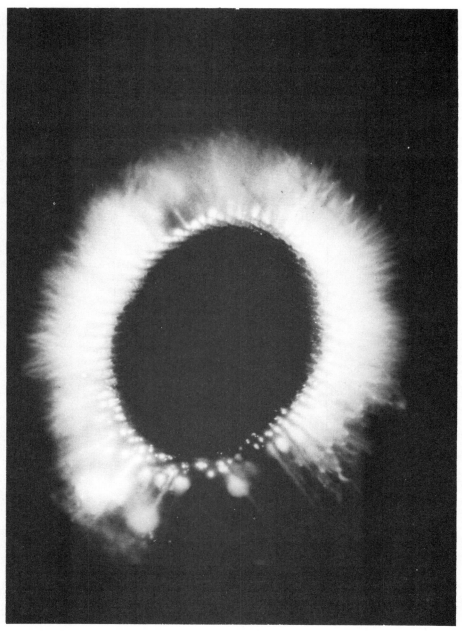

FIGURE 166. Electrophotograph, index finger pad, right hand, human subject
before ingestion of ginseng tea (courtesy, J. L. Hickman &
L. Amos).

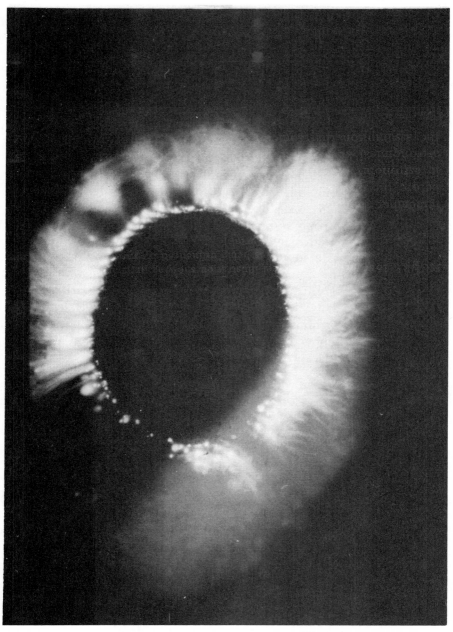

FIGURE 167. Electrophotograph, index finger pad, right hand, human subject
 five minutes after ingestion of ginseng tea (courtesy, J. L.
 Hickman & L. Amos).

There is a growing body of evidence that our materialistic model of the universe as derived from some of the reductionists' thinking, is very likely to be in error. Data from research in acupuncture and the human aura, as well as the findings of Kirlian photography specialists are disproving those who would take a reductionist point of view. In order to understand these new data, we will have to abandon many conventional concepts. We must be prepared to reject the very foundations of contemporary science, if need be, in order to understand what it is we are now seeing. Only by looking at a large spectrum of evidence will we be in a position to form new hypotheses, if they are required, to understand this living system we call humanity.

Heisenberg stated many years ago an uncertainty principle which can be restated simply—that the position and velocity of a body can only be determined within certain limits in one measurement. In other words, in the process of observing a particle, it is being influenced by the observer. Heisenberg's principle lends itself directly to helping us make sense out of psychokinetic events.

Already, a number of phenomena have been observed which challenge many accepted premises of science:

1. Human beings seem to have the ability to transfer information independently of known and accepted techniques that we understand in information transfer theory.

2. There is evidence indicating that a person apparently can influence matter merely with one's thought processes.

3. One person seems to be able to influence the health and well-being of another living system by proper application of one's thought processes, or by the channeling of certain forms of energy through one's consciousness.

4. The evidence indicates that the individual is able to influence one's own state of physical well-being merely by the way one thinks.

5. The individual seems to be able to project awareness to places other than the space currently occupied and to observe events distant from that space.

6. People seem to have energy fields not detectable by currently known direct reading instruments. Kirlian photography or some of

the different devices being investigated today may evolve into the instruments needed to measure this phenomenon.

7. The individual seems to be able to alter one's consciousness to experience other realities different than what is observed in one's ordinary waking state or in the ordinary space/time continuum.

8. We cannot discard the evidence that memory, consciousness, and identity may be enduring qualities of life going beyond this current existence.

These phenomena, if firmly established, would in fact place in jeopardy the materialistic paradigm that we have been living with for many years. That paradigm includes the concept that the person is only an organization of molecular structure. There appears to be more to a living system than the molecular structure that comprises it and that we understand at this point in time. The implications of these things extend from fundamental concepts of physics through our most lofty philosophic thinking. If these eight items can be established, they will alter our entire scientific methodology and the basic paradigms we have been living with.

Beyond that, however, how do we proceed to find out if this is true? What general approach can we take? What unifying idea can we call upon that seems to make sense, that seems to be a way of tying together all these apparent isolated phenomena? What general study seems to be indicated here? The lines of evidence point to a study of consciousness. Consciousness is a word which is difficult to define. Perhaps consciousness is a fundamental concept in itself. Perhaps we are talking about a field of consciousness.

All of these phenomena seem to bear upon or seem to have something to do with consciousness, awareness, and the ability to be aware of oneself.

Consciousness, the ability to be aware, is the only term broad enough to encompass all of these items. Therefore, I propose that what we are talking about is consciousness, rather than parapsychology, transpersonal psychology, physics, biology, microbiology, and medicine. These are disciplines and skills needed to study this problem. What we really should be studying is the problem itself, what I prefer to call "noetics," or the study of consciousness.

That word has an ancient and honorable Greek derivative and I doubt that many scientists will find it objectionable. In any event, consciousness is the unifying concept for all of these fields of endeavor.

I am not suggesting that everyone should be engaged in the study of consciousness or the study of noetics. I am suggesting that the physicist who is studying the energy fields we are talking about, the medical research person who is studying the healing concepts, the students who are researching Kirlian photography, should be aware that all of these fit into one large body of investigation which is unified at the level of consciousness. We have to be thinking of consciousness as a primal field that pervades not only the human being, but all of life.

Appendix A.

Adamenko, Viktor G., Ph.D., General Delivery 103009, Do Vostrebovaniya, Moscow K-9, U.S.S.R.

Barber, Theodore X., Ph.D., Medfield Foundation, Medfield, Mass. 02052, U.S.A.

Bresler, David, Ph.D., National Acupuncture Association, Suite 200, 1033 Gayley Avenue, Los Angeles, Cal. 90024, U.S.A.

Chaves, John F., Ph.D., Medfield Foundation, Medfield, Mass. 02052, U.S.A.

Elmendorff, Karl, Health Sciences Photographic Facility, University of Washington, Seattle, Wash. 98116, U.S.A.

Feldman, Robert, M.A., 82-56 212th Street, Hollis Hills, N.Y. 11427, U.S.A.

Gray, Jack I., Center for the Health Sciences, University of California, Los Angeles, Cal. 90024, U.S.A.

Hubacher, John, B.A., Center for the Health Sciences, University of California, Los Angeles, Cal. 90024, U.S.A.

Hurtak, James A., Department of Oriental Studies, California Institute of the Arts, Valencia, Cal. 90024, U.S.A.

Johnson, Kendall, A.B., J.D., Paraphysics, Inc., 16636 Calneva Drive, Encino, Cal. 91316, U.S.A.

Kirlian, Semyon D., Ph.D., Kazakh State University, Alma-Ata, Kazakh, U.S.S.R.

Kirsch, Carl, M.D., Institute for Bio-Energetic Analysis, 71 Park Avenue, New York, N.Y. 10016, U.S.A.

Kirsch, Sander, B.A., Institute for Bio-Energetic Analysis, 71 Park Avenue, New York, N.Y. 10016, U.S.A.

Krippner, Stanley, Ph.D., Humanistic Psychology Institute, 325 9th St., San Francisco, Cal. 94103, U.S.A.

Lok Yee-Kung, Hong Kong College of Chinese Acupuncture, Suite 4, 16 Kimberly Road, Zone "H," Kowloon, Hong Kong, B.C.C.

Miller, Richard Alan, B.S., Beltane, 1671 Harbor S.W., Seattle, Wash. 98116, U.S.A.

Mitchell, Edgar D., Ph.D., Institute for Noetic Studies, 575 Middle-field Road, Palo Alto, Cal. 94301, U.S.A.

Moss, Thelma, Ph.D., Center for the Health Sciences, University of California, Los Angeles, Cal. 90024, U.S.A.

Parker, Don H., Ph.D., Institute for Multilevel Learning International, Emlimar, Big Sur, Cal. 93920, U.S.A.

Pierrakos, John C., M.D., Institute for Bio-Energetic Analysis, 71 Park Avenue, New York, N.Y. 10016, U.S.A.

Rejdak, Zdenek, Ph.D., Czechoslovak Coordinating Committee for Research in Psychotronics, V. Chaloupkoch 59, Prague 9, Hloubetin, Czechoslovak Socialist Republic.

Rubin, Daniel, M.A., Foundation for ParaSensory Investigation, 1 West 81st Street, New York, N.Y. 10024, U.S.A.

Schwartz, Eric, Ph.D., Institute for Bio-Energetic Analysis, 71 Park Avenue, New York, N.Y. 10016, U.S.A.

Tiller, William A., Ph.D., Department of Materials Science, Stanford University, Stanford, Cal. 94305, U.S.A.

Wolff, Theodore, B.S., Institute for Bio-Energetic Analysis, 71 ·Park Avenue, New York, N.Y. 10016, U.S.A.

Yamamoto, Shizuko, 23 West 73rd Street, New York, N.Y. 10023, U.S.A.

Zeira, Yuval, A.E.E., Institute for Bio-Energetic Analysis, 71 Park Avenue, New York, N.Y. 10016, U.S.A.

Appendix B.
The Second Western
Hemisphere Conference on
Kirlian Photography,
Acupuncture, and
The Human Aura

MORNING SESSION: **KIRLIAN PHOTOGRAPHY**
Moderator: Judith R. Skutch, Foundation for ParaSensory Investigation.

Greetings from Semyon D. Kirlian, Viktor G. Adamenko, and Zdenek Rejdak, read in absentia by Robert D. Nelson, Central Premonitions Registry.

"International Developments in Biological Energy," Stanley Krippner, Maimonides Medical Center (Figure 168).

"Now You See It; Now You Don't," Kendall Johnson, University of California, Los Angeles.

"The Light Source in High-Voltage Photography," William A. Tiller, Stanford University.

"Human Control of a Bioelectric Field," Viktor G. Adamenko, Institute of Radio-Physics, read in absentia by Robert D. Nelson, Central Premonitions Registry.

"The Physical Mechanisms in Kirlian Photography," Richard Alan Miller, University of Washington.

"A High Frequency Filter Model of Kirlian Photography," Eric Schwartz, Institute for Bioenergetic Analysis.

FIGURE 168. Richie Havens and S. Krippner at the Second Western Hemis-
phere Conference on Kirlian Photography, Acupuncture, and
the Human Aura (courtesy, R. Mastrion).

"The Promise of Photopsychography," Don H. Parker, Institute
for Multilevel Learning, International.

Discussant: E. Douglas Dean, Newark College of Engineering.

Demonstration: Kirlian photography; Jonathan Cohen, Ronny
Mastrion, and Daniel Rubin (Figure 169).

FIGURE 169. D. Rubin demonstrating portable Kirlian electrophotography
apparatus (courtesy, R. P. Harris).

AFTERNOON SESSION: THE HUMAN AURA

Moderator: Lucille Kahn, Association for Research and
Enlightenment.

"Consciousness: The Unifying Concept," Edgar D. Mitchell,
Institute for Noetic Studies (Figure 170).

"The Human System: An Open-Ended Universe," James A.
Hurtak, California Institute of the Arts.

FIGURE 170. E. D. Mitchell discussing noetics (courtesy, R. P. Harris).

"The Human Energy Field," John Pierrakos, Institute for Bio-energetic Analysis.

"Experimental Measurements of the Human Energy Field," Richard Dobrin, Institute for Bioenergetic Analysis.

Discussant: Victor Gioscia, Center for the Study of Social Change.

Demonstration: Radiesthesia; Frances Farrelly (Figure 171).

FIGURE 171. F. Farrelly demonstrating radiesthesia (courtesy, R. P. Harris).

EVENING SESSION: ACUPUNCTURE
Moderator: Glen Boles, psychotherapist in private practice.

"Acupuncture and Moxibustion in Traditional Chinese Medicine," Lok Yee-Kung, Hong Kong College of Chinese Acupuncture.

"Acupuncture Analgesia: A Six-Factor Theory," Theodore X. Barber, Medfield Foundation.

"Scientific Approaches to the Study of Acupuncture Therapy," David Bresler, University of California, Los Angeles.

FIGURE 172. S. Yamamoto demonstrating shiatsu (courtesy, R. P. Harris).

Discussant: Long Sun Chu, physician in private practice.
Demonstration: Shiatsu (acupuncture massage); Shizuko
Yamamoto and Robert Feldman (Figure 172).

References

Adamenko, V. G. Electrodynamics of living systems. *Journal of Paraphysics*, 1970, *4*:113–120.

Adamenko, V. G. Objects moved at a distance by means of a controlled bioelectric field. In *Abstracts: Twentieth International Congress of Psychology*. Tokyo: International Congress of Psychology, 1972. P. 452.

Adamenko, V. G., Kirlian, V. Kh., & Kirlian, S. D. Detection of acupuncture points by the biometer. In *Galaxies of Life: The Human Aura in Acupuncture and Kirlian Photography*, Krippner, S., & Rubin, D. (eds.). New York: Gordon & Breach, 1973. Pp. 129–131.

Amos, L., Hickman, J., & Krumsiek, K. Kirlian photography as a new diagnostic tool. *Osteopathic Physician*, 1972, *39*:63–71.

Anon. China's doctors on tour. *Medical World News*, 1972, *13*:34–48.

Backster, C. Evidence of a primary perception in plant life. *International Journal of Parapsychology*, 1968, *10*:329–348.

Barber, T. X. Effects of hypnotic induction, suggestions of anesthesia and distraction on subjective and physiological responses to pain. A paper presented at the annual meeting of the Eastern Psychological Association, Philadelphia, Pa., 1969a.

Barber, T. X. *Hypnosis: A Scientific Approach*. New York: Van Nostrand Reinhold, 1969b.

Barber, T. X. *LSD, Marihuana, Yoga, and Hypnosis*. Chicago: Aldine, 1970.

Barber, T. X. Suggested ("hypnotic") behavior: The trance paradigm versus an alternative paradigm. In *Hypnosis: Research Developments and Perspectives*, Fromm, E., & Shor, R. E. (eds.). Chicago: Aldine-Atherton, 1973, Pp. 115–182.

Barber, T. X. The effects of "hypnosis" on pain: A critical review of experimental and clinical findings. *Psychosomatic Medicine*, 1963, *25*: 303–333.

Barber, T. X. Toward a theory of pain: Relief of chronic pain by prefrontal leucotomy, opiates, placebos, and hypnosis. *Psychological Bulletin*, 1959, *56*:430–460.

Barber, T. X., & Cooper, B. J. Effects on pain of experimentally-induced and spontaneous distraction. *Psychological Reports*, 1972, *31*:647–651.

Barber, T. X., & Hahn, K. W., Jr. Physiological and subjective responses to pain-producing stimulation under hypnotically-suggested and waking-imagined "analgesia." *Journal of Abnormal and Social Psychology*, 1962, *65*:411–418.

Becker, R. O. Electromagnetic forces and life processes. *Technology Review*, 1972, *75*:32–36.

Beecher, H. K. The powerful placebo. *Journal of the American Medical Association*, 1955, *159*:1602–1606.

Behkterev, V. M. Experiments in influencing "mentally" the behavior of animals. *Problems of Study and Education of the Personality*, 1920, 2:230–265.

Bekhterev, V. M. Telepathy with dogs. In *Psychic Discoveries by the Russians*, Ebon, M. (ed.). New York: New American Library, 1971. Pp. 45–59. Originally published in 1920.

Bernstein, J. Profiles (Albert Einstein – I), *New Yorker*, March 10, 1973.

Bohr, N. *Atomic Physics and Human Knowledge*. New York: Vintage, 1966.

Boyers, D., & Tiller, W. A. On corona discharge photography. *Journal of Applied Physics*, 1973, *44*:3102–3112.

Brown, P. E. Use of acupuncture in major surgery. *Lancet*, 1972, *1*:1328–1330.

Buhler, C. Basic theoretical concepts of humanistic psychology. *American Psychologist*, 1971, 26:378–386.

Buhler, C. *The Human Course of Life as a Psychological Problem*. Leipzig: Hirzel, 1933.

Burr, H. S. *Blueprint for Immortality: The Electric Patterns of Life*. London: Neville-Spearman, 1972.

Burr, H. S. Effect of a severe storm on electric properties of a tree and the earth. *Science*, 1956, *124*:1204–1205.

Burr, H. S., & Northrop, F. S. C. Evidence for the existence of an electromagnetic field in living organisms. *Proceedings, National Academy of Science*, 1939, 25: entire.

Capperauld, I. Acupuncture anesthesia and medicine in China today. *Surgery, Gynecology & Obstetrics*, 1972, *135*:440–445.

Capperauld, I., Cooper, E., & Saltoun, D. Acupuncture anesthesia in China. *Lancet*, 1972, 2:1136–1137.

Chaves, J. F., & Barber, T. X. Cognitive strategies, experimenter modeling, and expectation in the attenuation of pain. *Medfield Foundation Reports*, 1973, No. 129.

Chen, J. Y. P. Acupuncture. In *Medicine and Public Health in the People's Republic of China*, Quinn, J. R. (ed.). Washington, D.C.: U.S. Department of Health, Education, & Welfare, and National Institutes of Health, 1972. Pp. 65–90.

Chisholm, N. A. Acupuncture analgesia. *Lancet*, 1972, 2:540.

Cott, A. Controlled fasting treatment of schizophrenia in the U.S.S.R. *Schizophrenia*, 3:2–10, 1971.

de la Warr, G. *Biomagnetism*. Oxford: De la Warr Laboratories, 1967.

de Langre, J. *The First Book of Dō-In*. Hollywood, Cal.: Happiness Press, 1971.

Dawson, G. A., Winn, W. P. A model for streamer propagation. *Zeitschrift fur Physik*, 1965, *183*:159.

Dean, E. D., & DeLoach, E. E. What is the evidence for psychic healing? *Osteopathic Physician*, 1972, *39*:72–77, 136.

Dimond, E. G. Acupuncture anesthesia: Western medicine and Chinese traditional medicine. *Journal of the American Medical Association*, 1971, *218*:1558-1563.

Dodson, H. C., Jr., & Bennett, H. A. Relief of postoperative pain. *American Surgeon*, 1954, *20*:405-409.

Drake, D. Yin, Yang, and acupuncture. In *Acupuncture: What Can It Do For You?* New York: Newspaper Enterprise Assn., 1972. Pp. 28-31.

Ebon, M. (ed.). *Psychic Discoveries by the Russians*. New York: New American Library, 1971.

Editorial committee for acupuncture and moxibustion of the People's Publishing House, Peking, P.R.C. *Basic Acupuncture Techniques*. (Hsu, L., trans.) San Francisco: Basic Medicine Books, 1973.

Egbert, L. D., Batit, G. E., Turndorf, H., & Beecher, H. K. The value of the preoperative visit by an anesthetist. *Journal of the American Medical Association*, 1963, *185*:553-555.

Egbert, L. D., Battit, G. E., Welch, C. E., & Bartlett, M. K. Reduction of post-operative pain by encouragement and instruction of patients. *New England Journal of Medicine*, 1964, *270*:825-827.

Einstein, A. *The World As I See It*. (Harris, A., trans.) New York: Philosophical Library, 1934.

Eisenbud, J. *The World of Ted Serios*. New York: William Morrow, 1967.

Evans, M. B., & Paul, G. L. Effects of hypnotically suggested analgesia on physiological and subjective responses to cold stress. *Journal of Consulting and Clinical Psychology*, 1970. *35*:362-371.

Evans-Wentz, W. Y. *The Tibetan Book of the Dead*. Third edition. London: Oxford University Press, 1957.

Finer, B. Physiological studies of the relationship between the doctor and the patient in pain. *Acta Universitas Upsala*, 1970, *1*:1-24.

Freedman, L. R. The relevance of acupuncture. *Yale Journal of Biology and Medicine*, 1972, *45*:70-72.

Freemont-Smith, F. Discussion of Beecher's paper on perception of pain. In *Problems of Consciousness, First Conference*, Abramson, H. A., (ed.). New York: Josiah Macy, Jr., Foundation, 1950. P. 108.

Galston, A. W., & Savage, J. S. *Daily Life in People's China*. New York: Crowell, 1973.

Gammon, G. D., & Starr, I. Studies on the relief of pain by counter-irritation. *Journal of Clinical Investigation*, 1941, *20*:13-20.

Gemperle, M. Cited in *Science Digest*, 1972, *73*:6.

Gurion, W. G., Ferry, D. K. Bulk negative differential conductivity in a near cathode region in n-type germanium. *Journal of Applied Physics*, 1971, *42*:2502.

Hamilton, S., Brown, P., Hollington, M., & Rutherford, K. Anesthesia by acupuncture. *British Medical Journal*, 1972, *3*:352.

Hardy, J. D., Wolff, H. G., & Goodell, H. *Pain Sensations and Reactions.* Baltimore: Williams & Wilkins, 1952.

Hendin, D. Is acupuncture today's medical miracle? In *Acupuncture: What Can It Do For You?* New York: Newspaper Enterprise Assn., 1972. Pp. 4–7.

Herbert, B. Alexei Krivorotov, Russian "healer." *Journal of Paraphysics*, 1968, 4:112.

Herbert, B. The Kirlian controversy: Cut-away effect. *Journal of Paraphysics*, 1972, 6:rear cover.

Houde, R. W., & Wallenstein, S. L. A method for evaluating analgesics in patients with chronic pain. *Drug Addiction and Narcotics Bulletin*, 1953, Appendix F: 660–682.

Inyushin, V. M. Bioplasma and interaction of organisms. In *Symposium of Psychotronics*, Rejdak, Z., et. al. (eds.). Downton, Wiltshire, England: Paraphysical Laboratory, 1970. Pp. 50–53.

Inyushin, V. M. *Toward the Problem of the Luninescence of Tissue in High-Frequency Discharge Biological Action of Red Light*, Alma-Ata, Kazakh, U.S.S.R.: Kazakh State University, 1967.

Inyushin, V. M., et. al. *On the Biological Essence of the Kirlian Effect.* Alma-Ata, Kazakh, U.S.S.R.: Kazakh State University, 1968.

Jain, K. K. Glimpses of Chinese Medicine, 1971: (Changes after the cultural revolution). *Canadian Medical Association Journal*, 1972a, 106:46–50.

Jain, K. K. Glimpses of neurosurgery in the People's Republic of China. *Internal Surgery*, 1972b, 57:155–157.

Jallabert, M. Electricity (citation). In *Encyclopedia Britannica, Volume II*. First edition. London: Encyclopedia Britannica, 1771. P. 405.

Jungerman, J. A. A nuclear physicist looks at psychotronics. Paper presented at the First International Conference on Parapsychology and Psychotronics, Prague, 1973.

Kanfer, F. H., & Goldfoot, D. A. Self-control and tolerance of noxious stimulation. *Psychological Reports*, 1966, 18:79–85.

Kholodov, Y. A. *The Effect of Electromagnetic and Magnetic Fields on the Central Nervous System.* Moscow: Nauka, 1966.

Kilner, W. *The Human Aura or Atmosphere.* London: Keegan Press, 1917.

Kirlian, S. D., & Kirlian, V. Kh. *In the World of Wonderful Discharges.* Alma-Ata, Kazakh, U.S.S.R.: Kazakh State University, 1958.

Kirlian, S. D., & Kirlian, V. Kh. Photography and visual observations by means of high frequency currents. *Journal of Scientific and Applied Photography*, 1961, 6:397–403.

Kirlian, S. D., & Kirlian, V. Kh. Photography by means of high frequency currents. In *Galaxies of Life: The Human Aura in Acupuncture and Kirlian Photography*, Krippner, S., & Rubin, D. (eds.). New York: Gordon & Breach, 1973. Pp. 13–27.

Koenig, P. The Americanization of acupuncture. *Psychology Today*, 1973, 7:37–38.

Krippner, S., & Davidson, R. J. Acupuncture and hypnosis in the U.S.S.R. *Journal of Paraphysics,* 1972a, *6*:82–92.

Krippner, S., & Davidson, R. J. Parapsychology in the U.S.S.R., *Saturday Review,* March 18, 1972b.

Krippner, S., & Davidson, R. J. The use of convergent operations in bio-information research. *Journal for the Study of Consciousness,* 1972c, *5*:64–76.

Krippner, S., & Drucker, S. A. Field theory and Kirlian photography: An old map for a new territory. In *Galaxies of Life: The Human Aura in Acupuncture and Kirlian Photography,* Krippner, S., & Rubin, D. (eds.). New York: Gordon & Breach, 1973. Pp. 61–70.

Krippner, S., Hickman, J., Auerhahn, N., & Harris, R. Clairvoyant perception of target material in three states of consciousness. *Perceptual and Motor Skills,* 1972, *35*:439–446.

Krippner, S., & Rubin, D. (eds.). *Galaxies of Life: The Human Aura in Acupuncture and Kirlian Photography.* New York: Gordon & Breach, 1973.

Krippner, S., & Rubin, D. (eds.) *The Kirlian Aura.* New York: Anchor, 1974.

Kroger, W. S. Hypnotism and acupuncture. *Journal of the American Medical Association,* 1972, *220*:1012–1013.

Kroger, W. S. More on acupuncture and hypnosis. *Society for Clinical and Experimental Hypnosis Newsletter,* 1972, *13*:2–3.

Lawson-Wood, D., & Lawson-Wood, J. *The Five Elements of Acupuncture and Chinese Massage.* Sussex, England: Health Science Press, 1966.

Laszlo, D., & Spencer, H. Medical problems in the management of cancer. *Medical Clinics of North America,* 1953, *37*:869–880.

Laszlo, E. *Introduction to Systems Philosophy: Toward a New Paradigm of Contemporary Thought.* New York: Harper & Row, 1973.

Lennander, K. G. Beobachtungen uber die Sensibilitat in der Bauchhohle. *Mitteilungen aus den Grenzgebieten der Medizin und Chirurgie,* 1902, *10*:38–104.

Lennander, K. G. Ueber die Sensibilitat der Bauchhohle und uber lokale und allgemeine Anasthesie bei Bruch-und Brauchoperationen. *Centralblatt fur Chirurgie,* 1901, *8*:209.

Lennander, K. G. Ueber Hofrat Nothnagels zweite Hypothese der Darmkolik-schmerzen. *Mitteilungen aus den Grenzgebieten der Medizin und Chirurgie,* 1906a, *16*:19–23.

Lennander, K. G. Ueber lokale Ananthesie und uber Sensibilitat in Organ und Gewebe, weitere Beobachtungea. *Mitteilungen aus den Grenzgebeiten der Medizin und Chirurgie,* 1906b, *15*:465–494.

Lennander, K. G. Weitere Beobach-tungen uber Sensibilitat in Organ und Gewebe und uber lokale Anasthesie. *Deutsche Zeitschrift fur Chirurgie,* 1904, *13*:297–350.

Leonidov, I. Russians photograph life and death. *Fate,* September, 1962.

Lewis, T. *Pain.* New York: Macmillan, 1942.

Liu, W. Acupuncture anesthesia: A case report. *Journal of the American Medical Association*, 1972, *221*:87–88.

Loeb, L. B. *Electrical Coronas — Their Basic Physical Mechanisms*. Berkeley: Univ. of California Press, 1965.

Loeb, L. B., & Meek, J. M. *The Mechanism of the Electric Spark*. Stanford: Stanford University Press, 1941.

Lowen, A. *Physical Dynamics of Character Structure*, New York: Grune and Stratton, 1958.

Lowen, A. *The Betrayal of the Body*. New York: Macmillan, 1967.

Lozanov, G. Anesthetization through suggestion in a state of wakefulness. In *Proceedings of the 7th European Conference on Psychosomatic Research*. Rome: Privately printed, 1967. Pp. 399–402.

McGarey, W. A. The philosophy and clinical aspects of acupuncture as viewed from the framework of Western medicine. In *Transcript of the Acupuncture Symposium*. Los Altos, Cal.: Academy of Parapsychology and Medicine, 1972. Pp. 12–22.

Man, P. L., & Chen, C. H. Acupuncture "anesthesia"—A new theory and clinical study. *Current Therapeutic Research*, 1972, *14*:390–394.

Mann, F. Acupuncture analgesia in dentistry. *Lancet*, 1972, *1*:898–899.

Mann, F. Acupuncture anesthesia. A paper presented at the Symposium on Acupuncture, New York University School of Medicine, 1973.

Mann, F. *Acupuncture: The Ancient Chinese Art of Healing*. New York: Vintage Books, 1972.

Maslow, A. H. *Motivation and Personality*. New York: Harper, 1954.

Mastrion, R. Private communication, August 6, 1973.

Matsumoto, T. Acupuncture and U.S. medicine. *Journal of the American Medical Association*, 1972, *220*:1010.

Maxwell, J. C. *A Treatise on Electricity and Magnetism, Volumes I and II*. Second Edition. London: Oxford Press, 1881.

Mead, R. *On the Power and Influences of the Sun and Moon on Human Bodies, and of the Diseases that Rise from Thence*. London: R. Wellington, 1712.

Meek, J. M., & Craggs, J. D. *Electrical Breakdown of Gases*. London: Oxford Press, 1953.

Melzack, R. *The Puzzle of Pain*. New York: Basic Books, 1973b.

Melzack, R. Why acupuncture works. *Psychology Today*, 1973a, 7:28, 30, 32, 34, 37.

Melzack, R., & Wall, P. D. Pain mechanisms: A new theory. *Science*, 1965, *150*:971–979.

Merrill, F. H., & Von Hippel, A. An atmospheric interpretation of Lichtenberg figures and their application to the study of gas discharge phenomena. *Journal of Applied Physics*, 1939, *10*:873.

Mesmer, F. A. *Mesmerism*. London: Macdonald, 1779.

Mikhalevskii, V. L., & Frontov, G. S. Photographing surfaces of metal ores by means of high frequency currents. *Russian Journal of Scientific and Applied Photography and Cinematography*, 1966, 2:380–381.

Milner, D. R., & Smart, E. F. Private communication, 1973.

Miroshnitzenko, B. E. (ed.). *The Basis of Biogeometry: A Methodological Study of Stereobioenergetics.* Alma Alta, Kazakh, U.S.S.R.: Kazakh State University, 1972.

Mitchell, J. F. Local anesthesia in general surgery. *Journal of the American Medical Association*, 1907, 48:198–201.

Montandon, R. *Human Radiation.* Paris: Alcan, 1927.

Moss, T. Searching for psi from Prague to lower Siberia. *Psychic*, 1971, 2:40–44.

Moss, T., & Johnson, K. Bioplasma or corona discharge? In *Galaxies of Life: The Human Aura in Acupuncture and Kirlian Photography.* Krippner, S., & Rubin, D. (eds.). New York: Gordon & Breach, 1973. Pp. 29–51.

Moss, T., & Johnson, K. Is there an energy body? *Osteopathic Physician*, 1972a, 39:27–43.

Moss, T., & Johnson, K. Radiation field photography. *Psychic*, 1972b, 3:50–54.

Muramoto, N. Oriental diagnosis. *The Macrobiotic*, 1971, 11:7–13.

Murr, L. E. Fossilization of electrical corona streamers from silicon nitride crystal in the electron microscope. *Philosophical Magazine*, 1972, 25:721.

Nasser, E. Development of spark in air from a negative point. *Journal of Applied Physics*, 1971, 42:2839.

Nasser, E. Spark breakdown in air at a positive point. *IEEE Spectrum*, November, 1968.

Naumov, E. K., & Vilenskaya, L. V. *Bibliographies on Para-psychology (Psychoenergetics) and Related Subjects.* Springfield, Va.: National Technical Information Service, U.S. Department of Commerce, 1972.

Newton, I. *Mathematical Principles of Natural Philosophy.* Berkeley, Cal.: Univ. of California Press, 1934. Originally printed in 1729.

Notermans, S. L. H. Measurement of pain threshold determined by electrical stimulation and its clinical application. Part I, methods and factors possibly influencing the pain threshold. *Neurology*, 1966, 16:1071–1086.

Ostrander, S., & Schroeder, L. *Psychic Discoveries Behind the Iron Curtain.* New York: Prentice-Hall, 1970.

Ostrander, S., & Schroeder, L. Psychic enigmas and energies in the U.S.S.R. *Psychic*, 1971, 2:9–14.

Plutchik, R., & Hirsch, H. R. Skin impedance and phase angle as a function of frequency and current. *Science*, 1963, 141:927.

Presman, A. S. *Electromagnetic Fields and Life.* New York: Plenum Press, 1970.

Presman, A. S. The role of electromagnetic fields in vital processes. *Biofizika*, 1964, 9:13.

Price, H. L., & Dripps, R. D. Intravenous anesthetics. In *The Pharmacological Basis of Therapeutics*, Goodman, L. S., & Gilman, A. (eds.). Fourth edition. New York: Macmillan, 1970. Pp. 93–97.

Ratner, S. C. Comparative aspects of hypnosis. In *Handbook of Clinical and Experimental Hypnosis*, Gordon, E. (ed.). New York: Macmillan, 1967. Pp. 550–587.

Ravitz, L. J. Electromagnetic field monitoring of changing state-function, including hypnotic states. *Journal of the American Society of Psychosomatic Dentistry and Medicine*, 1970, *17*:119–129.

Ravitz, L. J. Electrometric correlates of the hypnotic state. *Science*, 1950, *112*:341–342.

Ravitz, L. J. History, measurement, and applicability of periodic changes in the electromagnetic field in health and disease. *Annals of the New York Academy of Sciences*, 1962, *98*:1144–1201.

Reich, W. *Character Analysis.* New York: Orgone Institute Press, 1949.

Reich, W. *The Discovery of the Orgone.* Two volumes. Rangeley, Me.: Orgone Institute Press, 1942.

Repin, L. The living organism and the magnetic field. *Sputnik*, April, 1967.

Reston, J. Now, about my operation. In *Acupuncture: What Can It Do For You?* New York: Newspaper Enterprise Assn., 1972. Pp. 8–11.

Rhee, J. L. Introductory remarks: Acupuncture: The need for an in depth appraisal. In *Transcript of the Acupuncture Symposium*. Los Altos, Cal.: Academy of Parapsychology and Medicine, 1972. Pp. 8–10.

Sampimon, R. L. N., & Woodruff, M. F. A. Some observations concerning the use of hypnosis as a substitute for anesthesia. *Medical Journal of Australia*, 1946, *1*:393–395.

Senizawa, K. *Massage: The Oriental Method.* San Francisco: Japan Publications, 1972.

Shealy, C. N. A physiological basis for electro-acupuncture. In *Transcript of the Acupuncture Symposium*. Los Altos, Cal.: Academy of Parapsychology & Medicine, 1972, Pp. 34–36.

Sherman, H. *"Wonder" Healers of the Philippines.* London: Psychic Press, 1967.

Shute, W. B. East meets West (I): Canadian eyes peek across the acupuncture threshold. *Canadian Medical Association Journal*, 1972, *107*:1002–1005.

Spanos, N. P., Barber, T. X., & Lang, G. Effects of hypnotic induction, suggestions of analgesia, and demands for honesty on subjective reports of pain. In *Cognitive Alteration of Feeling States*, London, H., & Nisbett, R. (eds.). Chicago: Aldine, in press.

Swaroop, N., Predecki, P. Low-frequency current oscillatons in polymer films at high D.C. fields. *Journal of Applied Physics*, 1971, *42*:863.

Szent-Gyorgyi, A. *Introduction to a Submolecular Biology.* London: Academic Press, 1960.

Taub, A. Acupuncture. *Science.* 1972, *178*:9.

Tiller, W. A. A technical report on some psychoenergetic devices. *A.R.E. Journal*, 1972, 7:81–94.

Tiller, W. A. Some energy field observations of man and nature. In *Galaxies of Life: The Human Aura in Acupuncture and Kirlian Photography*, Krippner, S., & Rubin, D. (eds.). New York: Gordon & Breach, 1973. Pp. 70–111.

Tkach, W. A firsthand report from China: "I have seen acupuncture work," says Nixon's doctor. *Today's Health*, 1972, *50*:50–56.

Toyama, P. M., & Nishizawa, M. The Physiological basis of acupuncture therapy. *North Carolina Medical Journal*, 1972, *33*:425–429.

Trent, J. C. Surgical anesthesia. *Journal of the History of Medicine*, 1946, *1*:505–511.

Tuckey, C. L. Psychotherapeutics; or treatment by hypnotism. *Woods Medical and Surgical Monographs*, 1889, *3*:721.

Ullman, M., & Krippner, S., with Vaughan, A. *Dream Telepathy*. New York: Macmillan, 1973.

Valentine, T. *Psychic Surgery*. Chicago: Henry Regnery, 1973.

Vassilchenko, G. S. *Several Systematic Neuroses and their Pathogenetic Treatment*. Moscow: Meditsina, 1969.

Veith, I. Acupuncture: Ancient enigma to East and West. *American Journal of Psychiatry*, 1972, *129*:333–336.

Veith, I. (ed. & trans.). *Huang Ti Nei Ching Su Wen: The Yellow Emperor's Classic of Internal Medicine*. New edition. Berkeley: University of California Press, 1970.

von Bertalanffy, L. General system theory and psychiatry. In *American Handbook of Psychiatry, Volume Three*, Arieti, S. (ed.). New York: Basic Books, 1966. Pp. 705–710.

von Reichenbach, C. *Psycho-Physiological Researches on the Dynamics of Magnetism, Electricity, Heat, Light, Crystallization, and Chemism, in their Relation to Vital Force*. New York: Clinton Hall, 1851.

Wall, P. An eye on the needle. *New Scientist*, July 20, 1972.

Warren, F. Z. Film presentation on acupuncture anesthesia and panel discussion on acupuncture. In *Transcript of the Acupuncture Symposium*. Los Altos, Cal.: Academy of Parapsychology and Medicine, 1972. Pp. 86–92.

Wigner, E. P. Remarks on the mind–body question. In *The Scientist Speculates*, Good, I. J. (ed.). London: Heinemann, 1962. Pp. 284–302.

Worsley, J. R. *Is Acupuncture For You?* New York: Harper & Row, 1973.

Worsley, J. R. Using the aura as a diagnostic aid. *Osteopathic Physician*, 1972, *39*:47–59.

Zahradnicek, J. *The Photochemical Effects of Maxwell's Currents*. Prague: Faculty of Sciences, Masaryk University, 1948.

Zelany, W. Variation of size and charge of Lichtenberg figures with voltage. *American Journal of Physics*, 1945, *13*:106.

Zinchenko, V. P., Leontiev, A. N., Lomov, B. F., & Luria, A. R. Parapsychology: Fiction or reality? *Questions of Philosophy*, 1973, *27*:128–136.

IN MEMORIAM

Chinese Poem #1

In the first month of the year,
not by our calendar, but a older more poetic one
Heaven and Earth unite
producing a quickening
in seeds long entombed in dark earth.

The coming together of the strong and the weak
is inevitable
Harmony made of the proper arrangement
begins a song that swells
out from the center.
Each creature hearing the sound,
begins silently singing and dancing in joyous response
till the whole world rocks and rolls.
The great song of birth—echoing reechoing;
I am; I am; I am.

Robert Pochily
(1945–1973)

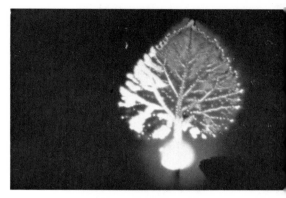

FIGURE 45. Electrophotograph, campanula leaf, intact (courtesy, T. Moss & K. Johnson). *COLOR*

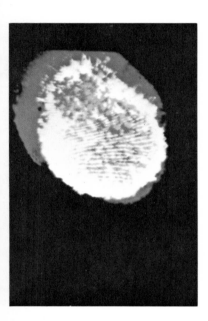

FIGURE 27. Electrophotograph, right index finger pad, aroused subject (courtesy, T. Moss & K. Johnson). *COLOR*

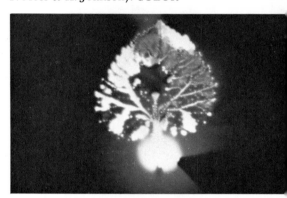

FIGURE 46. Electrophotograph, campanula leaf, immediately after mutilation (courtesy, T. Moss & K. Johnson). *COLOR*

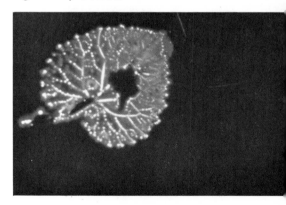

FIGURE 47. Electrophotograph, mutilated campanula leaf, untreated (courtesy, T. Moss & K. Johnson). *COLOR*

STANLEY KRIPPNER, Ph.D.

As a scientist, psychologist, and respected author, Dr. Krippner is internationally known for his investigations into psychoenergetic phenomena.

In the United States, where ESP, parapsychology and related areas are just beginning to infiltrate the scientific community as a bonafide field of study, Dr. Krippner has been a major influence in developing serious psychic research. He was dubbed "sceptic among the spooks" by **Psychology Today**, for his critical, scientific approach to all experimental work in this area.

Currently Vice President for the Western Hemisphere of the International Association for Psychotronic Research in Prague, and Program Planning Coordinator, Humanistic Psychology Institute, San Francisco, Dr. Krippner has numerous other affiliations with educational and research institutions concerned with psychic studies.

He is the author and co-author of over 200 articles in various psychological, psychiatric, and educational journals. With Daniel Rubin, he co-edited the book *Galaxies of Life* (Gordon and Breach 1973), and is co-author of *Dream Telepathy* (Macmillan, 1973), as well as editor-in-chief of the Gordon and Breach journal, *Psychoenergetic Systems.*

DANIEL RUBIN

Mr. Rubin is a Research Associate at the Foundation for ParaSensory Investigation in New York City, and commutes as a Graduate Student in the Department of Psychology at California State College in Sonoma. He is a consulting editor for the journal, *Psycho-energetic Systems,* and has assisted Dr. Krippner in the work being done at the Dream Laboratory in Maimonides Medical Center in Brooklyn.